IMAGES
of America

JIM THORPE IN THE 20TH CENTURY

IMAGES
of America

JIM THORPE IN THE
20TH CENTURY

John H. Drury Jr. and Joan Gilbert

ARCADIA
PUBLISHING

Published by Arcadia Publishing
Charleston, South Carolina

Library of Congress Control Number: 2005925677

For all general information, please contact Arcadia Publishing:
Telephone 843-853-2070
Fax 843-853-0044
E-mail sales@arcadiapublishing.com
For customer service and orders:
Toll-Free 1-888-313-2665

Visit us on the Internet at www.arcadiapublishing.com

On the cover: This photograph was taken from the east bank of the Lehigh River at the foot of Bear Mountain. From left to right are the navigation building, the courthouse, and, on the hillside, the Asa Packer Mansion. (Courtesy of Lynda Kane Kacicz of Affordable Framing.)

CONTENTS

ACKNOWLEDGMENTS

The authors would like to thank the following for the use of their photographs: Ann Baddick, Joe Boyle, Rita Boyle, Dennis De Mara, Dimmick Memorial Library, David Drury, Jane Engler, George Hart, Ray Holland, Jim Thorpe Lions Club, Mauch Chunk Museum and Cultural Center, Agnes McCartney, Ray Mulligan, National Canal Museum, Evelyn Norwood, Louise Ogilve, Old Jail Museum, Thomas Potter, Joseph Sebelin, Smithsonian Institution, Laura Thomas, the *Times News*, Lars Wass of the Swedish Association for the Promotion of Sports, and Mary Wohlhaas. Special thanks to Al Zagofsky for his generous contribution of photographs and for scanning the images.

PREFACE

Just as civilizations rise and fall, so do the economies of small towns. Such was the case with Mauch Chunk, Pennsylvania, now known as Jim Thorpe. Established in 1818 as a coal shipping outpost on the banks of the Lehigh River by Philadelphians Josiah White and Erskine Hazard and German immigrant George F. A. Hauto, the wilderness settlement soon became the headquarters of the Lehigh Coal and Navigation Company and a thriving company town.

Initially, coal was carried by horse and wagon nine miles over the mountains from the Summit Hill mine to the Lehigh River and shipped downstream by ark through an ingenious system of hydrostatic sluices, known as "bear trap locks." When supply could no longer keep up with demand, the movement of coal was expedited. A single-line gravity railroad known as the Mauch Chunk Railroad opened in 1828, and in 1829, the 46-mile Lower Division of the Lehigh Navigation—a combination of canal and Lehigh River slack water—connected Mauch Chunk to Easton. Coal was brought to the Mauch Chunk waterfront by gravity railroad and transported by mule-drawn coal boat down the Lower Division to Easton, where it either continued along the Delaware Canal to Philadelphia or along the Morris Canal to New York City.

As the Lehigh Coal and Navigation Company's transportation network grew and prospered, so did the town of Mauch Chunk. In 1838, the Lower Division of the Lehigh Navigation was extended 26 miles northward through the magnificent gorge of the Lehigh River to White Haven. At White Haven, the company's Lehigh and Susquehanna Railroad connected the Lehigh Navigation with the Susquehanna Navigation at Wilkes-Barre. In addition to new influxes of coal into the Upper Division from mines to the west of the river, and from the Wyoming Valley and Wilkes-Barre area to the north, packet boat tourism increased with the extension of the waterway. Passengers could board a boat at Bristol, near Philadelphia, or on the New Jersey side of the Hudson River from New York City, travel along connector canals to the Lehigh Navigation, and choose to disembark at the scenic town of Mauch Chunk, or continue on to the White Haven terminus. There, they could either board a passenger train for Wilkes-Barre or, as Josiah White did while on a sightseeing trip with his daughter Rebecca in October 1846, remain on board the boat as it was loaded onto a boat train for the 20-mile journey between the Lehigh and Susquehanna Navigations. From Wilkes-Barre, packet boaters could head south along the Susquehanna Navigation or to points west and north by its West and North Branch Canals.

By the late 1800s, two railroads—the Lehigh Valley and the Lehigh and Susquehanna (later leased to the Central Railroad of New Jersey)—ran through the Lehigh Gorge, transporting coal

and passengers throughout the region. With its mountains and waterfalls and attractions like the round-trip Switchback Gravity Railroad (formerly the single-line Mauch Chunk Railroad), Mauch Chunk—promoted by the railroads as "the Switzerland of America"—was second only to Niagara Falls as the most visited destination of rail excursionists. With its twin economies of coal transportation and tourism, and millionaire residents erecting millionaire homes, fine churches and buildings, the once wilderness outpost was basking in its Golden Age by the mid-19th century. But Mauch Chunk's Golden Age was not to last. By the dawn of the next century, the economic situation had begun to erode.

In order to assess economic and social change in 20th-century Mauch Chunk, this book begins with a look at the town's 19th-century Golden Age of coal transportation and tourism. It then covers the town's slow economic decline and the abysmal depths to which its once-prosperous economy fell. The mid-20th century brings the strange quid pro quo proposition of Patricia Thorpe, widow of Jim Thorpe, the legendary Native American Olympian. The final years include the newly renamed town's ultimate rise as the economy is pulled up by its bootstraps by a combination of long-time residents and newcomers to town.

One

MAUCH CHUNK'S GOLDEN AGE

From that auspicious day in 1820 when Josiah White sent the first shipment of anthracite coal down the Lehigh River by way of the bear trap lock and dam system, the industrial outpost of Mauch Chunk began to prosper. By the mid-19th century, with its twin economies of coal shipment and tourism, Mauch Chunk was not only a bustling Victorian town, it was the esteemed seat of Carbon County government.

As the town evolved, its social and ethnic structure was revealed through its physical layout. In contrast to modern town planning, with its wealthy suburbs and frequently run-down interiors, Mauch Chunk's main street, Broadway, revealed the opposite. As Broadway ascended the narrow ravine formed by the Mauch Chunk Creek tumbling toward the Lehigh River, the transition from rich homes in the heart of town to middle-class to working poor on the outskirts was evident.

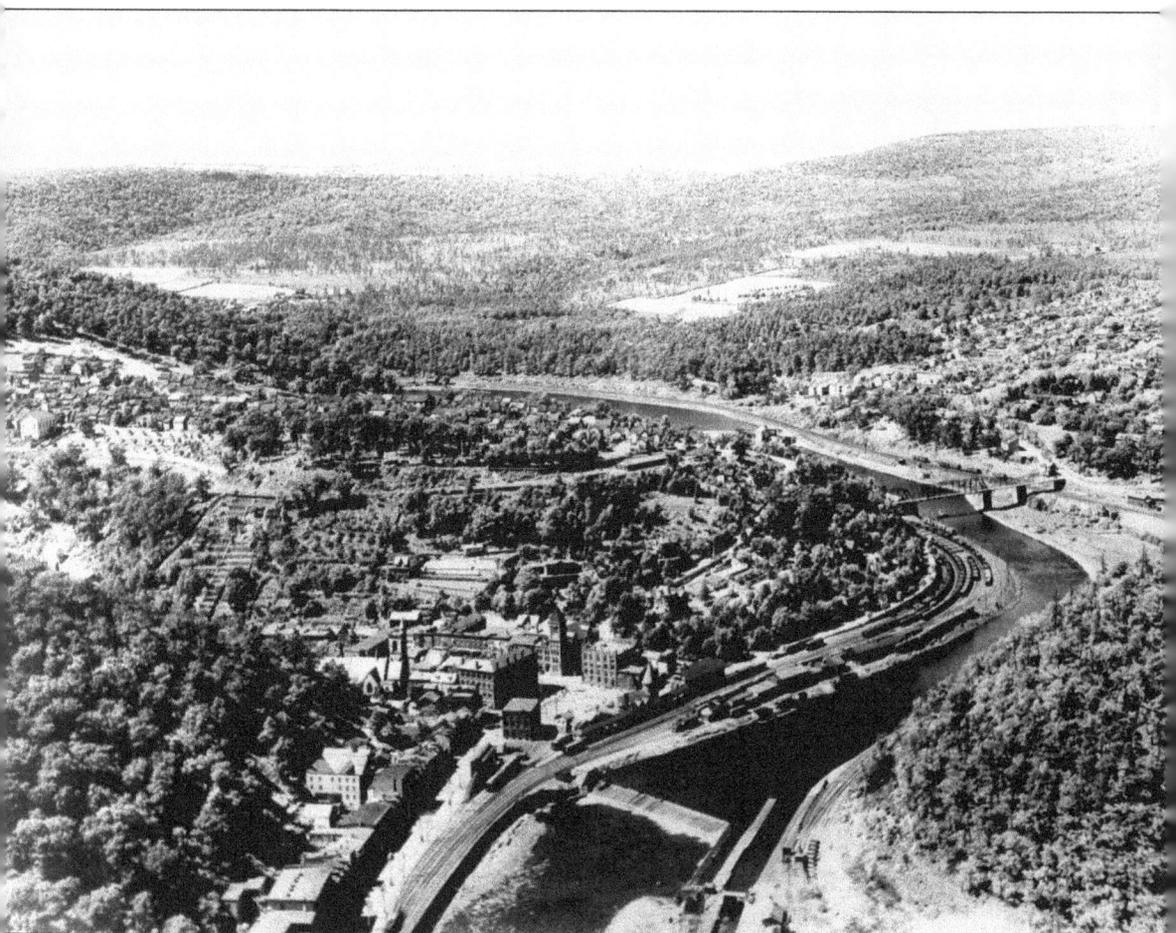

Established in 1818 at the foot of a ravine where the Mauch Chunk Creek enters the west bank of the Lehigh River, Mauch Chunk's expansion was constrained by the mountainous topography. Before long, its population spilled over to the river's east bank. Three distinct districts make up the town, which was renamed Jim Thorpe in 1954: the Historic District, a residential and commercial section on the Lehigh's west bank; the Heights, a residential section on a plateau above the Historic District; and East Jim Thorpe (formerly East Mauch Chunk), a residential and small business area on the east bank.

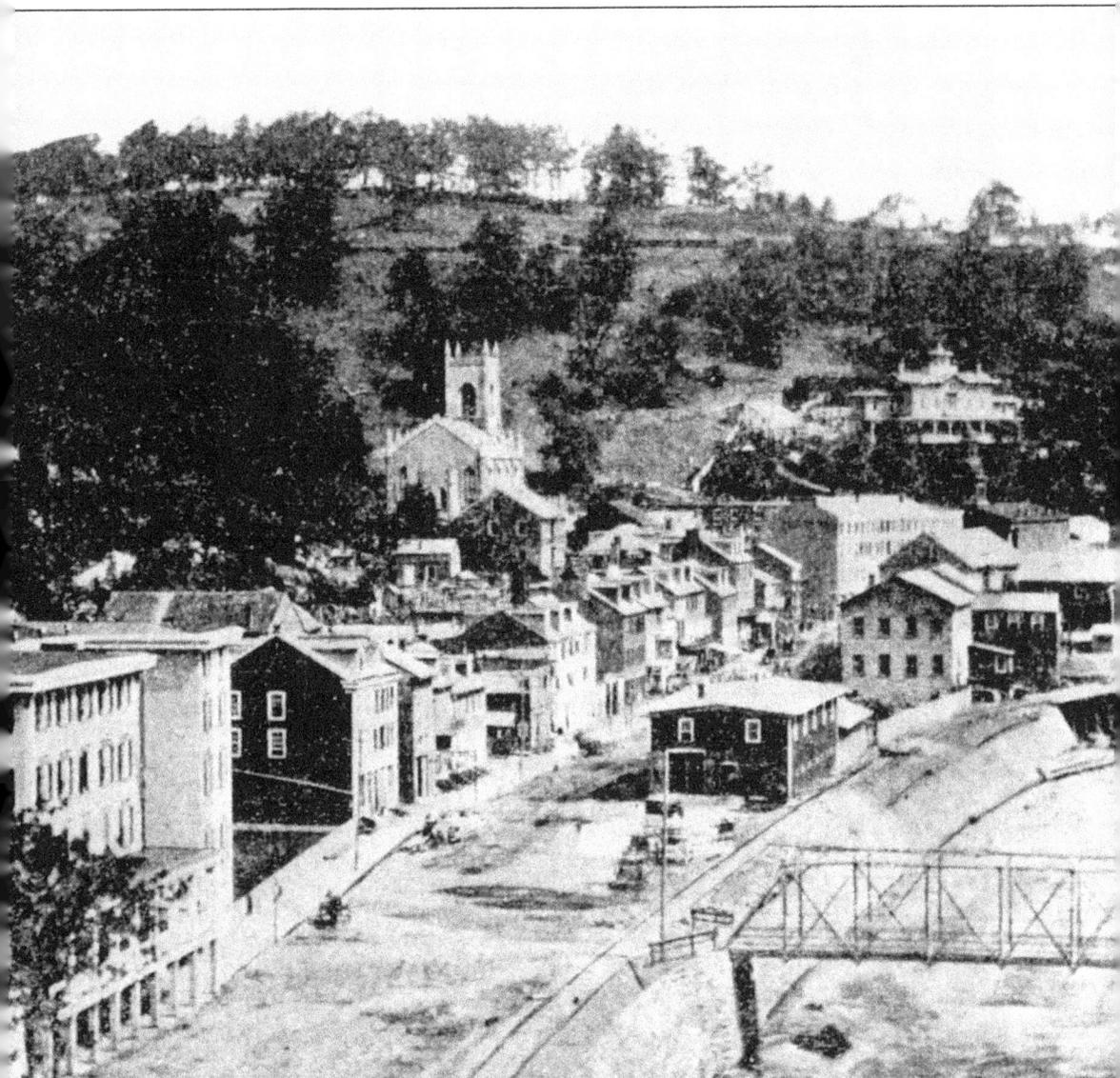

This early photograph of Mauch Chunk was taken some time after 1861, when the Italianate mansion of Asa Packer, founder of the Lehigh Valley Railroad, was built on the hillside (right) and before 1865, when the second Church of St. Mark's replaced the Norman-towered church in the center. Susquehanna Street, the dirt road into town, parallels the Lehigh River.

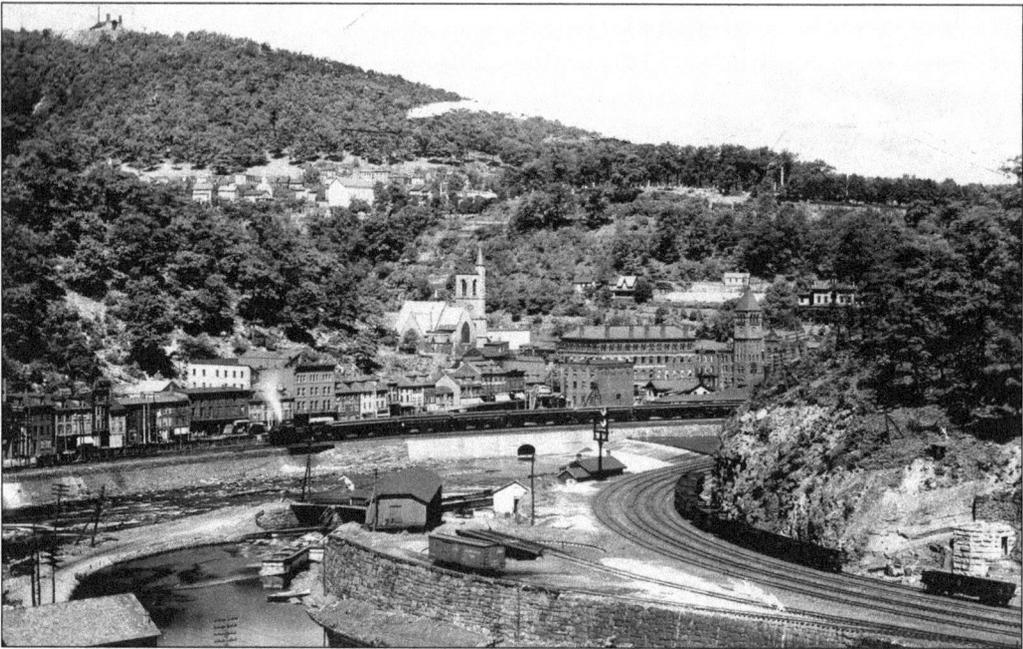

The Lehigh Coal and Navigation Company opened the 46-mile Lower Division of the Lehigh Canal between Mauch Chunk and Easton in 1829. The canal entered the Lehigh River at Mauch Chunk through Lock 1. Coal-loading operations took place in a pool (harbor) formed by the Mauch Chunk Dam to the south and the Packer Dam to the north.

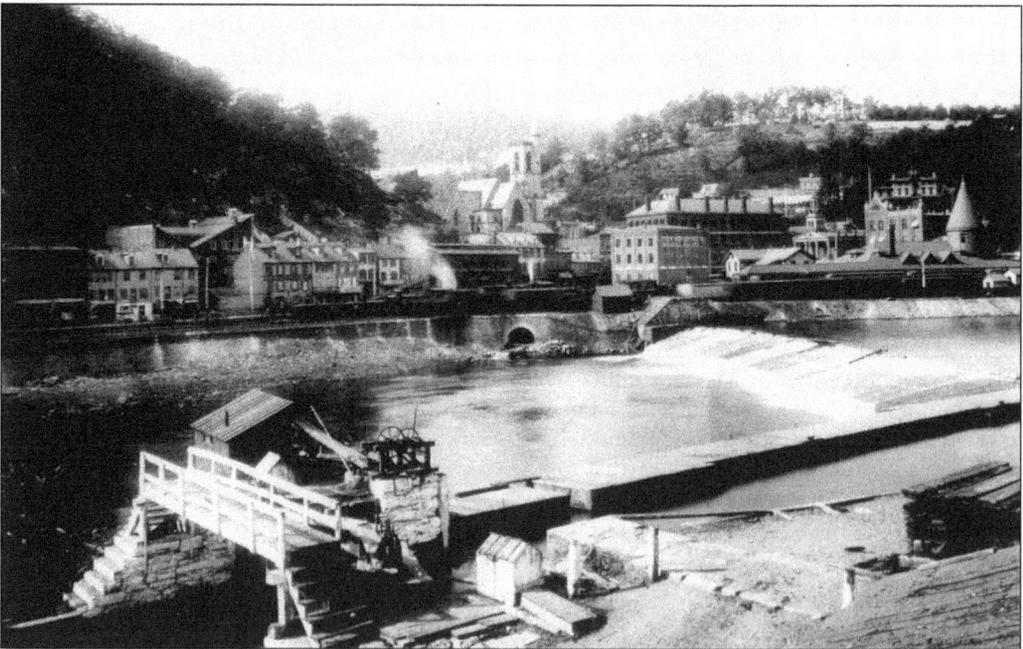

Houses, commercial buildings, warehouses, rail tracks, and the turreted Central Railroad of New Jersey station crowd the Mauch Chunk waterfront in the second half of the 19th century. To alleviate flooding and provide more room for development, the Mauch Chunk Creek was routed through a culvert (center of photograph) beneath the town.

12

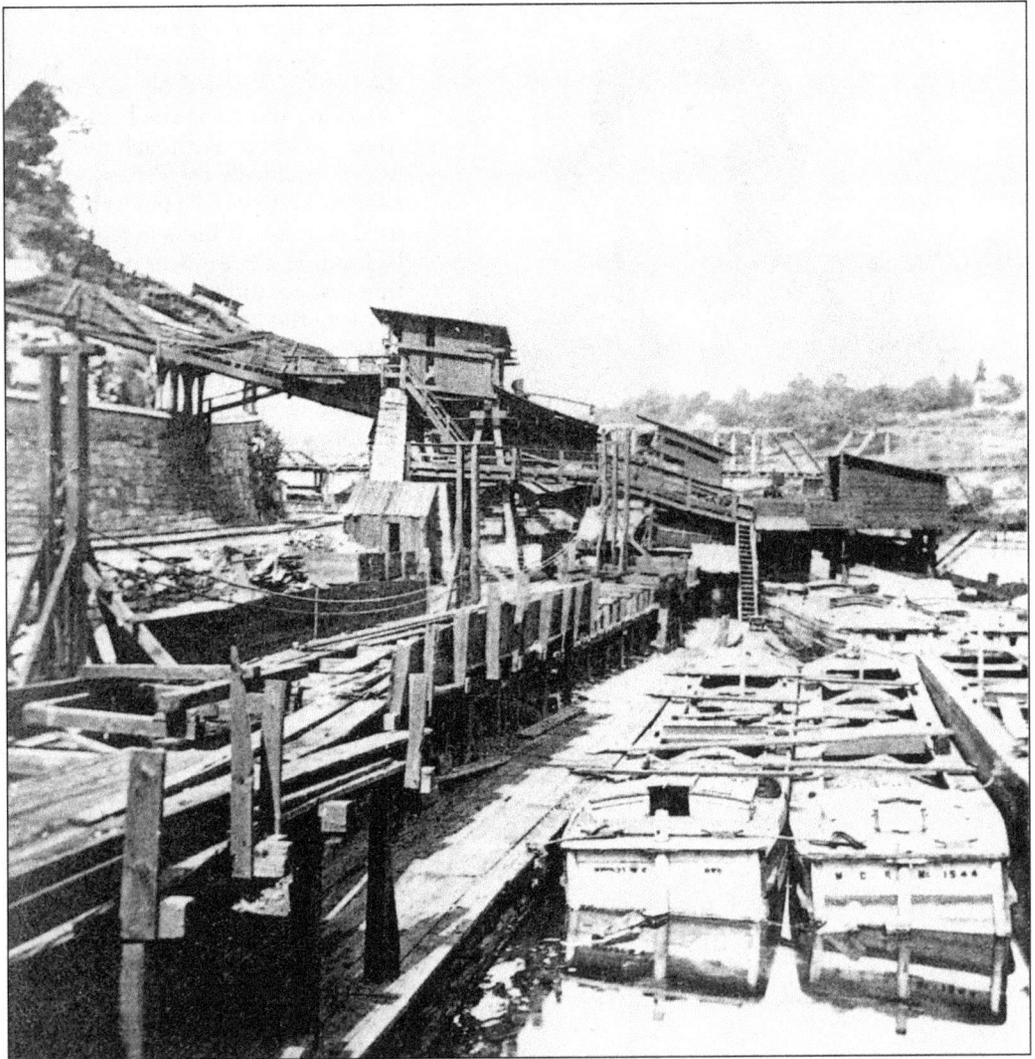

Coal was transported nine miles over the mountains from the Summit Hill mine to the Mauch Chunk pool by the Switchback Gravity Railroad and loaded, by chute, onto waiting coal boats. This operation ceased when the railroads reached the mines and the Switchback became exclusively a passenger carrier in 1872.

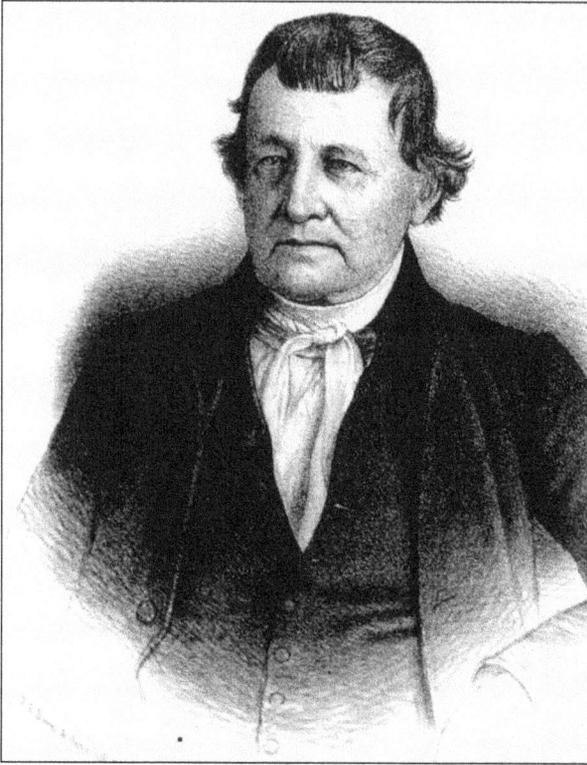

A brilliant engineer and visionary, Josiah White (1781–1850) cofounded the Lehigh Coal and Navigation Company and made the Lehigh River navigable. Although funds were collected by the Pennsylvania Legislature to build a navigation in 1771, it was White's ingenious hydrostatic sluices (bear trap locks) that first permitted coal arks to navigate the Lehigh River. White was the first to build a residence on Mount Pisgah, the prime home-building site for Mauch Chunk's millionaires. Measuring 20 by 30 feet, it was a simple, white clapboard house which he named Whitehall.

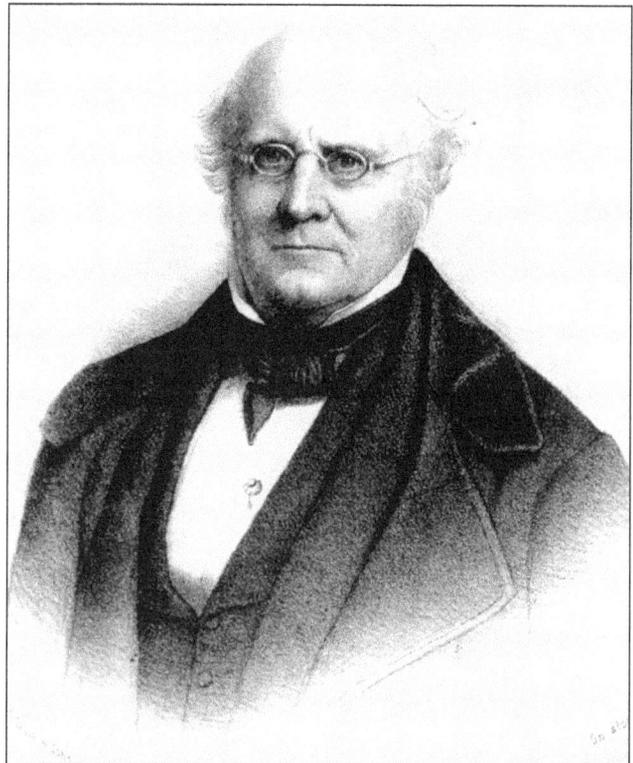

Erskine Hazard, White's business partner since 1811 and an able engineer and administrator, cofounded the Lehigh Coal and Navigation Company and wrote "The Law" acquiring navigation rights to the Lehigh River from the State of Pennsylvania in 1818. A third partner in the company, George F. A. O. Hauto, was paid off handsomely in 1820 when he was perceived as untrustworthy by his partners and investors.

An experienced engineer who had worked on the Erie Canal, Edwin A. Douglas was hired by the Lehigh Coal and Navigation Company in 1835. He served as chief engineer on the construction of the Upper Division of the Lehigh Canal and on the Lehigh and Susquehanna Railroad, the overland connection between the Lehigh and Susquehanna Navigations.

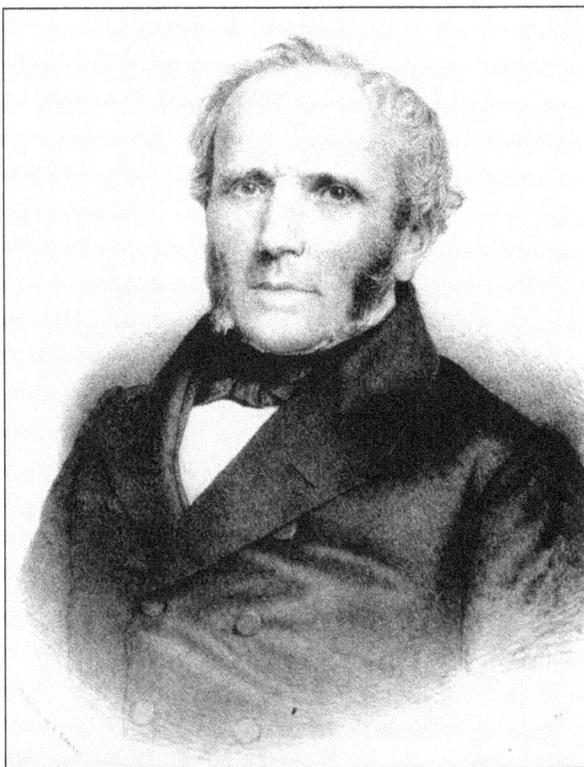

When Douglas succeeded White as manager of the Lehigh Coal and Navigation Company, he took up residence at Whitehall. His contributions to the home were to add a parlor and wraparound porch and double the square footage.

The next Lehigh Coal and Navigation Company manager to occupy Whitehall was John Leisenring. He joined the company at age 16 after his father became landlord of the Mansion House Inn. Assistant to then chief engineer Edwin A. Douglas, young Leisenring rose through the ranks and was in charge of the company when a flood on the Lehigh destroyed the Upper Division of the canal in 1862. Although the Upper Division's high locks and dams were deemed too dangerous to rebuild, Leisenring's "energy and promptness" were credited for the swift reopening of the Lower Division.

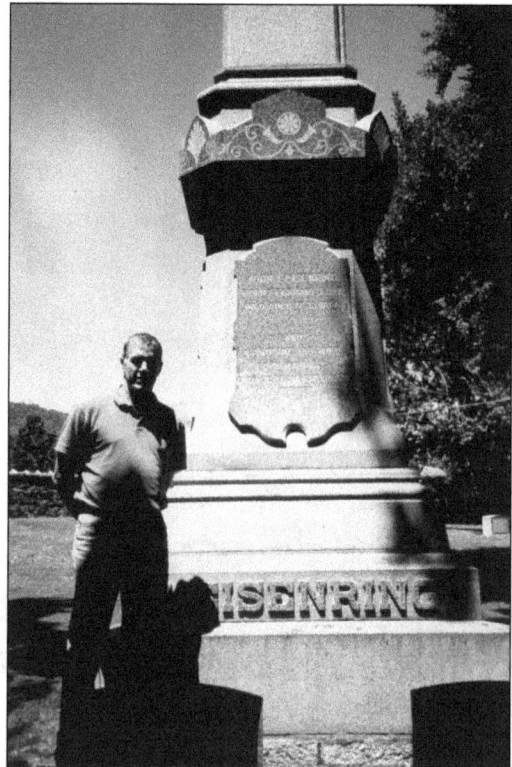

In 2004, a sixth-generation descendant of Lehigh Coal and Navigation Company manager John Leisenring stands in front of the Leisenring family obelisk in Mauch Chunk's 1823 cemetery. Even without the beard and moustache, the likeness to his ancestor is remarkable.

When Leisenring took up residence, he renovated Whitehall in the Italianate style popular with Victorians and renamed it Parkhurst. Bearing little resemblance to Josiah White's plainly functional home, Parkhurst stands amid its glorious gardens as John Leisenring and his family enjoy a sunny day. South Mountain (Flagstaff) and St. Mark's Episcopal Church appear in the background.

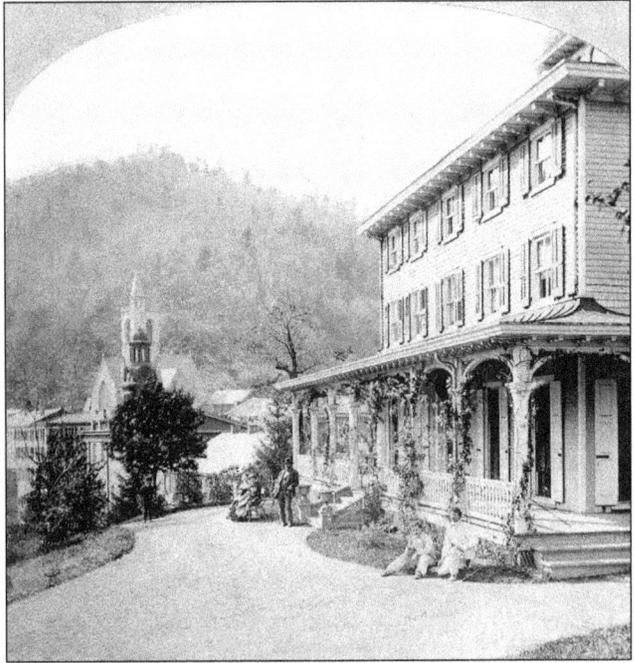

With the summer foliage gone, buildings belonging to the Switchback Gravity Railroad can be seen above the rooftops of Whitehall in this unique photograph. (Courtesy of Joseph Sebelin.)

Whereas Josiah White indulged his passion for exotic animals by building a railed park for llamas, elk, and peacocks, John Leisenring preferred surrounding Parkhurst with a Japanese-style garden.

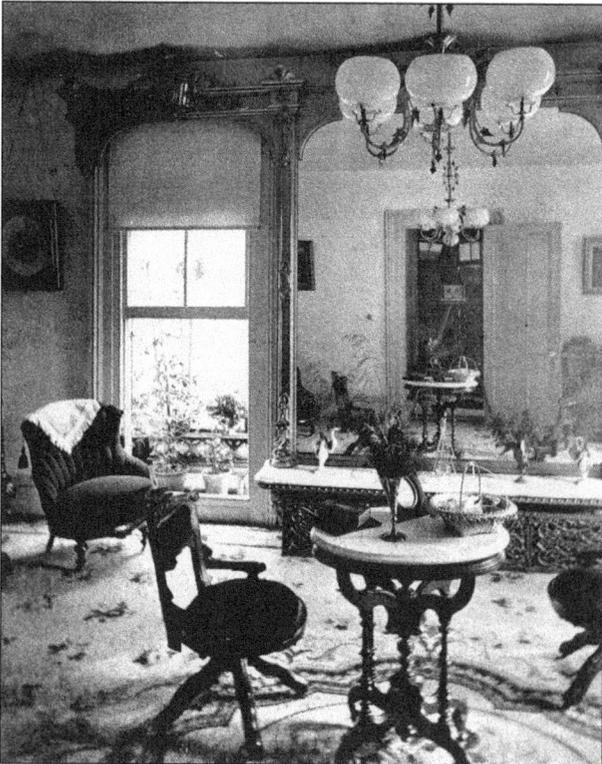

Parkhurst was as ornate inside as it was outside. Elegant furnishings, fixtures and carpets adorned the front parlor.

In 1885, Parkhurst was moved to Center Street in East Mauch Chunk. The saga of Parkhurst, formerly Whitehall, does not end with its relocation; it continues in chapter eight of this book. Following Parkhurst's removal, Dr. James S. Wentz built a German-style mansion on the site. When Wentz vacated the mansion, it became the Moose Hall, which was then demolished in 1963. The Civil War Monument is visible in the foreground of this photograph.

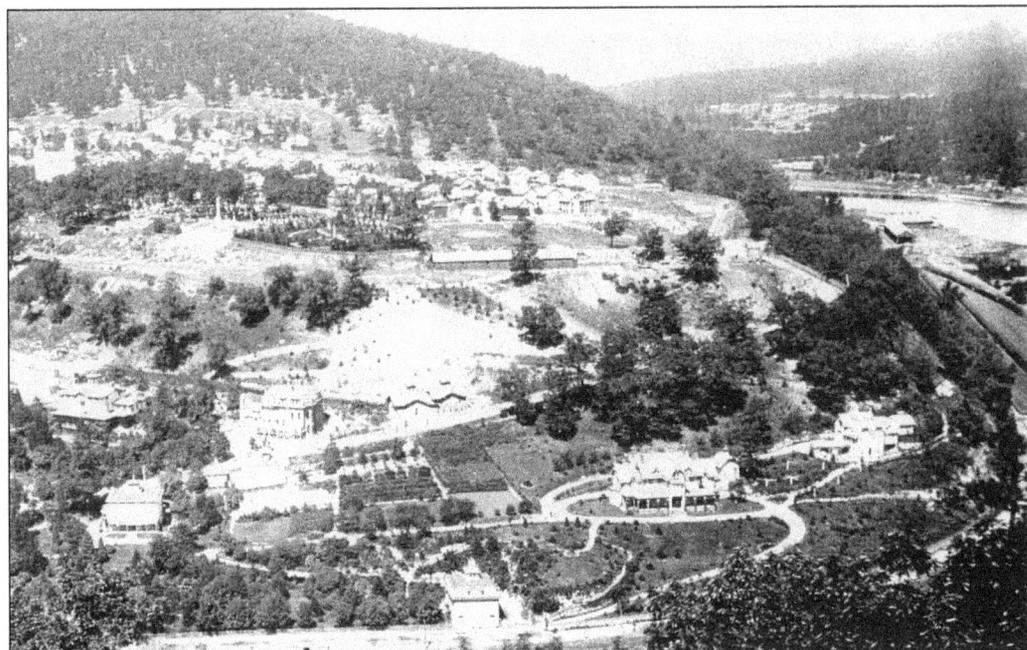

The mansion of coal and iron baron Marlon Kemmerer occupied the hillside during Mauch Chunk's Golden Age. With its circular carriageways and coach house, it can be seen in the right foreground of the photograph. Today, all that remain are the carriage house and grounds, now known as Kemmerer Park.

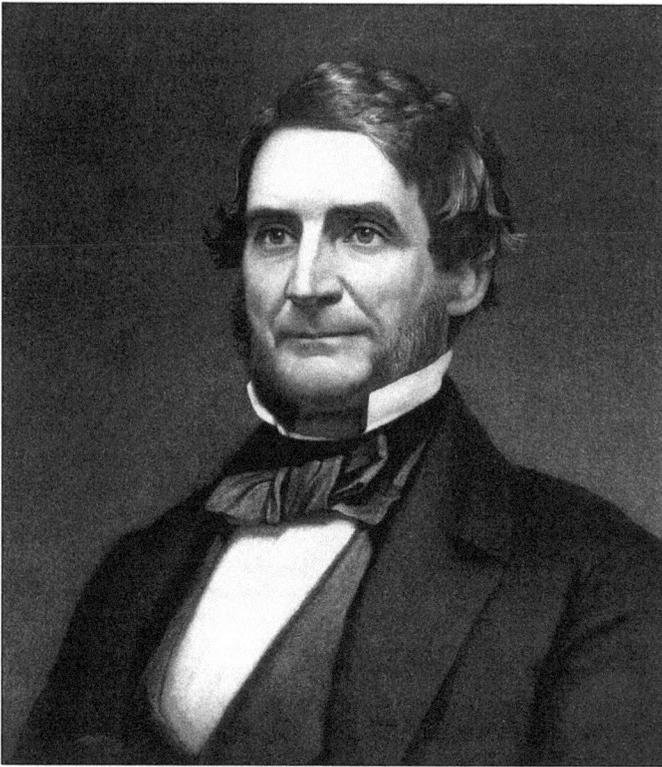

Although the homes of other rich Mauch Chunkers on Mount Pisgah were torn down over the years, the mansions of Asa and Harry Packer stand as stalwart today as the day they were built. Asa Packer came to Mauch Chunk in 1830 looking for carpenter work on the Lehigh Canal. Working his way up from canal laborer to boat builder, merchant, and landowner, Packer ultimately founded the Lehigh Valley Railroad. As Asa's star rose, he became a state legislator, judge, United States congressman, and founder of Lehigh University. When he died in 1879, he was said to be America's third-richest man.

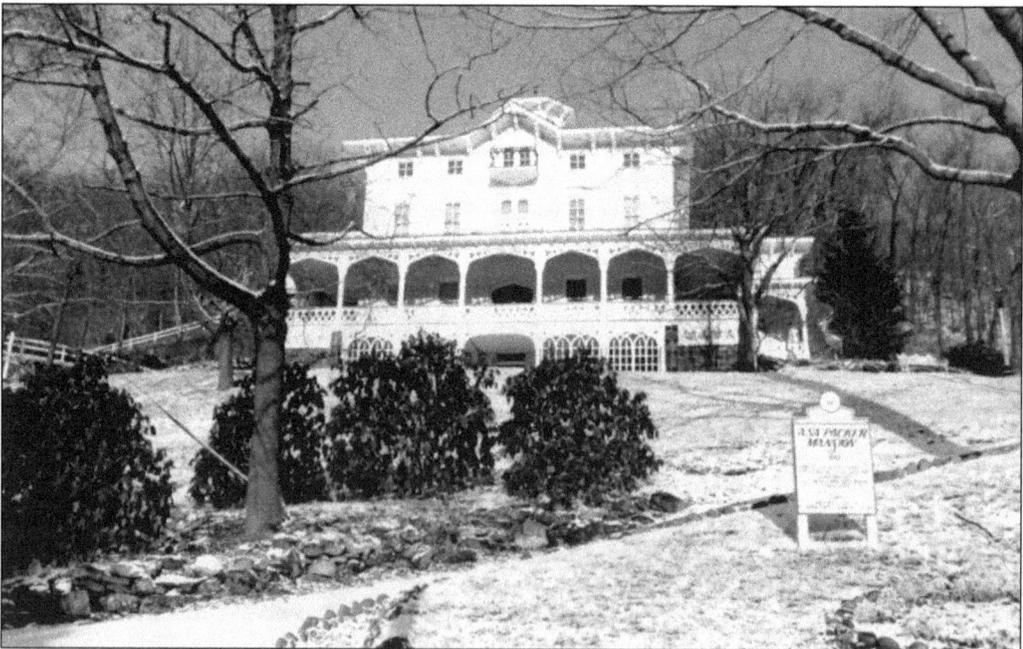

Situated on a rise overlooking the Lehigh River and the railroads, the 1861 Asa Packer Mansion is an Italianate villa with loggias, Gothic ornamental features, a porch, and a cupola from which Asa supposedly watched the arrival and departure of his trains.

Like his older brother Robert, Harry Eldred Packer was involved in the operation of the Lehigh Valley Railroad. When he married the beautiful Mary Augusta Lockhart, his father, Asa, gifted the couple with a mansion next to his own. Harry died of cirrhosis of the liver at the age of 34.

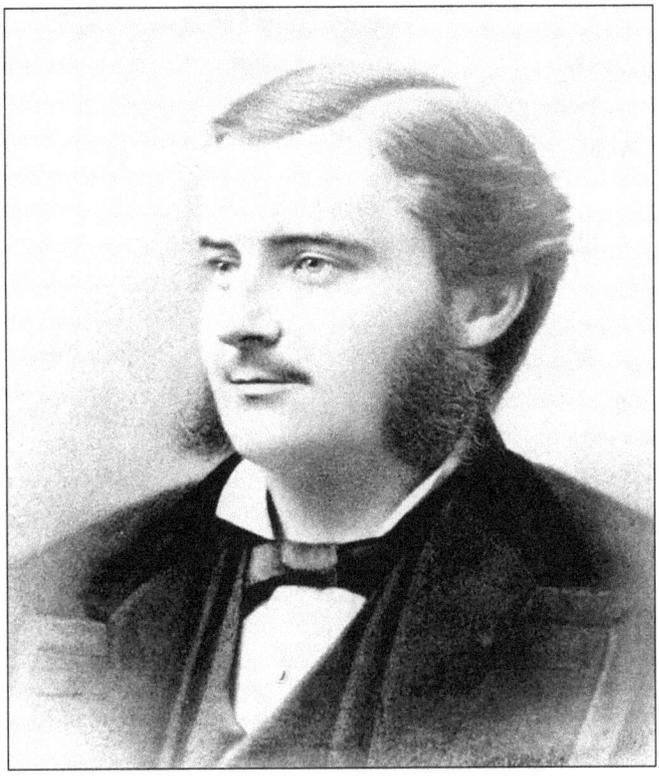

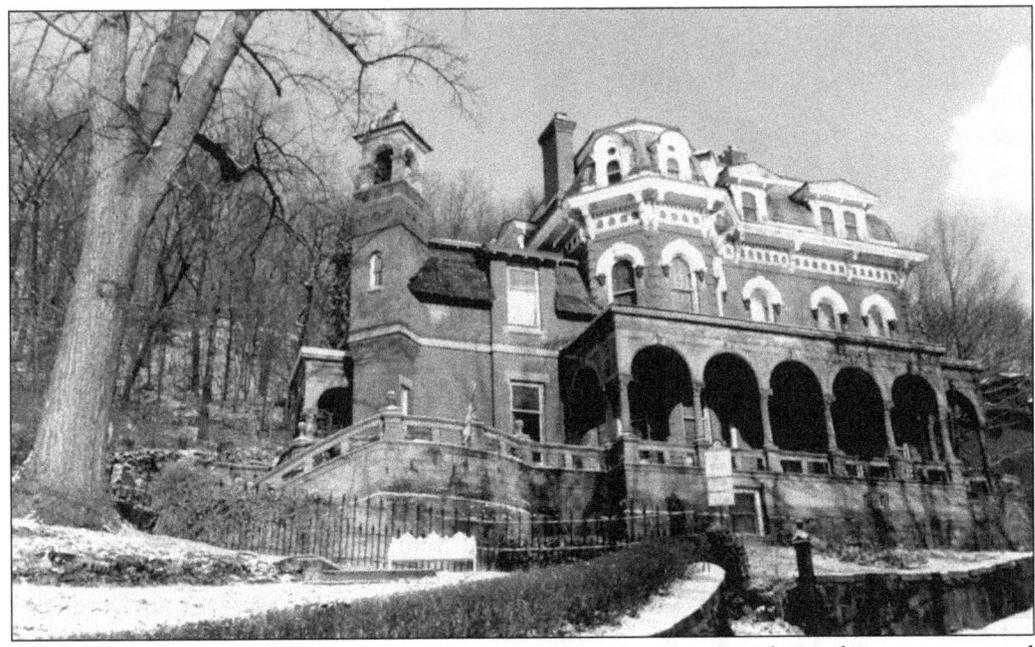

The Harry Packer Mansion is a high Victorian mansard mansion with porches, cornices, and dormers. Built in 1874, it is a guest house today.

A carriageway runs alongside the Harry Packer Mansion coach house and continues behind the mansions of Harry and Asa Packer. It ends at the small two-story home of the former caretaker of the Asa Packer Mansion.

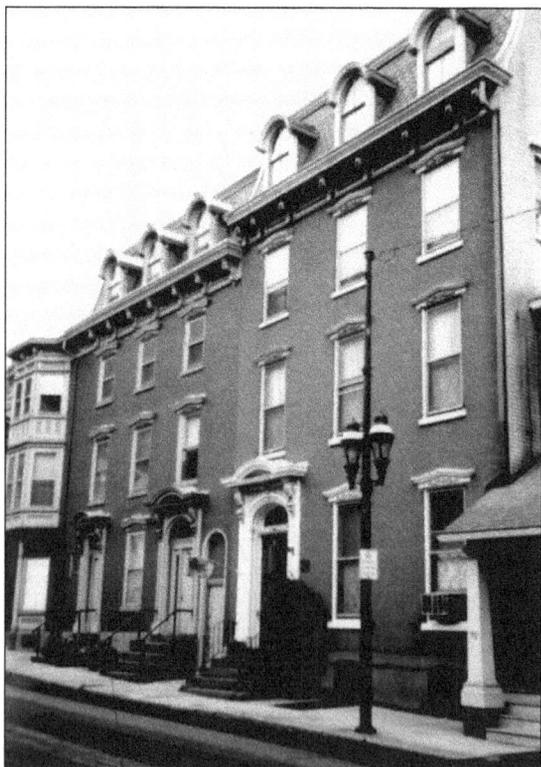

Instead of mansions, some of Mauch Chunk's richest citizens built large state-of-the-art homes along Broadway in the middle of the 19th century. Known as "Millionaires' Row," these homes opened directly onto the street. Numbers 72 to 74 Broadway (shown here) are four-story brick homes with French Second Empire mansard roofs and terraced gardens in the rear.

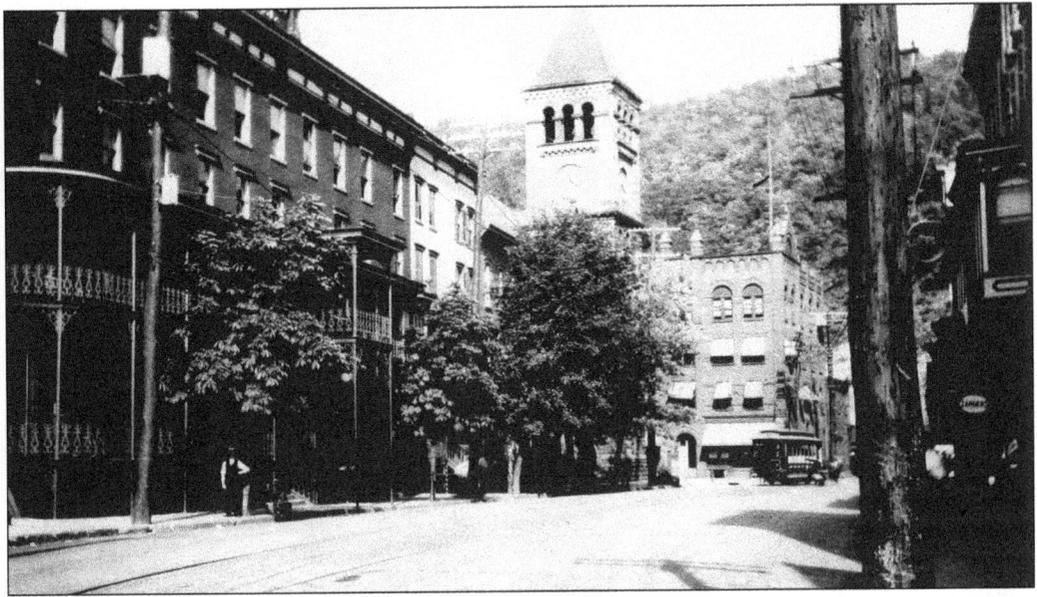

Certainly not shy about glorifying their town, Mauch Chunkers named their narrow main street Broadway and the mountain ascended by the Switchback Gravity Railroad Mount Pisgah, after the biblical mountain overlooking the Promised Land. Market Square, a wider area at the lower end of Broadway, was a combination of small shops, a bank, and the large New Orleans–style American Hotel (now the Inn at Jim Thorpe).

Seemingly unaware of the photographer, these gentlemen loaf in front of the American Hotel.

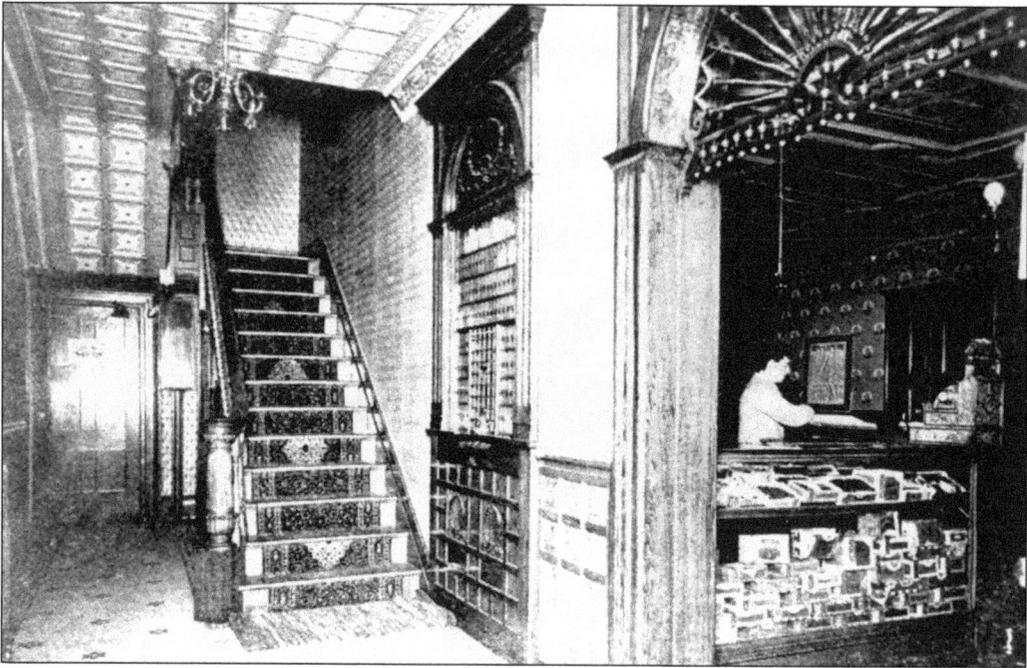

Between taking reservations and selling items like chocolate, cigars, and tobacco, the desk clerk is kept busy in the lobby of the American Hotel.

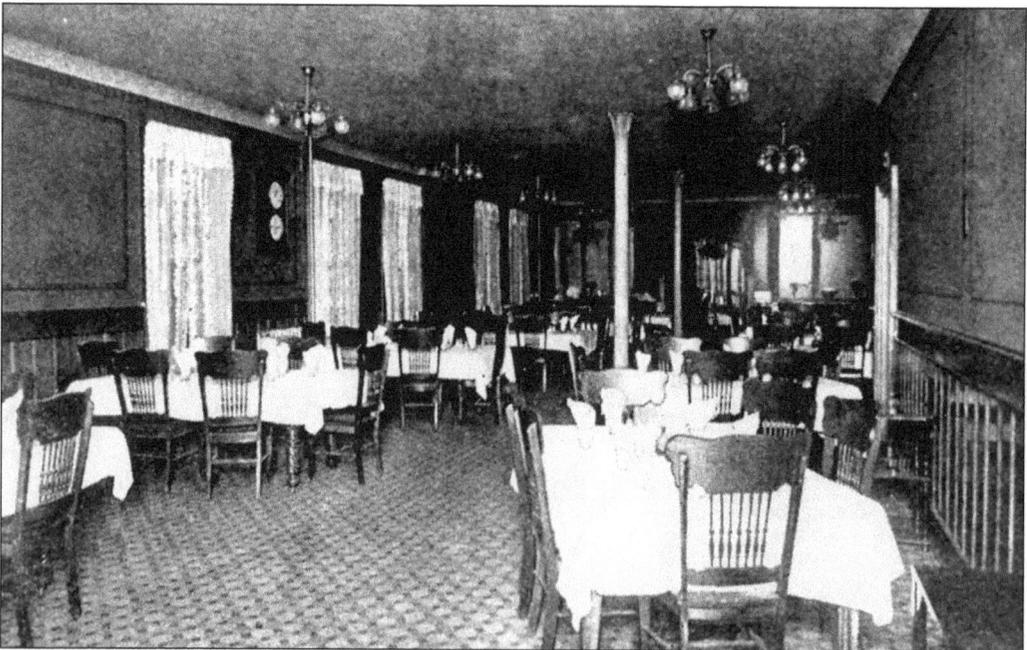

With its tables set and pressed-back chairs in place, the dining room awaits the hotel's hungry dinner guests.

Department stores and small shops along Susquehanna Street and Broadway catered to townspeople and tourists. Here shopkeepers on the west side of Market Square (Lower Broadway) relax as the flood waters of the Mauch Chunk Creek recede after overflowing its underground culvert.

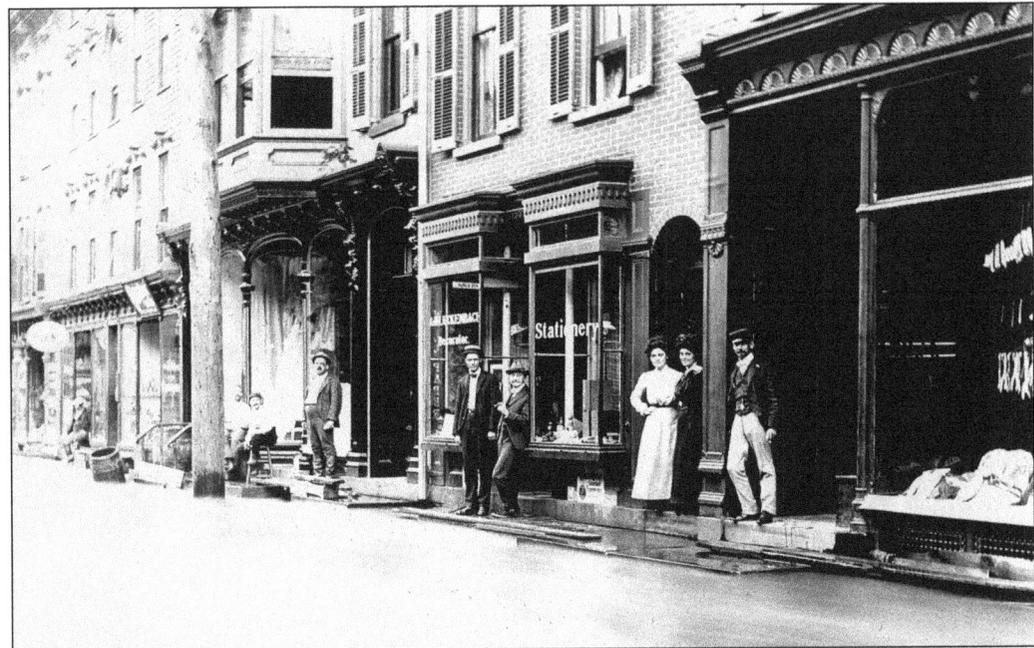

Farther down Market Square, the same thing is happening. Though tame by comparison to past floods in Mauch Chunk, this flood produced the high water mark seen on the telephone pole.

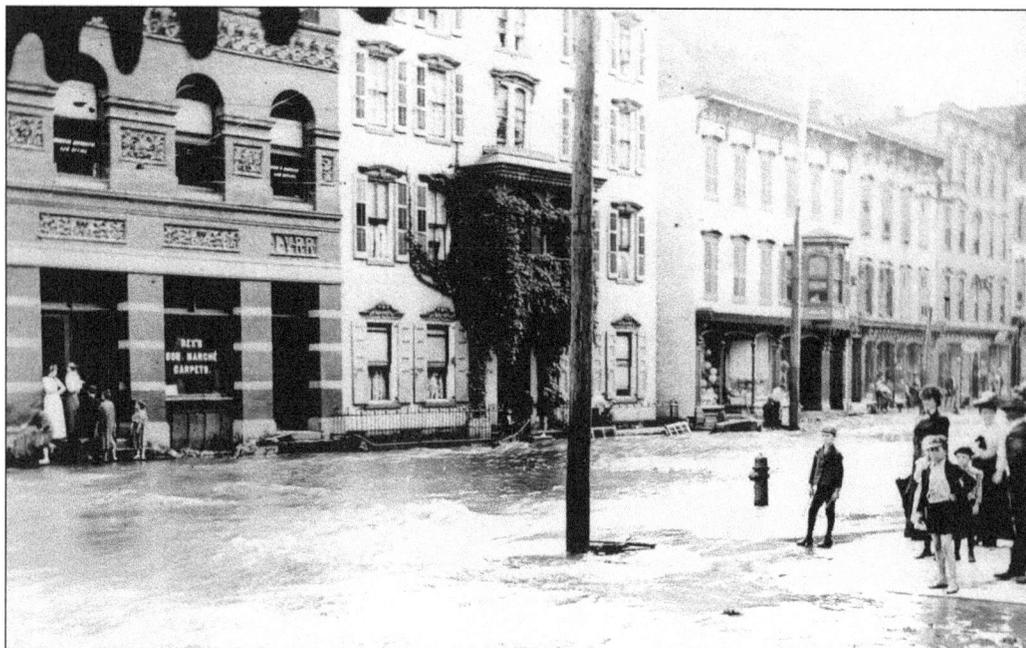

Before long, Mauch Chunkers and tourists were taking to the streets again. While a mother herds her children through the puddles, shoppers across the street await news of a flood sale at the Bon Marche—not the world-famous Bon Marche in Paris, but Rex's Bon Marche carpet emporium in Mauch Chunk.

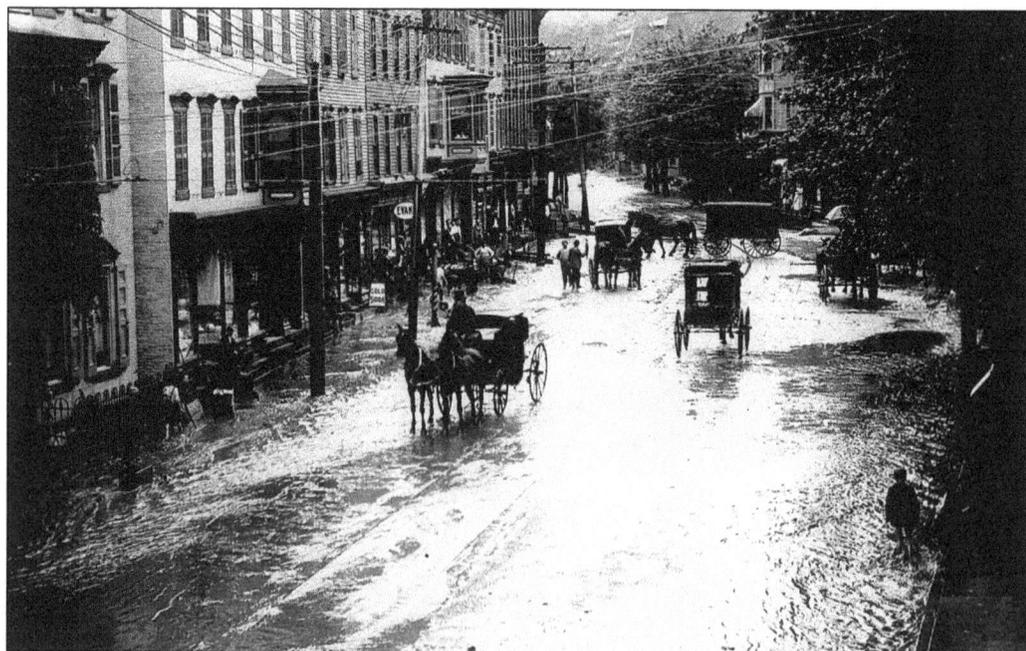

Taxi, anyone? Horse and carriages—some looking to pick up a fare, others making a delivery—travel through the flood waters in Market Square on Lower Broadway.

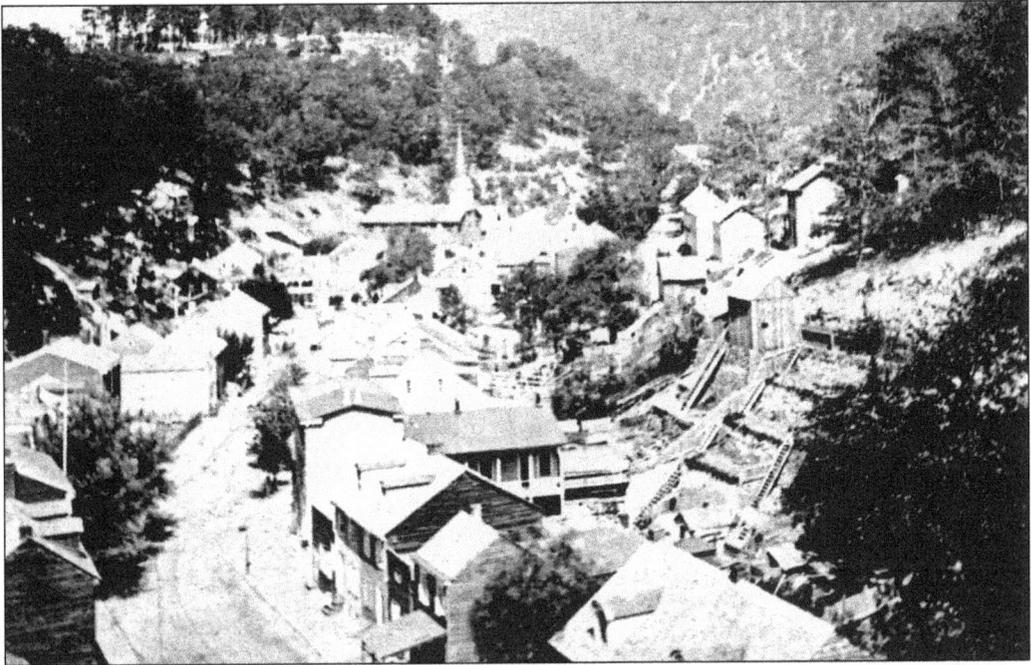

Rooftops meet along Broadway and West Broadway. As the merging streets ascend the narrow ravine, millionaire and middle-class residences give way to working-class homes.

An early photograph shows Mauch Chunk's first cemetery, opened in 1823, perched high above Broadway. A community of working-class homes known as the Heights was established on the cemetery's northern edge.

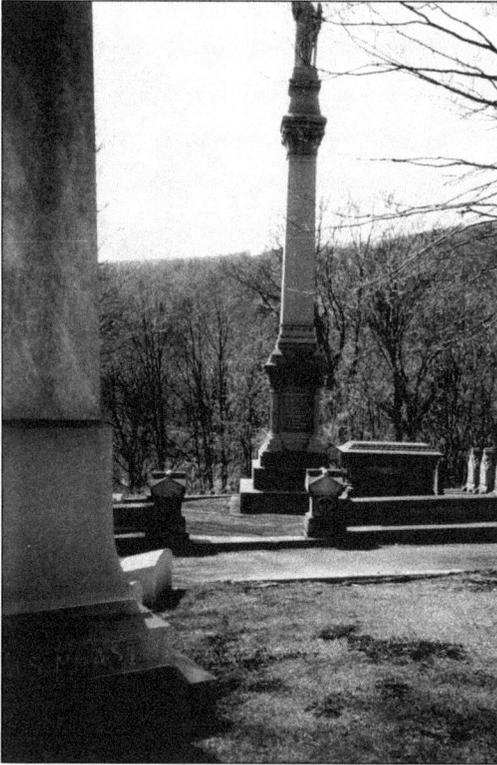

Just as the composition of the town reveals social division, so does Mauch Chunk's first cemetery. The obelisks and mausoleums of the millionaires are clustered together above their mansions on one side of the cemetery; the small markers and unmarked graves of the working class are on the other side. The Asa Packer obelisk is seen here.

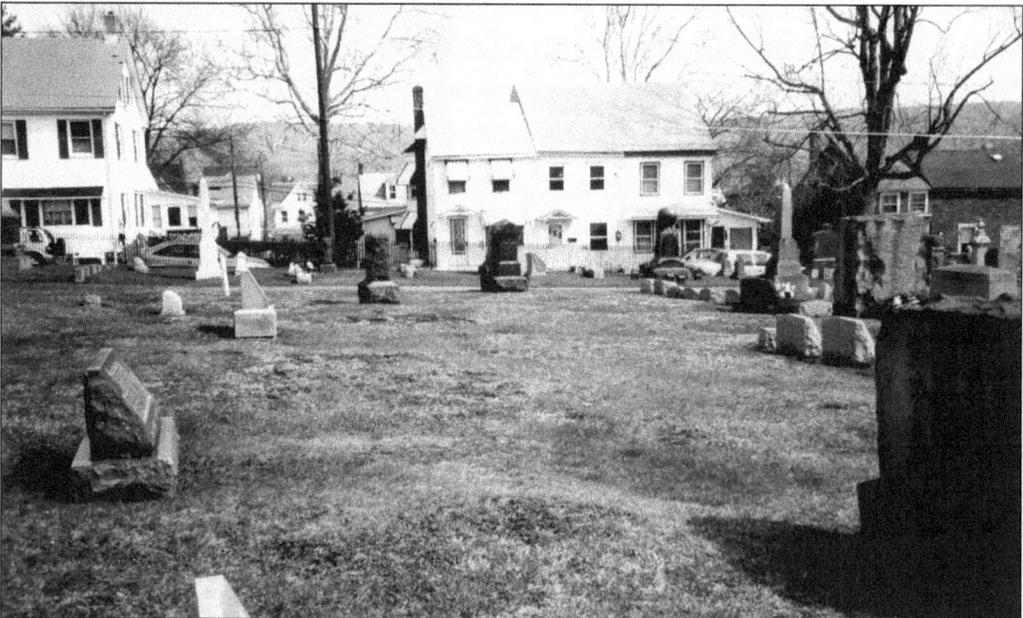

Each marker, no matter its size, tells its own sad tale. Here lie Civil War veterans, victims of typhoid fever, large numbers of children who died in infancy, and a man from Liverpool, England, who could not forget his origins. Even Asa Packer's millions could not stave off the scourge of infant death. The Packer obelisk casts its sad shadow on the graves of infant daughters Catherine, Hanna, and Gertrude.

Two

THE MOLLY MAGUIRES

As mule-drawn coal boats descended the Lehigh Canal and coal wagons rolled along the tracks of the Lehigh Valley and Jersey Central Railroads, unrest in the coalfields smouldered like a mine fire below ground. With the demand for coal increasing and its price rising as the country industrialized, mine owners continued to enrich themselves on the backs of mine workers without regard for social conditions. Wages were so low that miners and their families—most of them immigrants—could not exist from pay day to pay day. Forced to buy life's necessities on credit at the company store, they sank deeper and deeper into debt in a vicious cycle of earning and owing.

Vowing to stop the abuse, rebellious Irishmen banded together as the Molly Maguires, a secret society intent on seeking social justice. Although the aim of the Mollies was worthy, their means were brutal and bloody. Coal bosses were murdered throughout Carbon and Schuylkill Counties. To stop the mayhem, the Reading Railroad hired James "McKenna" McParlan to penetrate the secret society. As a result of McParlan's undercover work, 19 Mollies were convicted and hanged, 7 of them in Carbon County.

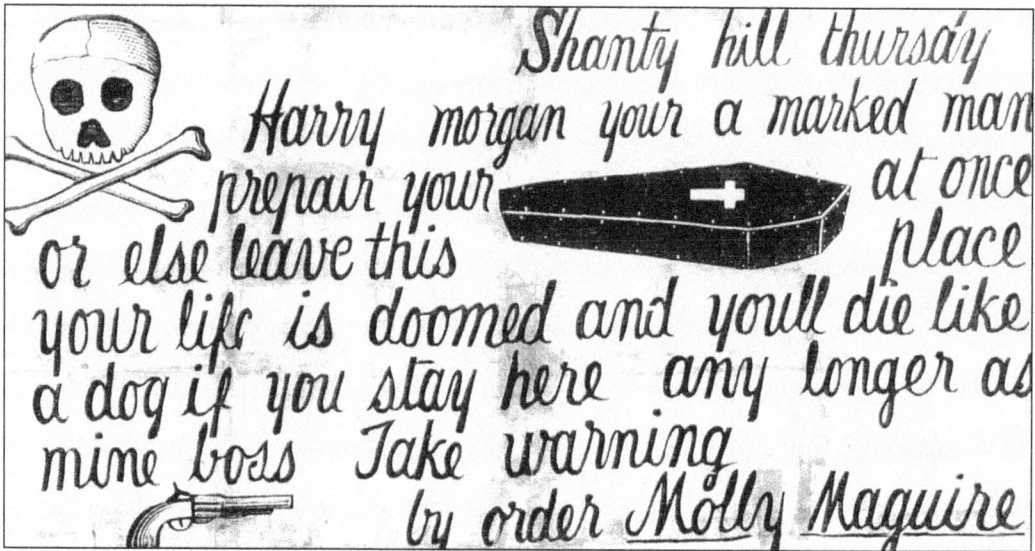

Warnings and demands emblazoned with crude but ominous drawings were sent by the Molly Maguires to targeted individuals. Failure to comply meant almost certain death. Hangings in Carbon County Jail resulted from three murders—those of George K. Smith, Morgan Powell, and John P. Jones. (Courtesy of Ray Holland.)

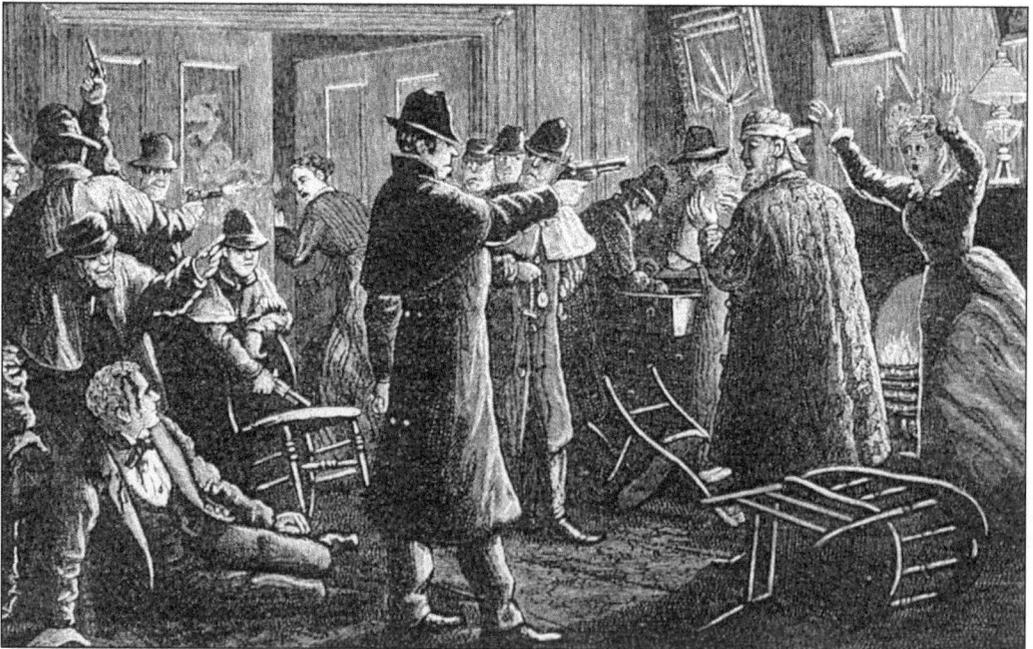

George K. Smith of the George K. Smith Coal Company was murdered in his home in Audenried, Carbon County, on November 5, 1863. Sick in bed, Smith heard a commotion and went downstairs. Confronted by a tall man, a Welshman believed to be Evan Jones, and 15 to 20 men disguised as miners and soldiers, Smith died of a pistol shot to his head and three bullets to his body.

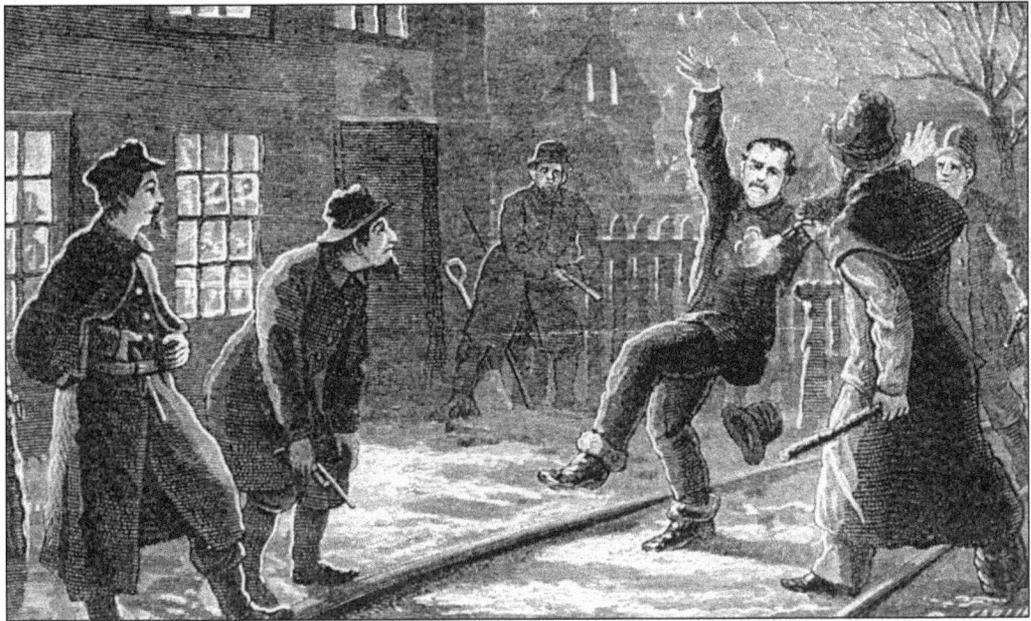

Morgan Powell, assistant superintendent of the Lehigh and Wilkes-Barre Coal and Iron Company, was killed in Summit Hill on December 2, 1871. Three men approached him from behind and fired a pistol shot into his left breast, paralyzing him. Powell died two days later.

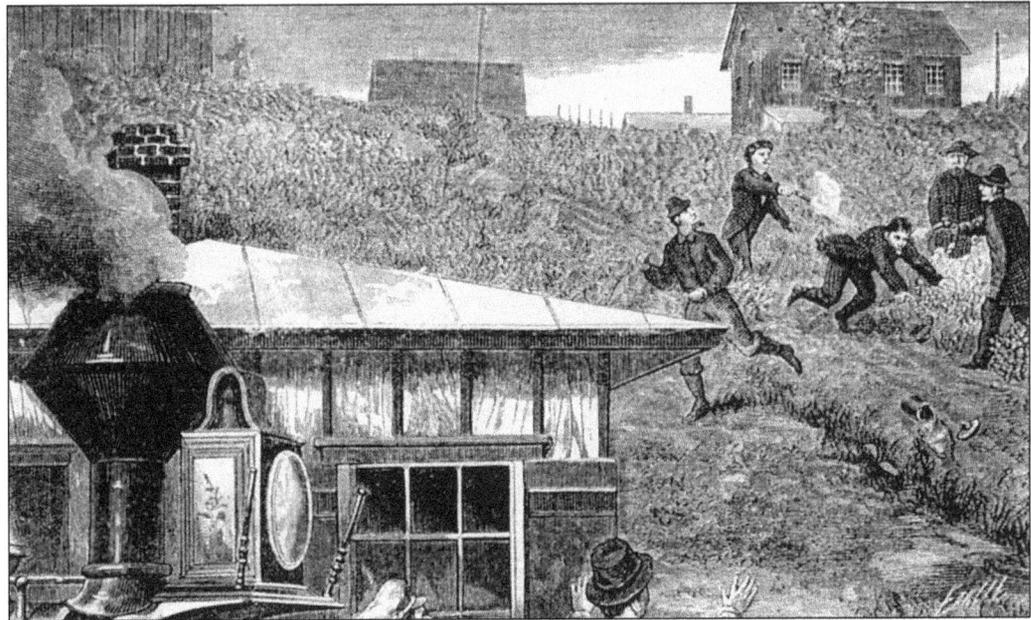

On September 3, 1875, mine superintendent John P. Jones was ambushed and murdered by two men, said to be Edward Kelly and Mike Doyle, in Lansford on his way to work. Each man fired one shot, then riddled Jones's body with bullets.

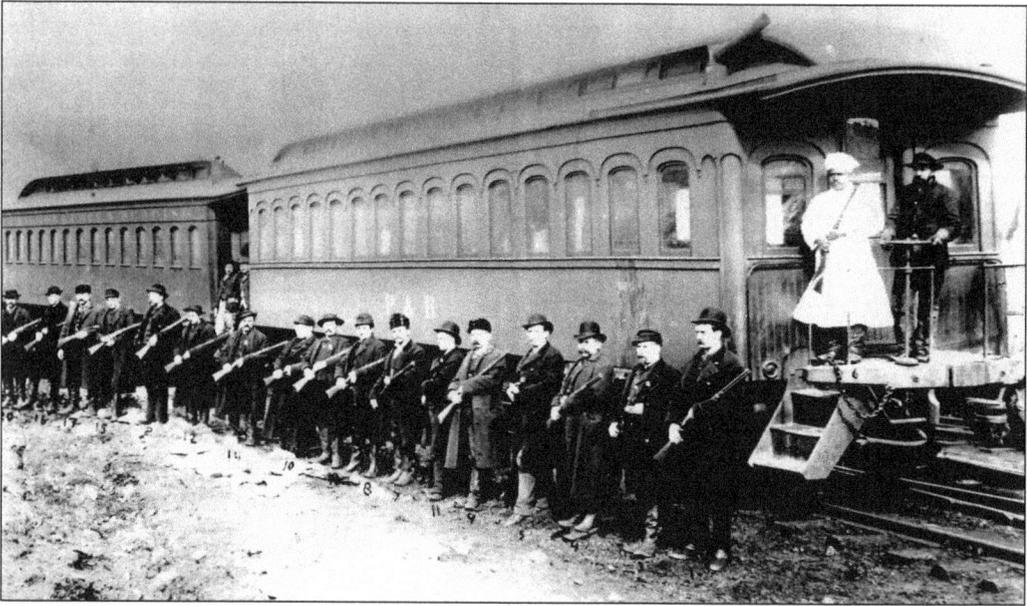

Although the Coal and Iron Police (shown here) were hired by the coal companies to protect company interests and investigate the murders, their efforts failed. It was only when James McParlan, Pinkerton agent, went undercover as James McKenna and penetrated the Molly organization that members were brought to justice in Mauch Chunk and Pottsville. (Courtesy of Penn State Campus, Schuylkill County.)

On Black Thursday, June 21, 1877, Mauch Chunk's "Day of the Rope," four Molly Maguires were hanged in Carbon County Jail—Michael J. Doyle and Edward Kelly for the murder of John P. Jones; John Donahue for the murder of Morgan Powell; and Alexander Campbell for the murders of both Jones and Powell. On March 28, 1878, Thomas P. Fisher was hanged for the murder of Morgan Powell, and on January 14, 1879, James McDonnell and Charles Sharp were hanged for the murder of George K. Smith.

As Alexander Campbell was about to be escorted from cell 17 to the scaffold for the murders of John P. Jones and Morgan Powell, he put his hand on the wall, proclaiming his innocence.

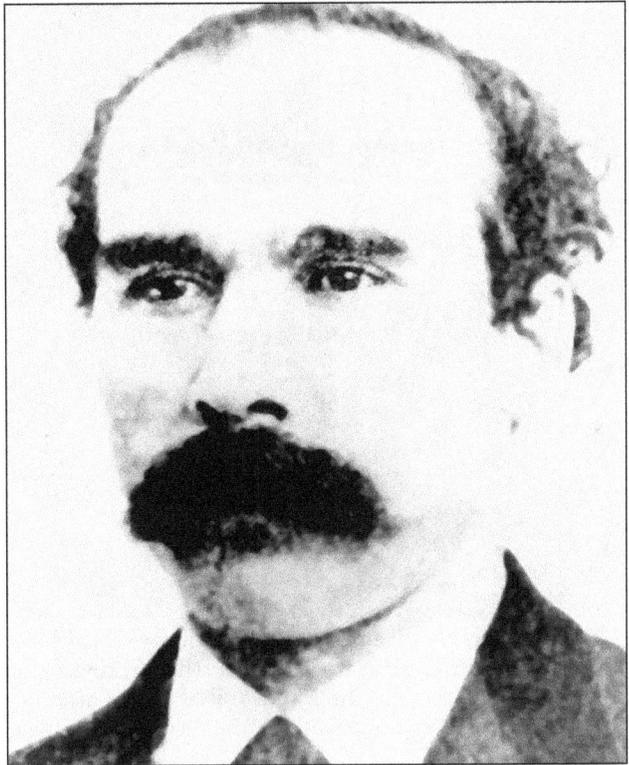

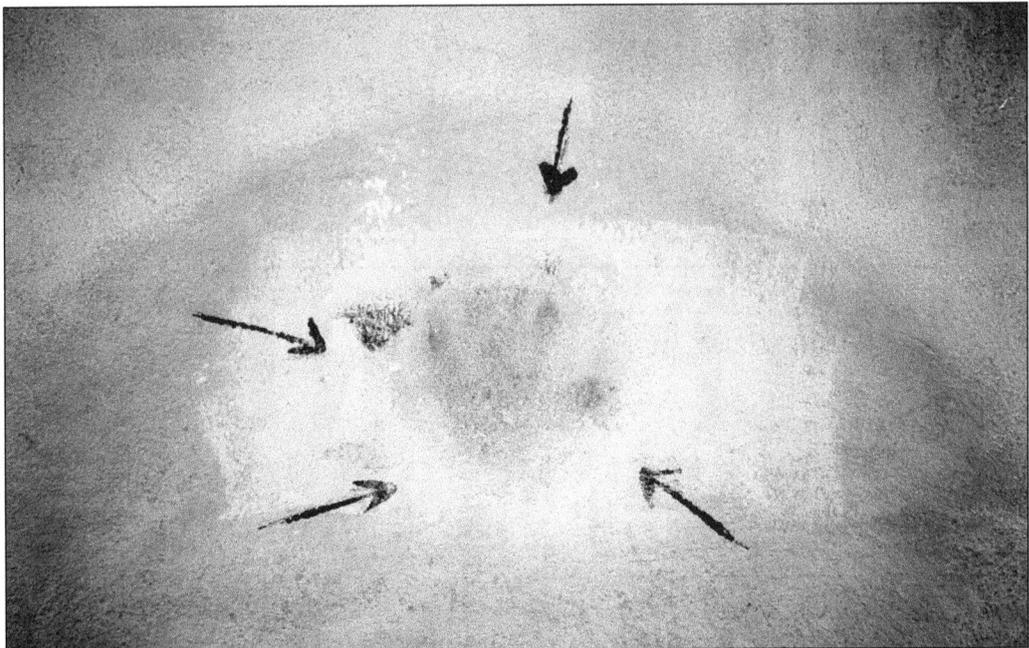

Despite attempts to erase Campbell's hand print it remains on the wall of cell 17 to this day as an eerie reminder that justice may not have been served.

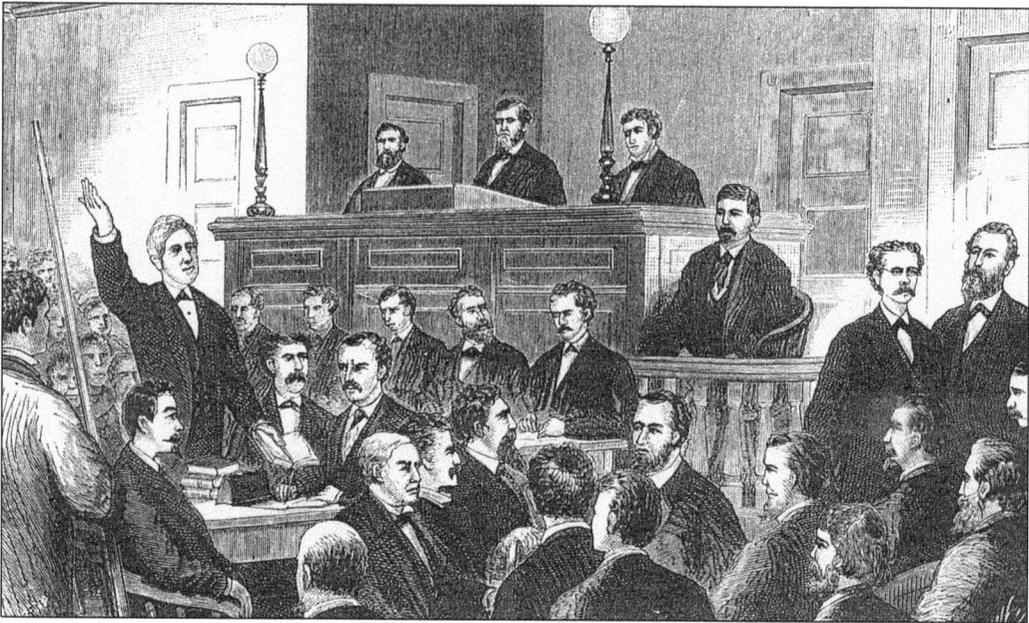

Although Hon. Asa Packer, Carbon County's wealthiest citizen, did not preside at the Molly Maguire trial in Carbon County Courthouse, revisionist historians conclude that he stacked the prosecution against the Mollies. Packer was afraid that if the Mollies were not convicted, they would unionize mine workers and disrupt the movement of coal along his lucrative Lehigh Valley Railroad.

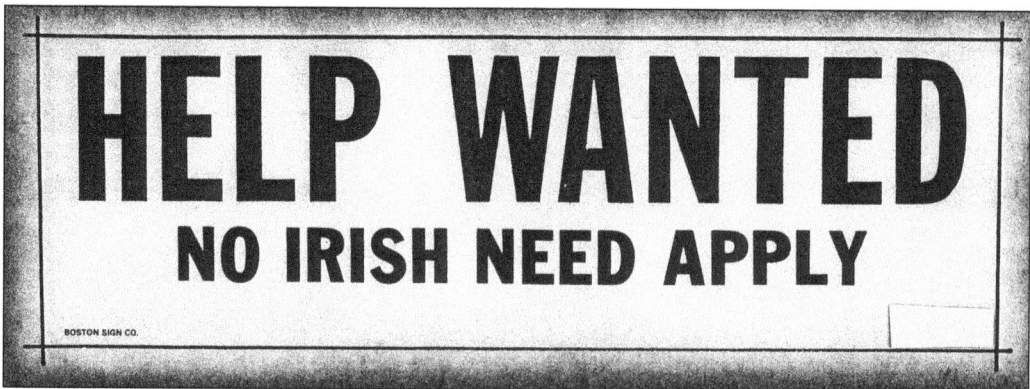

HELP WANTED
NO IRISH NEED APPLY

BOSTON SIGN CO.

Whether the result of the Molly Maguire trials or Irish raucousness, anti-Irish sentiment was apparent in late-19th-century Mauch Chunk. Help wanted signs appeared in shop windows inscribed with the words, "No Irish need apply." (Courtesy of Ray Mulligan.)

Three

EAST MAUCH CHUNK

With Mauch Chunk's population exploding by the 1850s, the Lehigh Coal and Navigation Company laid out 60 acres in lots across the Lehigh River and sold them for $100 each. Known as East Mauch Chunk, the community evolved into one of middle-class homes and small businesses. With most of East Mauch Chunk's population being German Protestant and Mauch Chunk's working-class being Irish Catholic, ethnic division and rivalry existed between the towns.

Life in East Mauch Chunk is revealed through a box of glass negatives that were discovered in an old house that was being renovated. Offered to the Mauch Chunk Museum, the photographs tell the story of an extended and unidentified middle-class family who lived a comfortable life in East Mauch Chunk at the dawn of the 20th century.

This small home, with its newly painted trim and Germanic-style ornamentation, provided the clue to the location of the rest of the photographs. The house still exists today on Center Street in East Jim Thorpe.

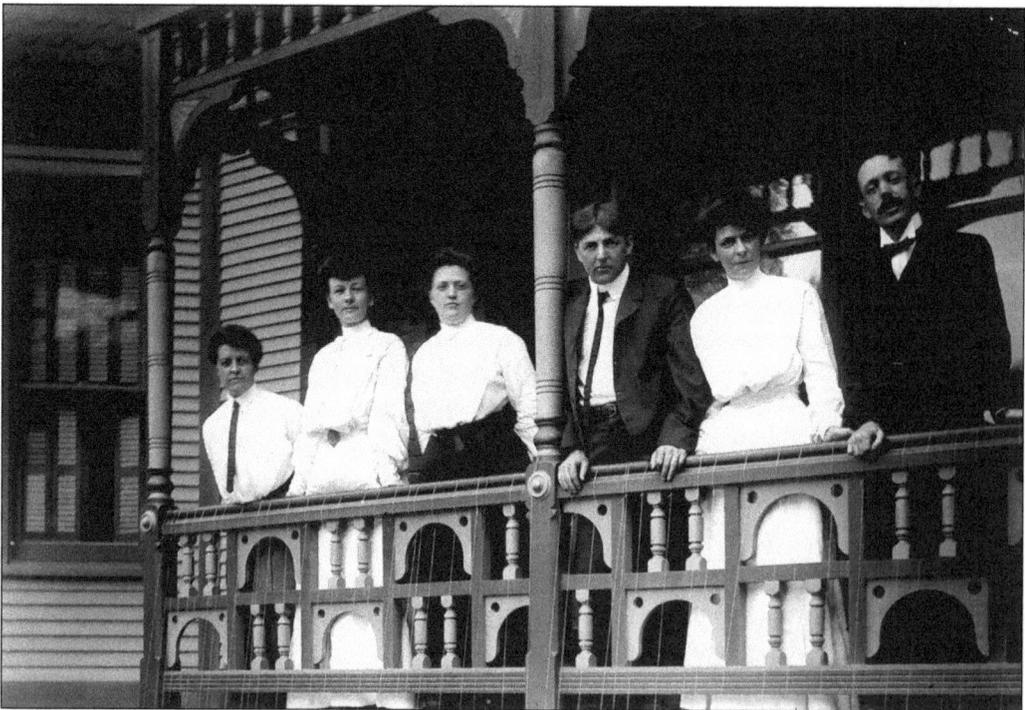

A family gathers for a special occasion on the front porch of another East Mauch Chunk home.

Perhaps the occasion for this family gathering was a christening. Propped up by a cushion, a baby poses contentedly in this beautiful glass-negative photograph.

Big brother gets into the act in the well-equipped nursery, which, judging by its toys and decor, is that of a baby girl. Sadly, big brother may have lived a very short life. He is believed to be the pre-teen lying in state in the family's flower-bedecked front parlor in Images of America: *Jim Thorpe (Mauch Chunk)*.

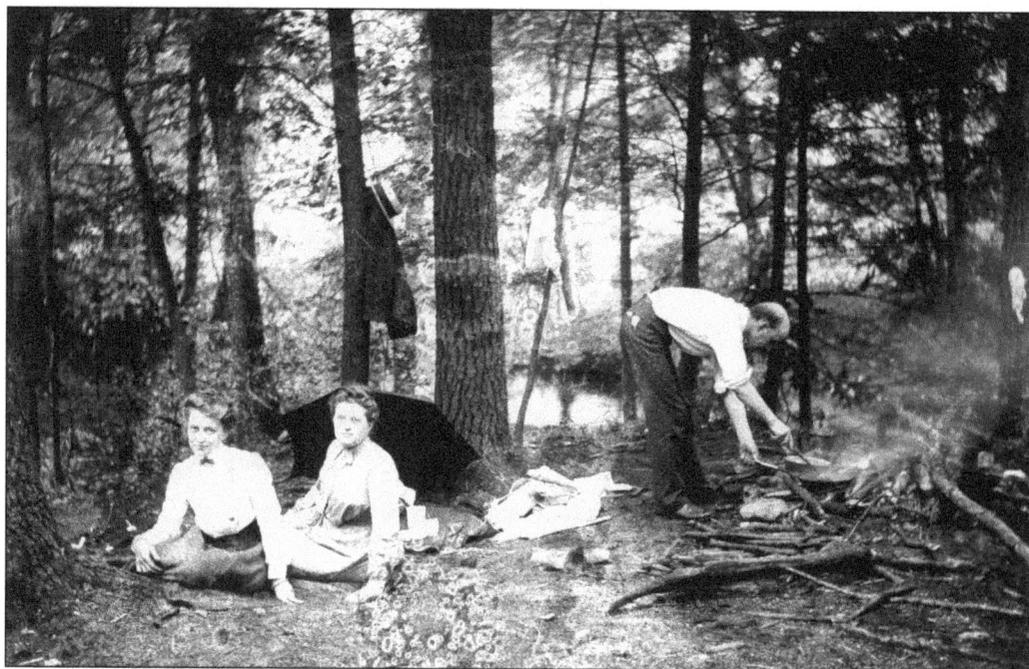

A cook stoops to get the wood fire going.

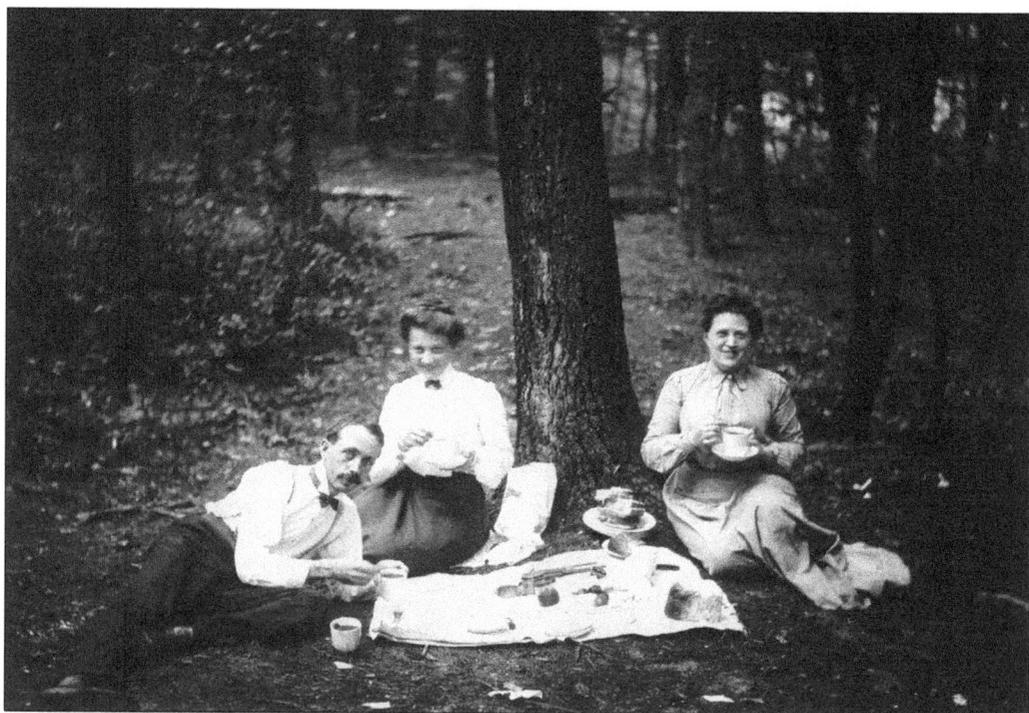

When the meat is done and the smoke clears, it is *le dejeuner sur l'herbe* in Mauch Chunk. Edouard Manet could not have asked for better subject matter.

While women stayed home cooking, cleaning, crocheting, knitting, or reading, men hunted deer and bear on the surrounding hillsides, or fished at Big Pond (Lake Harmony).

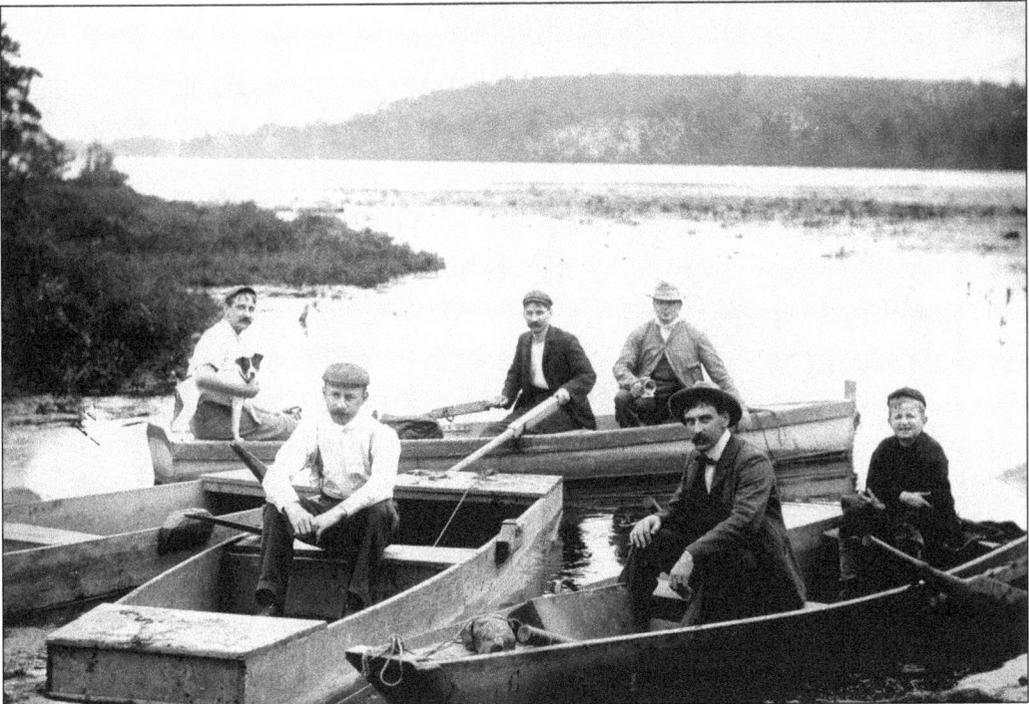

The boy, seen previously with his baby sister, is a few years older as he enjoys a day of fishing and boating with his father.

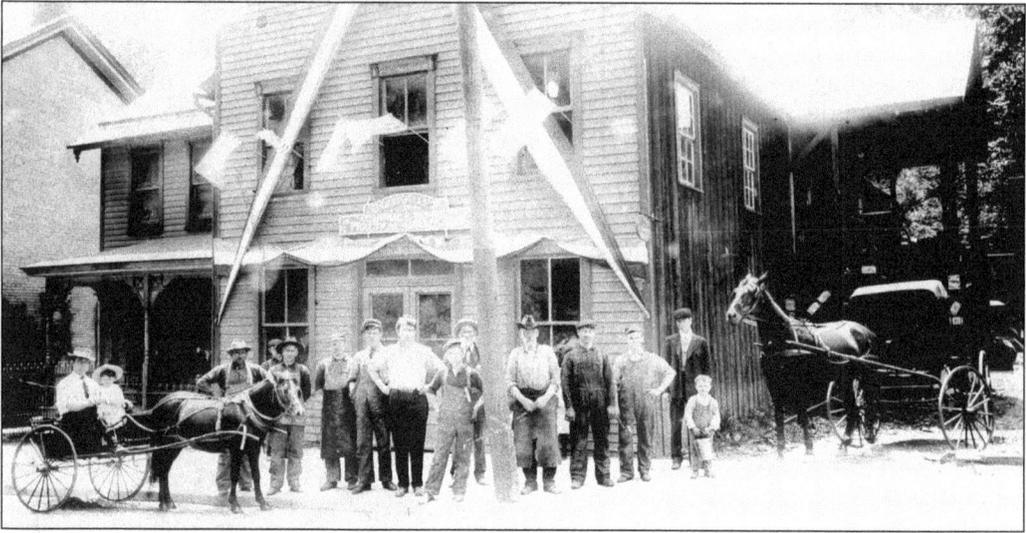

A blacksmith and carriage works were as important in the 19th century as today's mechanic and garage. As the work crew poses for a photograph outside Corrill's Carriage Works, a horse and pony wait to be shod.

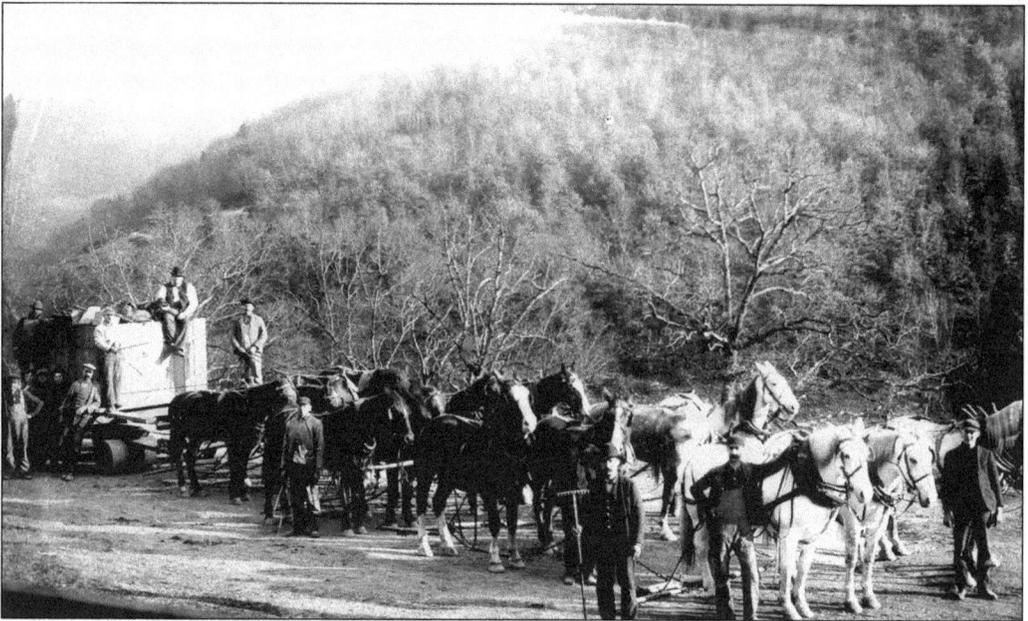

If it takes 15 horses to haul a load of cut stone, how many blacksmiths does it take to shoe the horses? From the topography, this action seems to have taken place in Glen Onoko.

Four

THE TOURIST SCENE

Nestled between South Mountain (Flagstaff) and Mount Pisgah, with Bear Mountain across the Lehigh River, Mauch Chunk inevitably attracted tourists. Even before the first packet boat sailed up the Lehigh Canal from Easton, visitors were descending on Mauch Chunk to see the amazing works of Josiah White and Erskine Hazard. To accommodate the curious, the Lehigh Coal and Navigation Company built a hotel near the waterfront in 1823 and named it the Mauch Chunk Inn. In "Mauch Chunk Visit in 1828," a visitor who rode a hinged raft down the Upper Lehigh River from Rockport in 1828 described the inn this way:

> A few steps from the landing of the raft brought me to the Mauch Chunk Hotel, a large and elegant building, well finished and furnished, and crowded with well dressed, fashionable people, evidently strangers on a visit to the mines. A glance round the tea table told me there was both beauty and grace among the female visitants. An examination of the book where each person's name is recorded informed me that some of the first characters and talent of the state were guests at the mansion.

James Audubon wrote the above words while sketching wild birds in the Lehigh Gorge in 1828. Little did he realize that, when his ornithological guide *Birds of America* was published, his fame would far exceed the fame of those whose signatures appeared in the guest book.

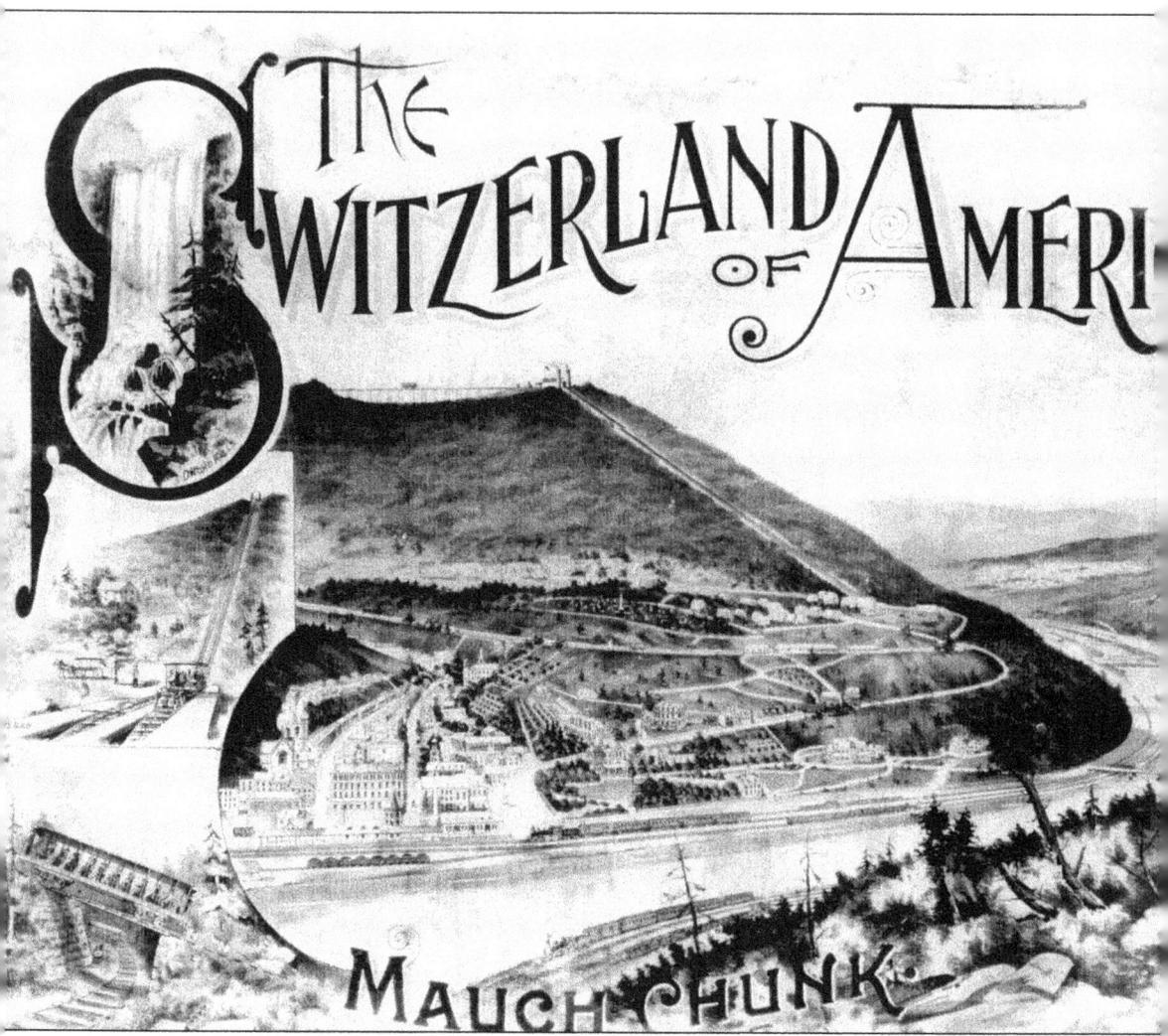

Quick to capitalize on the area's great scenic beauty, the railroads named Mauch Chunk "the Switzerland of America." (Courtesy of Ray Holland.)

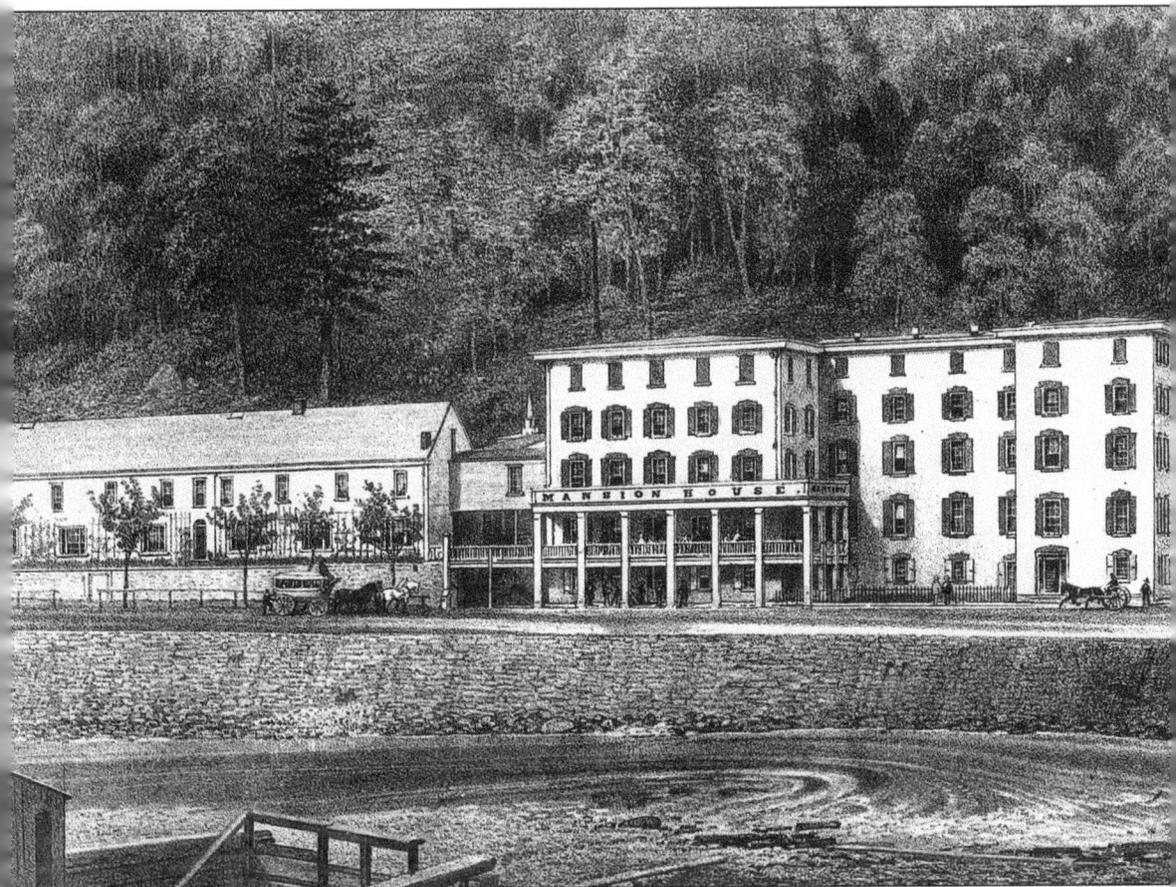

Constructed at the base of South Mountain in 1823, the Mauch Chunk Inn soon became known as the Mansion House as it expanded to meet the needs of the growing town. The *Carbon County Transit* offered the following observation on June 6, 1843:

> There's Stedman's Mauch Chunk hotel, commanding a view of the river, canal, and railroad, and all the coal wharves where the pomp and circumstance of coal shippings are enacting—all in black lie the hundred gondolas of the Lehigh, manned by black white men, in suits deep-hued as the bargemen on the Lagunes [*sic*] of Venice. This is a charming spot in an angle of a mountain, with mountains around and the most comprehensive and interesting view to town, piazza'd from head to foot, with a chance for a ramble among shrubberies and along terraced gardens or a mountain reach.

A footbridge from the original Lehigh Valley station crossed the Lehigh opposite the Mansion House. By the end of the 19th century, the hotel stretched along Susquehanna Street and had 300 rooms.

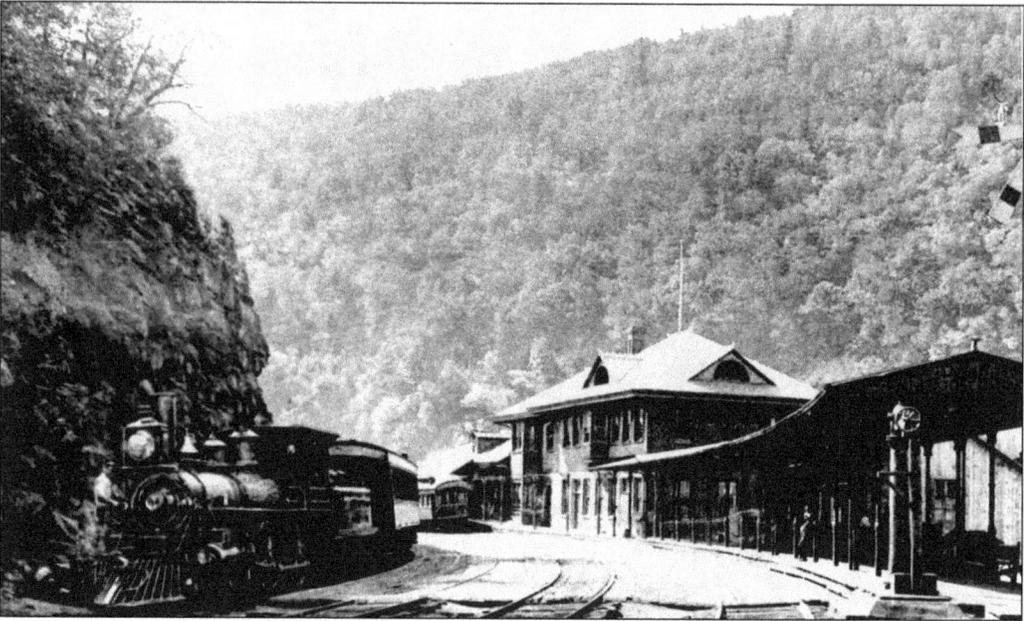

The original Lehigh Valley station was built on the east side of the river near the entrance to Lock One on the Lower Division of the Lehigh Navigation. A footbridge crossed the river opposite the Mansion House Inn, providing passenger access to Mauch Chunk. Subsequently, a new station was built south of the iron footbridge linking East Mauch Chunk to Mauch Chunk. (Courtesy of Agnes McCartney.)

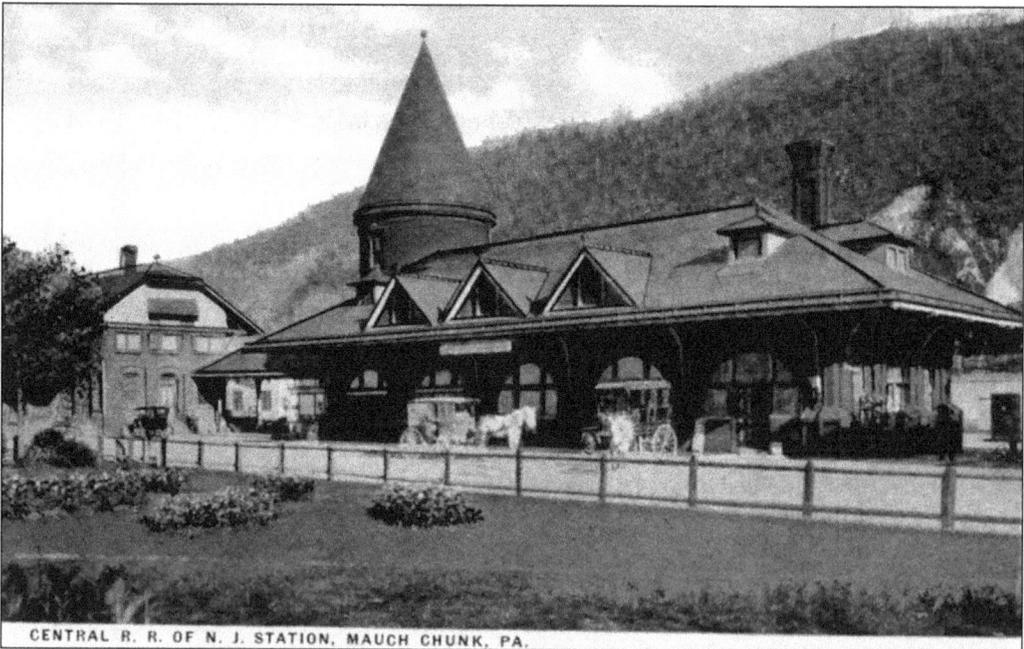

CENTRAL R. R. OF N. J. STATION, MAUCH CHUNK, PA.

The New Jersey Central passenger station was constructed in the center of town in 1888. Turreted with gabled dormers projecting from the eaves of a hipped roof, it is flanked with decorative brick arches along the public side of the square. Between the two railroads, 22 trains a day brought tourists to Mauch Chunk.

44

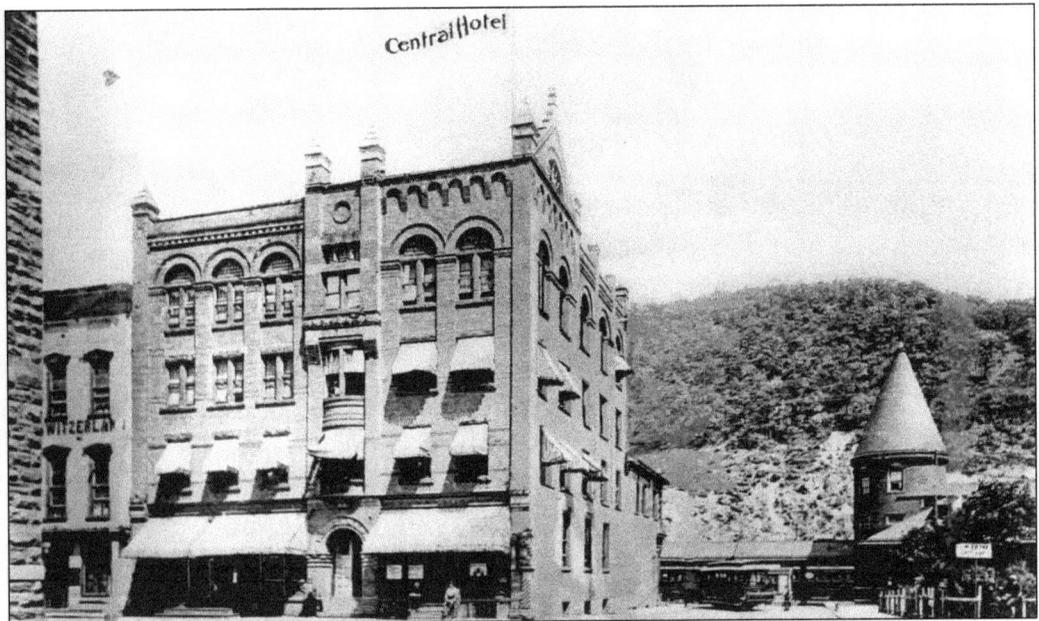

Central Hotel

Tourists arriving by train did not have far to go to their hotels. The Mansion House stood opposite the Lehigh Valley station; the American Hotel (now the Inn at Jim Thorpe) was a stone's throw from the Jersey Central station. Seen here is a section of Hotel Row including the Switzerland (left) and Central (right) hotels. The Armbruster is missing from this photograph.

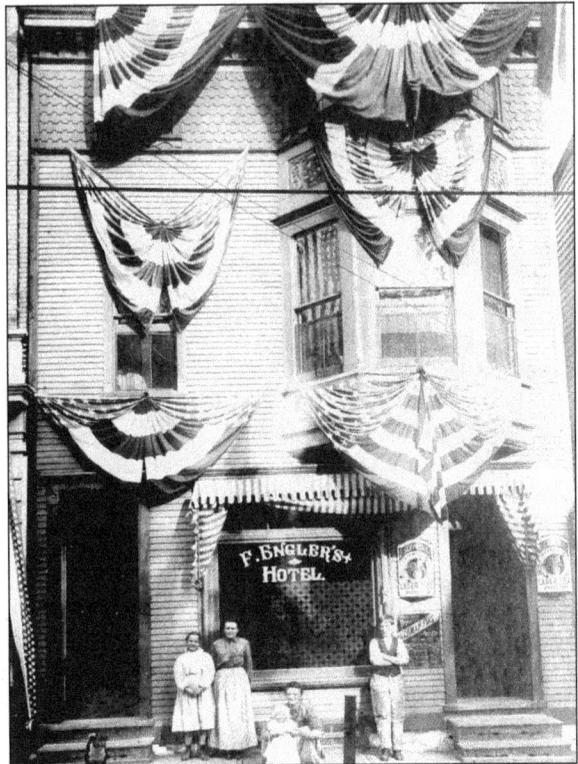

Small hotels catered to the less wealthy. The proprietors of F. Engler's Hotel pose outside their Center Street premises, decorated for a gala occasion, perhaps July 4. Conspicuous on each side of the doorway are signs for one of Mauch Chunk's premium brews: Schweibinz's lager beer. (Courtesy of Jane Engler.)

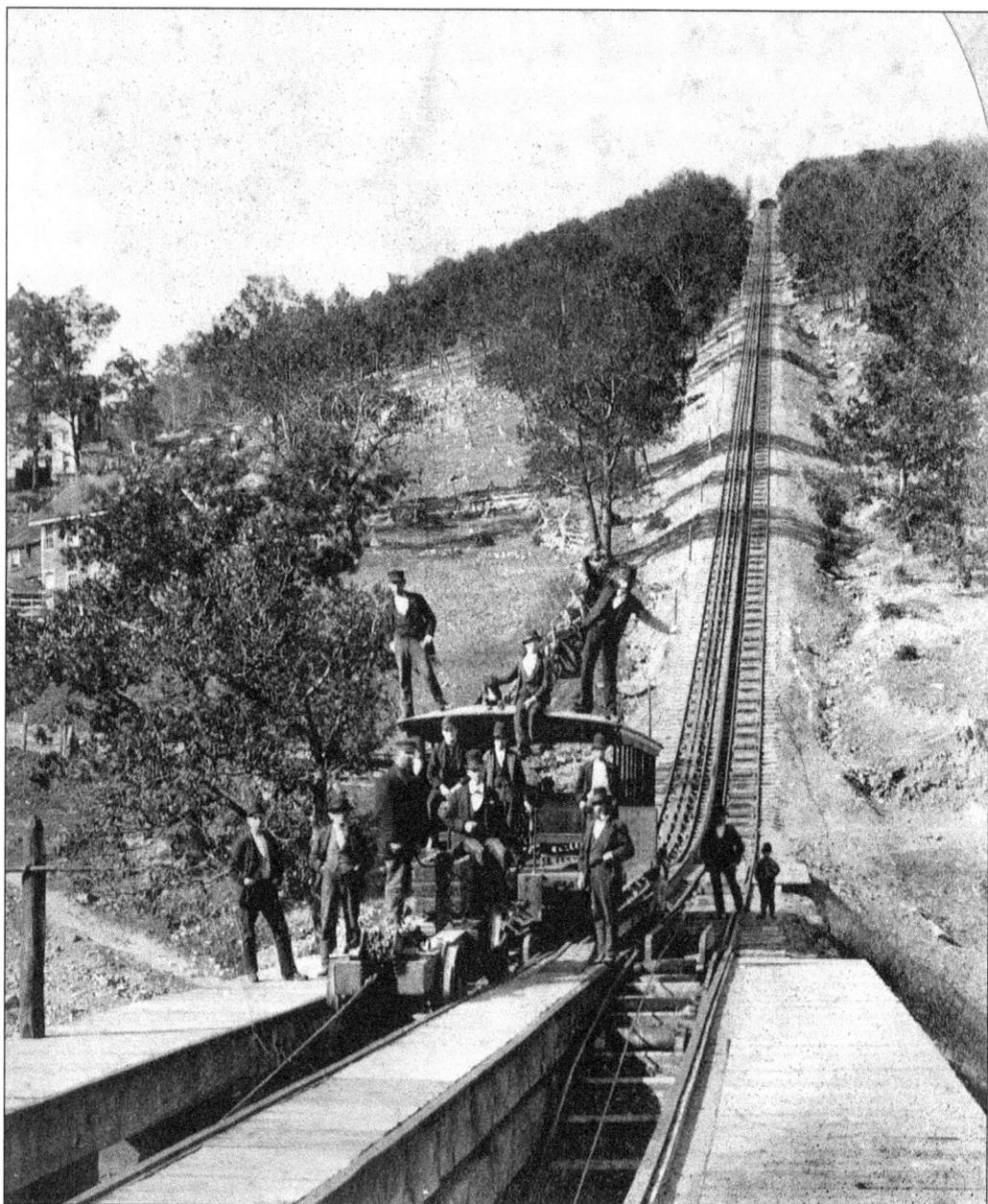

Mauch Chunk's most popular tourist attraction was the Switchback Gravity Railroad. Originally, it made three passenger runs a day between Mauch Chunk and Summit Hill. When the car passed over the pit at the base of the 2,322-foot-long Mount Pisgah Plane, a barney or safety car rose automatically behind the ascending car. Hauled up by a giant wheel in the engine house, the barney pushed the cars up the incline. Following the opening of the Hauto tunnel, which allowed major railroads to access the Panther Valley mines directly, the Switchback was no longer needed to haul coal and became the plaything of tourists in 1872.

The unusual photographs on this page were taken from inside a Switchback car. As the car approaches the Mount Pisgah engine house, tourists watch it ascend the 2,322-foot plane. (Courtesy of Ray Holland.)

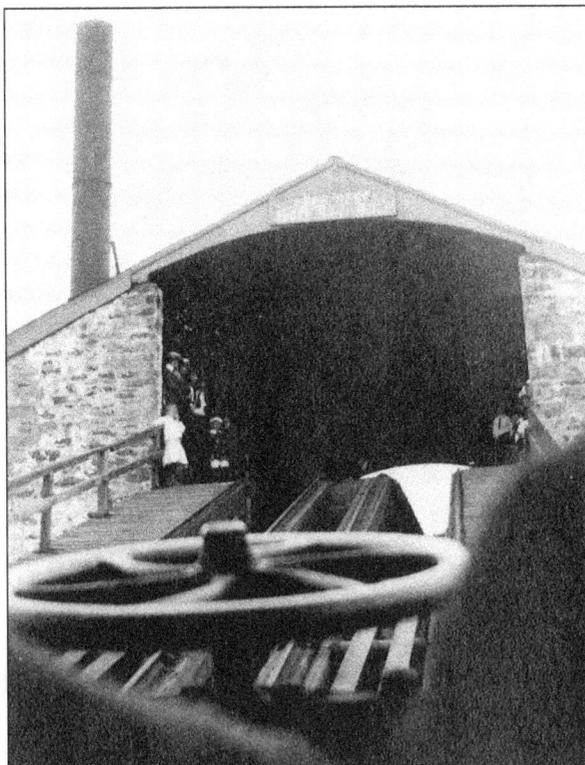

After leaving the Mount Pisgah engine house, the car crosses a trestle and speeds by gravity toward the 2,270-foot-long Mount Jefferson Plane. When this photograph was taken, a lookout at the Jefferson end of the trestle provided magnificent views of the Lehigh River, the Heights section of Mauch Chunk, Lower Broadway, and Flagstaff. (Courtesy of Ray Holland.)

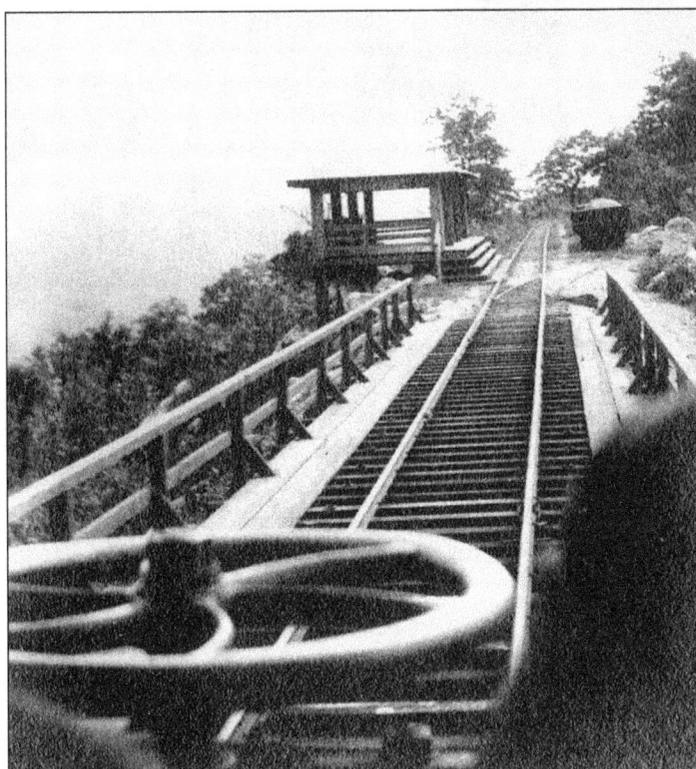

47

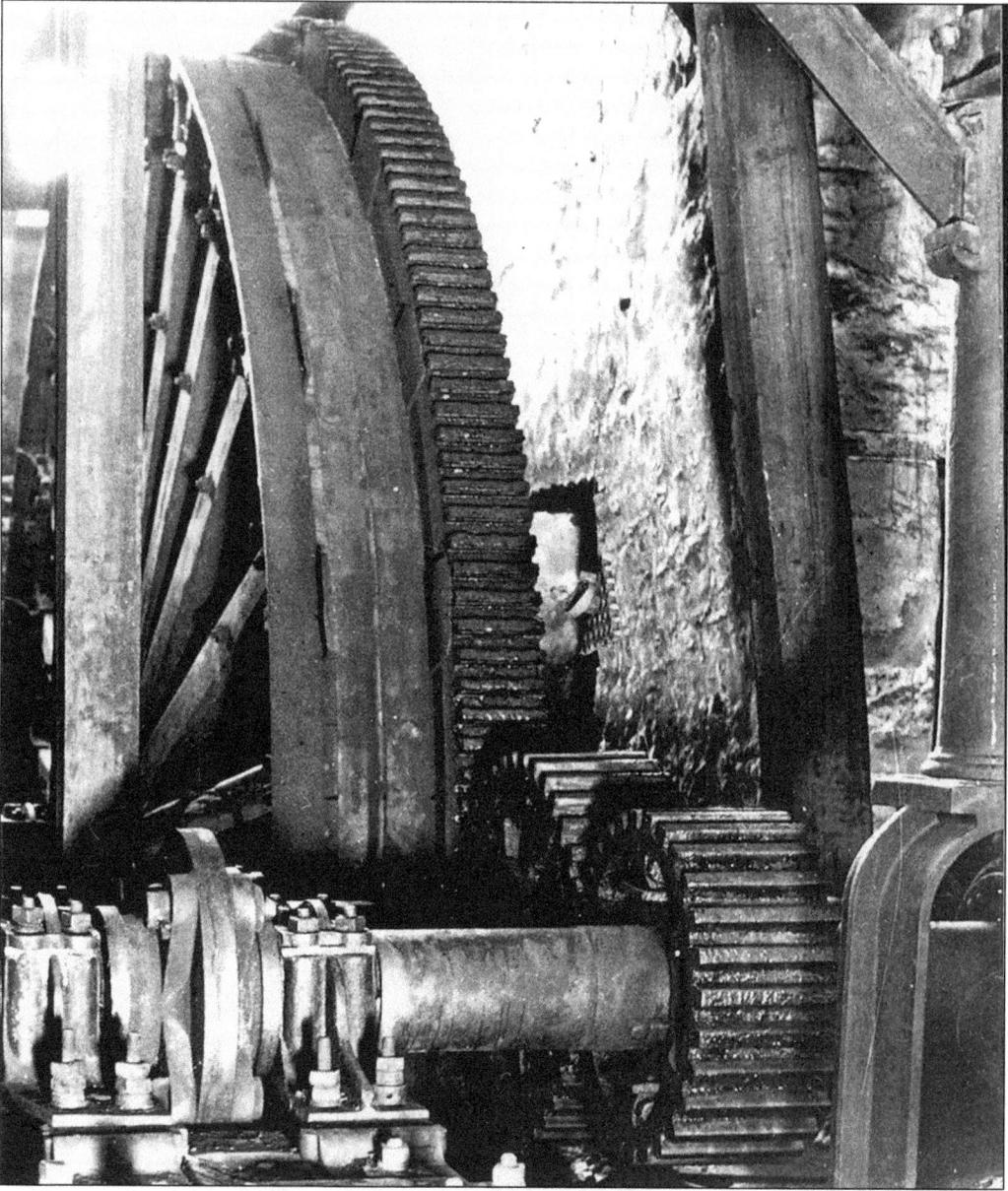

Oiled, all geared up, and ready to go, the 27-foot-diameter driving wheel in the Mount Pisgah engine house was used to haul in the barney car.

Tourists enjoy a spectacular bird's-eye view of Mauch Chunk and the Lehigh River from the 1,000-foot lookout on Flagstaff Mountain in October 1904. The viewing range is estimated to be 65 miles.

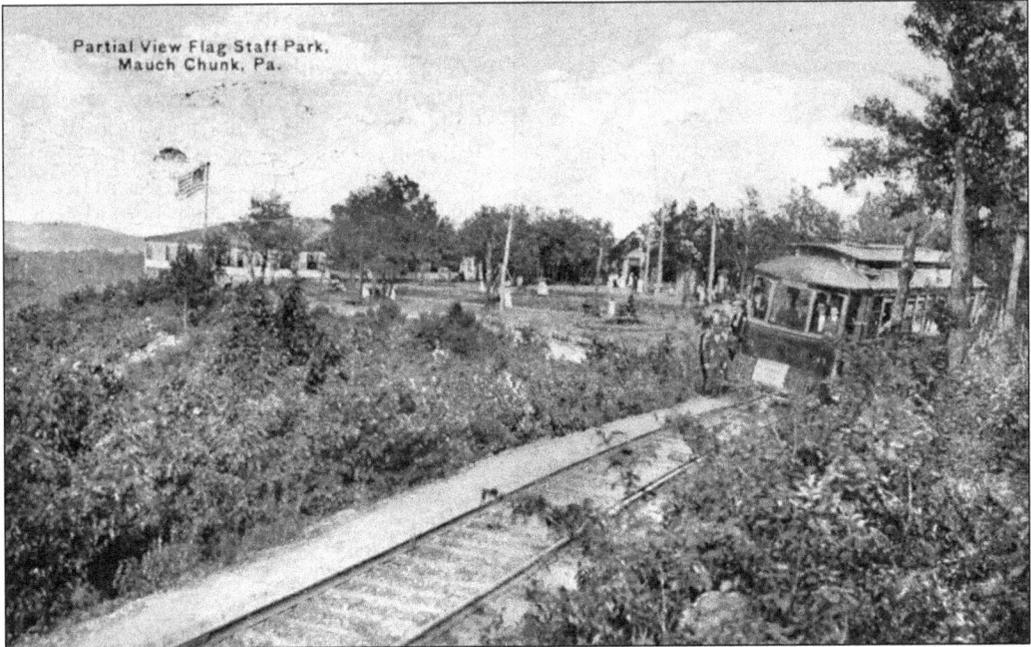

Partial View Flag Staff Park,
Mauch Chunk, Pa.

When the Mauch Chunk, Lehighton, and Slatington Railway Company inaugurated trolley service to Lehighton by way of Flagstaff in 1901, an amusement park and dance hall, known as the Ballroom in the Clouds, was built on top of Flagstaff.

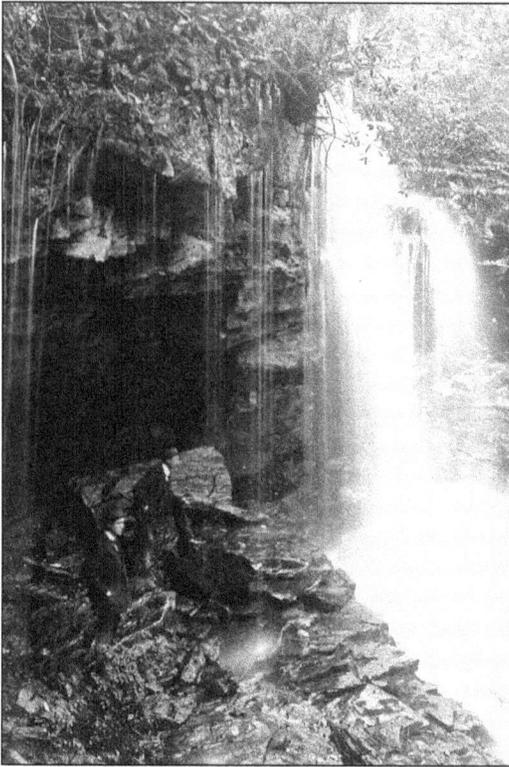

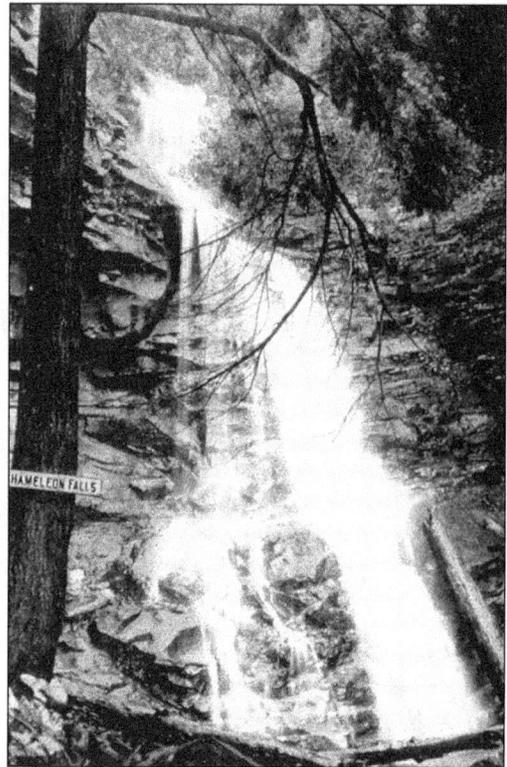

Chameleon Falls

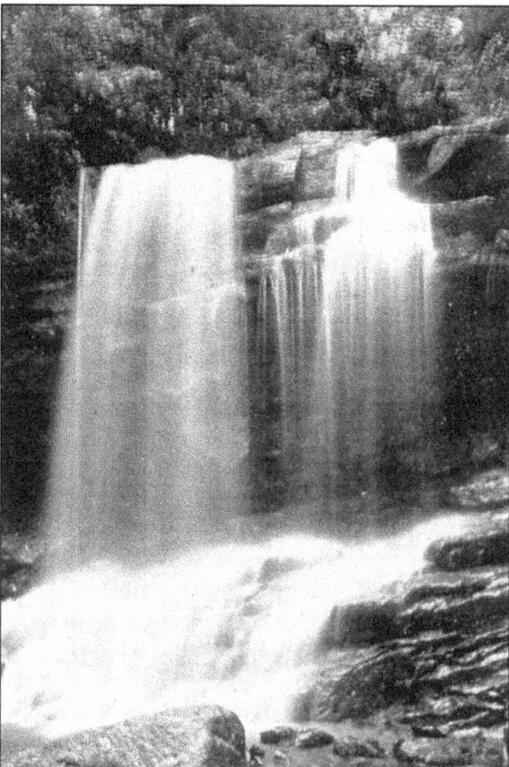

Sharing the tourist spotlight with the Switchback and Flagstaff and served directly by rail in the 19th century was beautiful Glen Onoko, with its towering gorge, cascading stream, and three waterfalls. The highest of the falls is the 75-foot Onoko Falls (above left). It was named after the princess who is said to have leapt to her death from the summit when her father, a Lenape chief, banished her lover, Opachee, a brave from a rival tribe. The 50-foot Chameleon Falls (above right) and 45-foot Cave Falls (below) make up the trio of waterfalls.

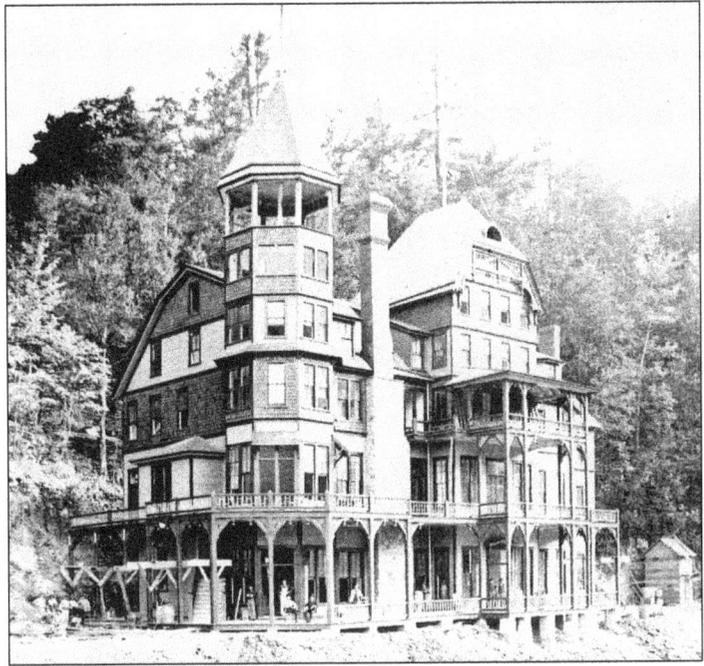

Looking like an image right out of *Dracula* is Glen Onoko's four-story, 47-room Wahnetah Hotel. With its dance pavilion, 84-foot bar, horse-and-carriage rides, tennis courts, and scenic trails up the falls, the Wahnetah was a veritable 19th-century Club Med. On April 27, 1911, the hotel was burned to the ground by a forest fire.

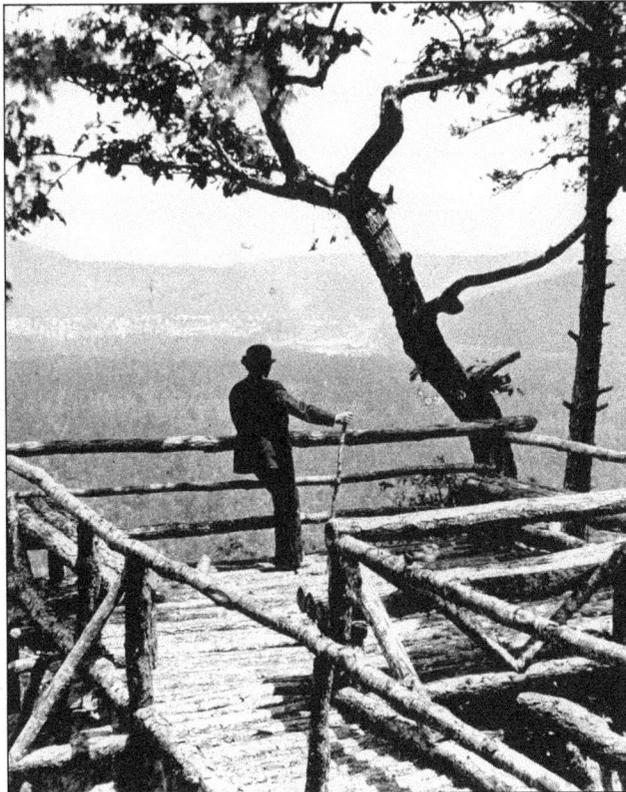

Climbing the mountain and crossing the cataracts was made easy by the Wahnetah Hotel staff. Staircases, bridges, and pathways led to the falls and to the top of Broad Mountain. Here, a man stands on the lookout and views the vast vista of mountains and woodlands rising up from the Lehigh Gorge.

51

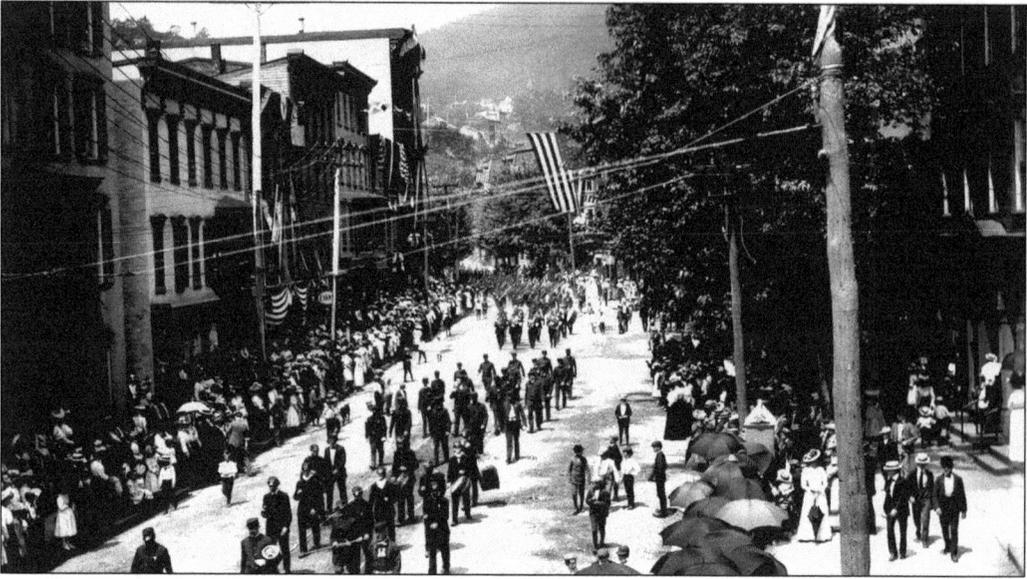

Everybody loves a parade—including Mauch Chunkers and tourists! Here, the 1st Rifle Regiment of Civil War Veterans, known as the "Bucktails," reunite and parade down Broadway in September 1891. Patriotic to the core, proud of the men who fought and died for the Union, residents line the parade route and mingle with tourists. (Courtesy of the Old Jail Museum.)

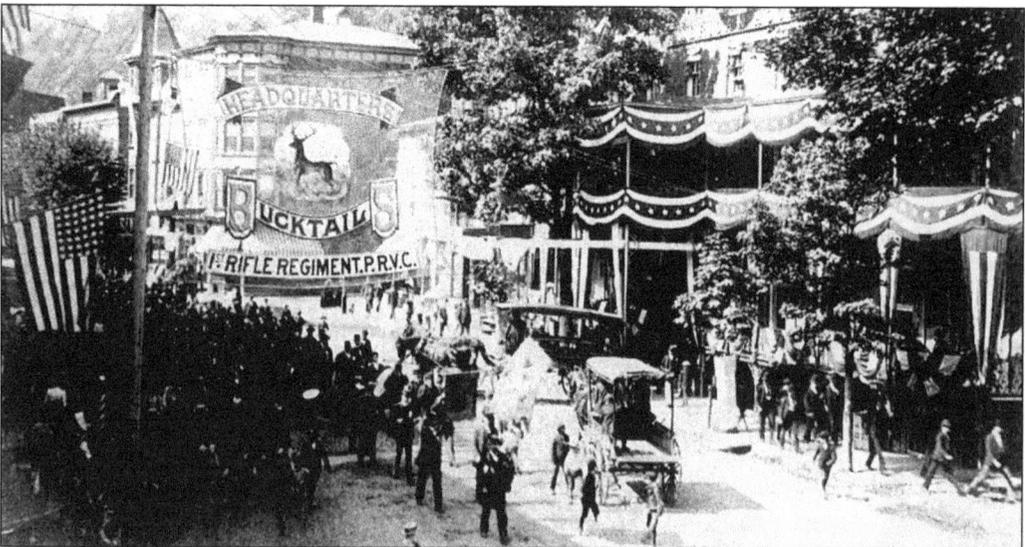

The Bucktails pass the American Hotel, its balconies decorated with bunting, on their way to ceremonies at the Civil War Monument on Hazard Square at the base of Packer Hill.

Five

ECONOMIC COLLAPSE

When the Lehigh Valley Railroad and Central Railroad of New Jersey reached Mauch Chunk in the second half of the 19th century and extended their tracks into the coalfields north and west of the Lehigh River, Mauch Chunk's status as a coal-shipping center began to change. As coal shipments on the Lehigh Canal steadily decreased, long trains of coal wagons bypassed Mauch Chunk along the tracks of the two railroads. In 1855, the year Asa Packer connected Easton to Mauch Chunk by the Lehigh Valley Railroad, 1,275,050 tons of coal passed down the Upper and Lower Divisions of the Lehigh Navigation. By the time the 20-mile section of canal between Mauch Chunk and Laury's Station had closed in 1922, only 67,575 tons of coal passed along the last remaining section of the navigation. Although 1922 was a particularly bad year and coal shipments rose slightly thereafter, statistically it was obvious that the great anthracite waterway was on its way out.

The downfall of coal mining, railroads, and tourism began when petroleum emerged as the 20th-century fuel of choice. As coal was replaced by petroleum in industry and home heating, and rail excursion tourism and freight transportation were eroded by the automobile and truck, railroading fell into decline.

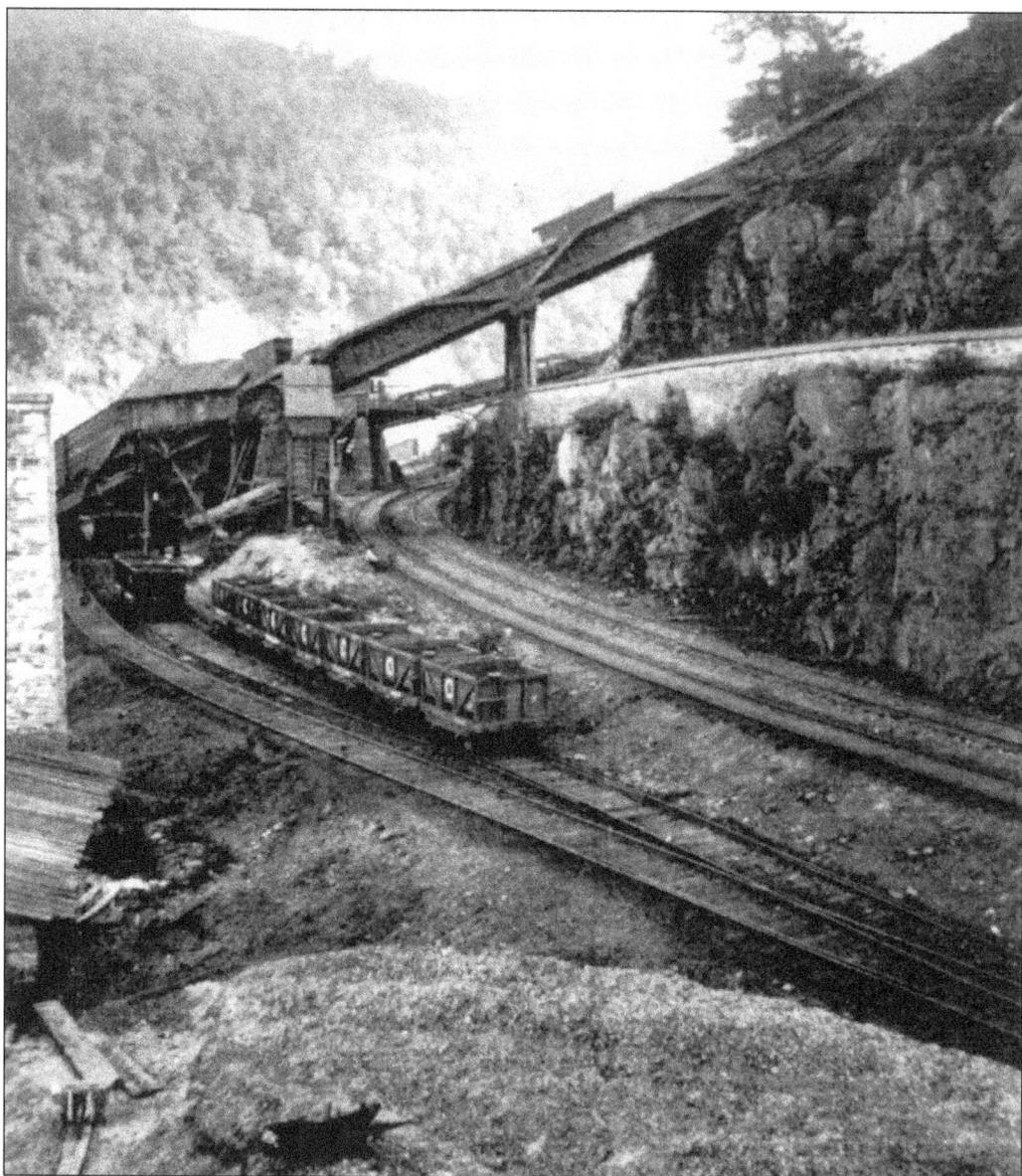

This photograph speaks a thousand words. Not only is the main line of the Jersey Central running beneath the Switchback coal chutes, railroad wagons are being loaded at chutes designed to load coal boats on the Lehigh Canal. In 1870, when the railroads reached the mines by way of the Hauto tunnel, the coal chutes became obsolete.

Coal boats wait to be loaded at the Beaver Meadow docks on the east side of the Mauch Chunk pool. On November 5, 1836, the Beaver Meadow Railroad began hauling coal from mines west of the river to Parryville on the Lower Division of the Lehigh Canal. Following the opening of the Upper Division in 1838, it also unloaded coal at Penn Haven, nine miles up the new navigation. In 1841, when a flood on the Lehigh destroyed the bridges en route to Parryville, its terminus became Mauch Chunk.

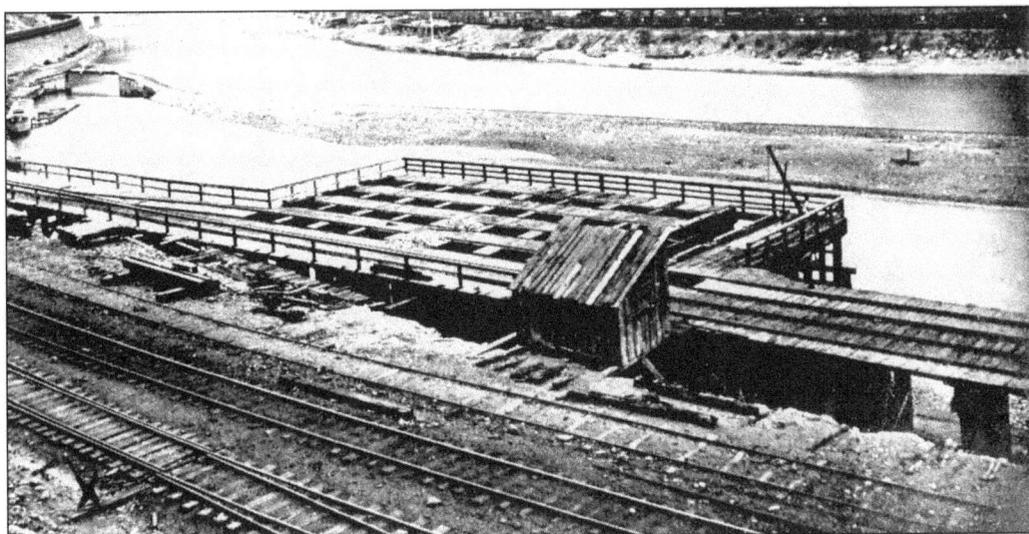

Following the destruction of the Upper Division in 1862, Coalport, three-quarters of a mile north of Mauch Chunk, became the prime loading center for coal passing down the Lower Division of the Lehigh Canal. As a result, the Beaver Meadow loading docks (above) fell into disrepair. (Courtesy of Thomas Potter.)

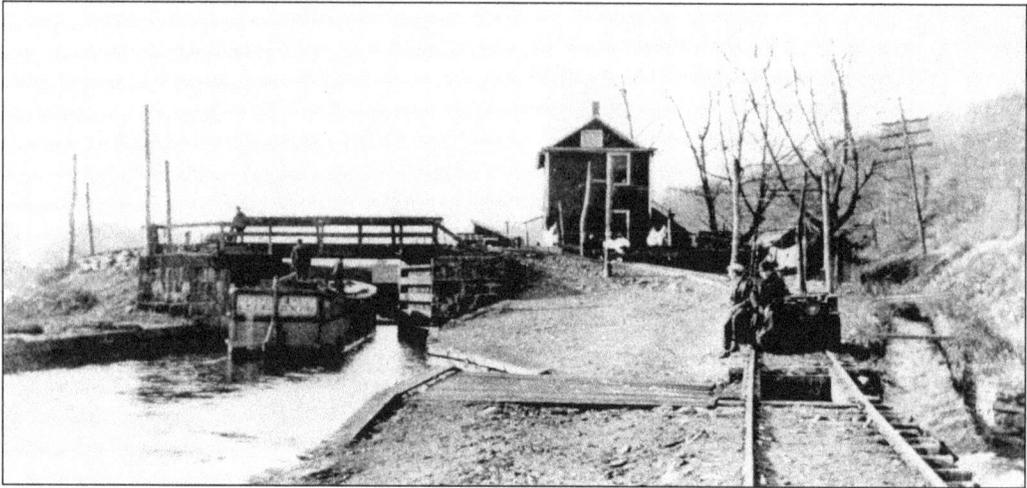

In 1907, Lehigh Coal and Navigation officials initiated a series of experiments to expedite coal shipments by replacing the trusty mule. Experimental tows included a naphtha-powered boat, mine engine, monorail, and an adapted truck. All proved to be failures. The increased speed of the boats tore up the canal banks and caused a pile-up of boats at the locks. Here, a mine engine on an experimental run tows a coal boat between Coalport (lock in background) and Weighlock. (Courtesy of the National Canal Museum.)

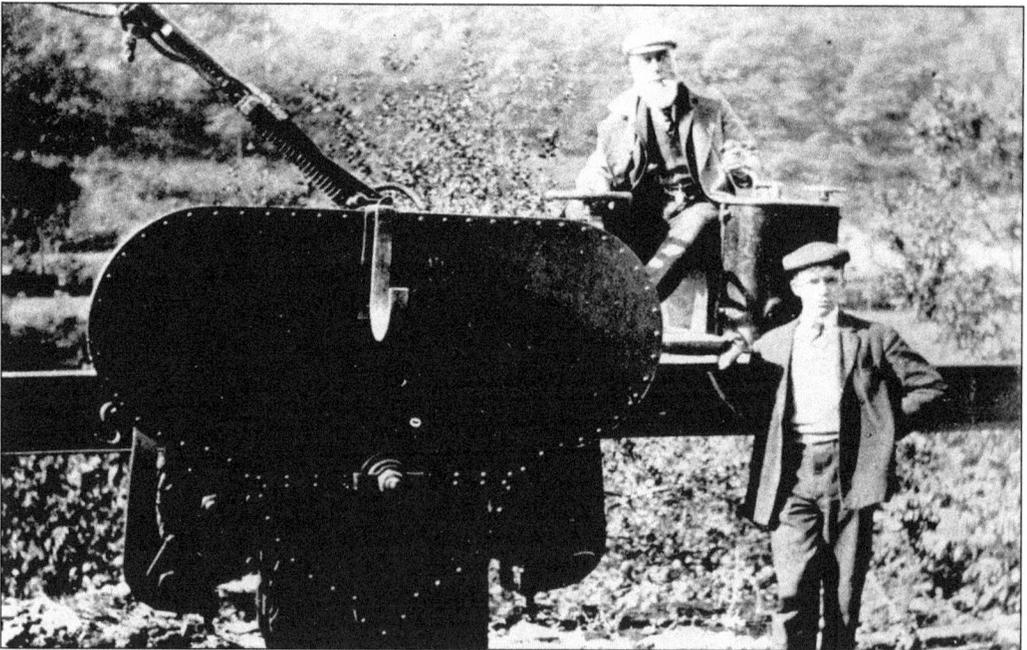

A section of monorail was installed between the weigh lock and Lock 7 above Weissport. Known as an electrice mule, the tractor running along the monorail could tow two loaded boats or four empty boars at a time. The tractor is shown here with its inventors Leon Girard (seated on the monorail) and his son Ernest (standing). (Courtesy of the National Canal Museum.)

56

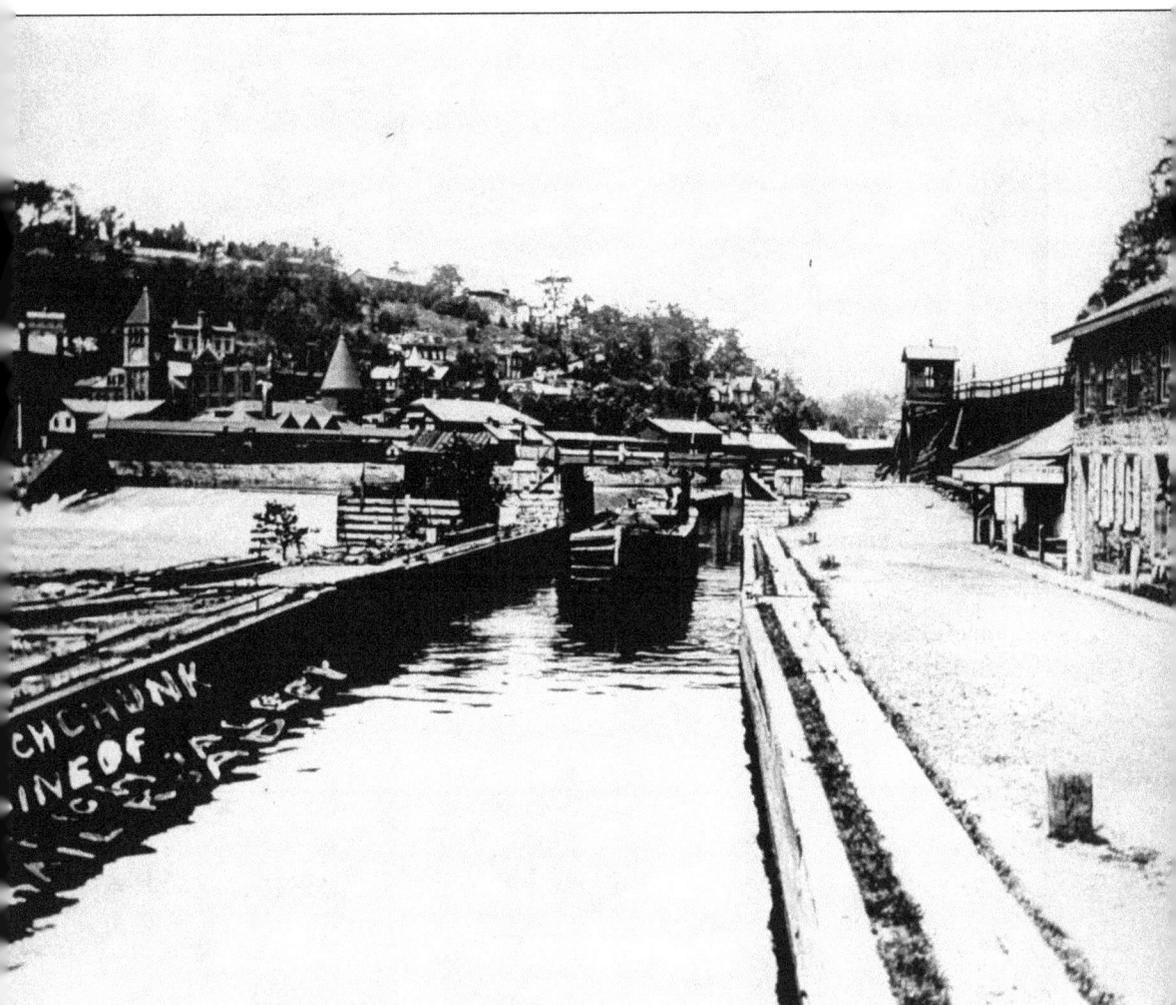

This image signifies the end of an era, as a private commercial boat, or hackey, passes from the Mauch Chunk pool through Lock 1 into the Lower Division. Opposite the lock house, graffiti scrawled on the wharf proclaims, "Mauch Chunk on the line of the Lehigh Valley Railroad." The 20-mile section of the Lehigh Navigation between Mauch Chunk and Laurys Station closed in 1922. From 1922 until the Lower Division ceased operating in 1932, the Central Railroad of New Jersey transported coal from the mines to Laurys Station, where it was loaded onto coal boats for the trip to Easton and on down the Delaware Canal. In 1942, the Lower Division of the Lehigh Navigation met the same fate as the Upper Division—it was wiped out by a disastrous flood.

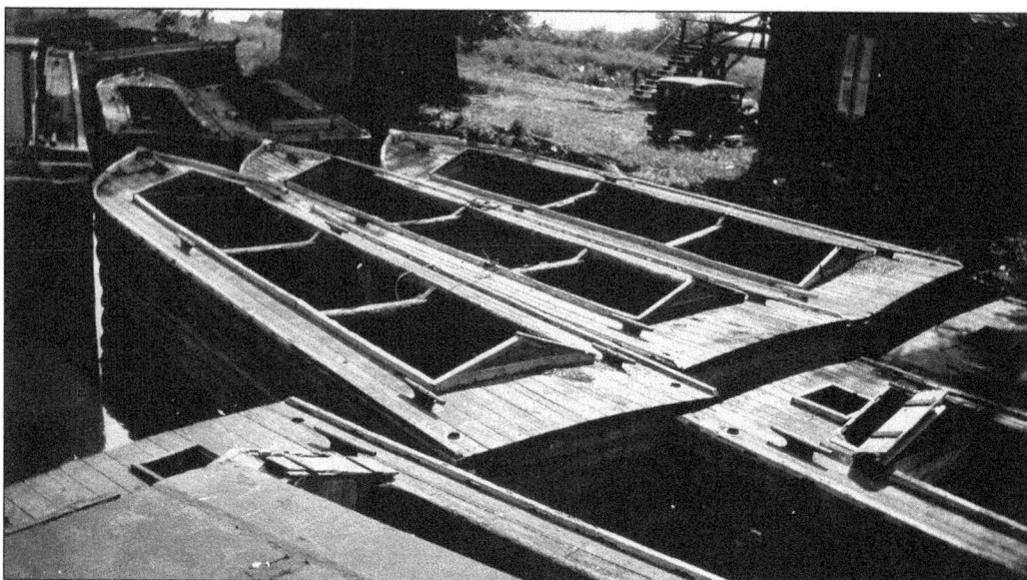

Abandoned coal boats, their hatches and cabin tops removed, await their fate. When the last section of the Lehigh Canal closed between Laurys Station and Easton, a number of coal boats were scuttled in a water-filled quarry in Northampton; others were broken apart.

In 1981, after six years of labor, the Triborough Sportsmans' Association raised the front section of a hinged Lehigh coal boat from the quarry and placed it on view. Originally, coal boats were one continuous 87.5-foot length, but proving hard to maneuver and load, they were hinged in two 43.5-foot sections around the mid-19th century. (Courtesy of Al Zagofsky.)

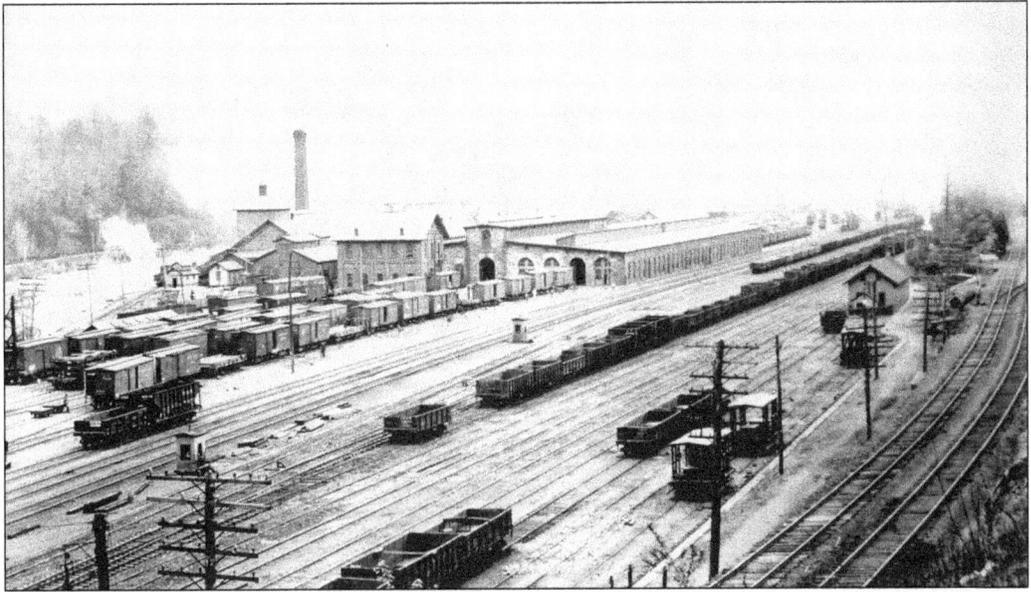

Sidings for coal cars once lined the main line tracks on the west side of the Lehigh River north of Mauch Chunk and south of town at the Packerton Yards (above). On the east side, they paralleled the coal loading docks of the Beaver Meadow Railroad. At Packerton, empty coal wagons were inspected and repaired and loaded wagons were weighed and routed to various destinations. At their peak, the shops and yard employed 2,200 men and could accomodate 4,000 coal cars.

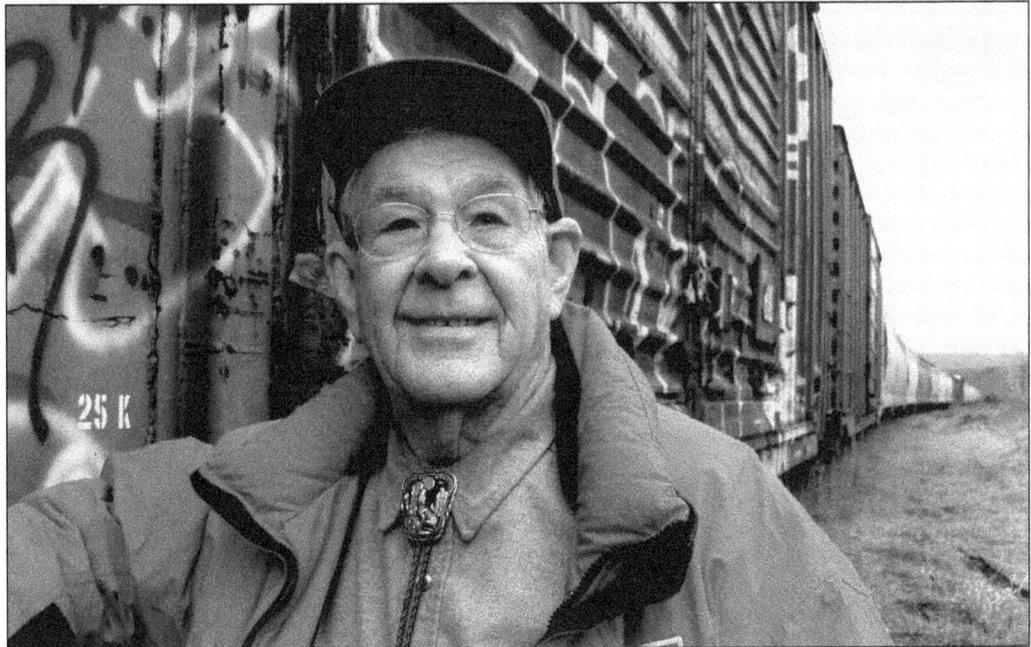

The last yardmaster at Packerton, 81-year-old Al Feuerstein takes a trip back in time with newspaperman Al Zagofsky. With the 47-acre Packerton Yards slated for commercial revival, Feuerstein reminisces as he leans against a Norfolk Southern Railroad car bearing the ubiquitous symbol of modernism, graffiti. (Courtesy of Al Zagofsky.)

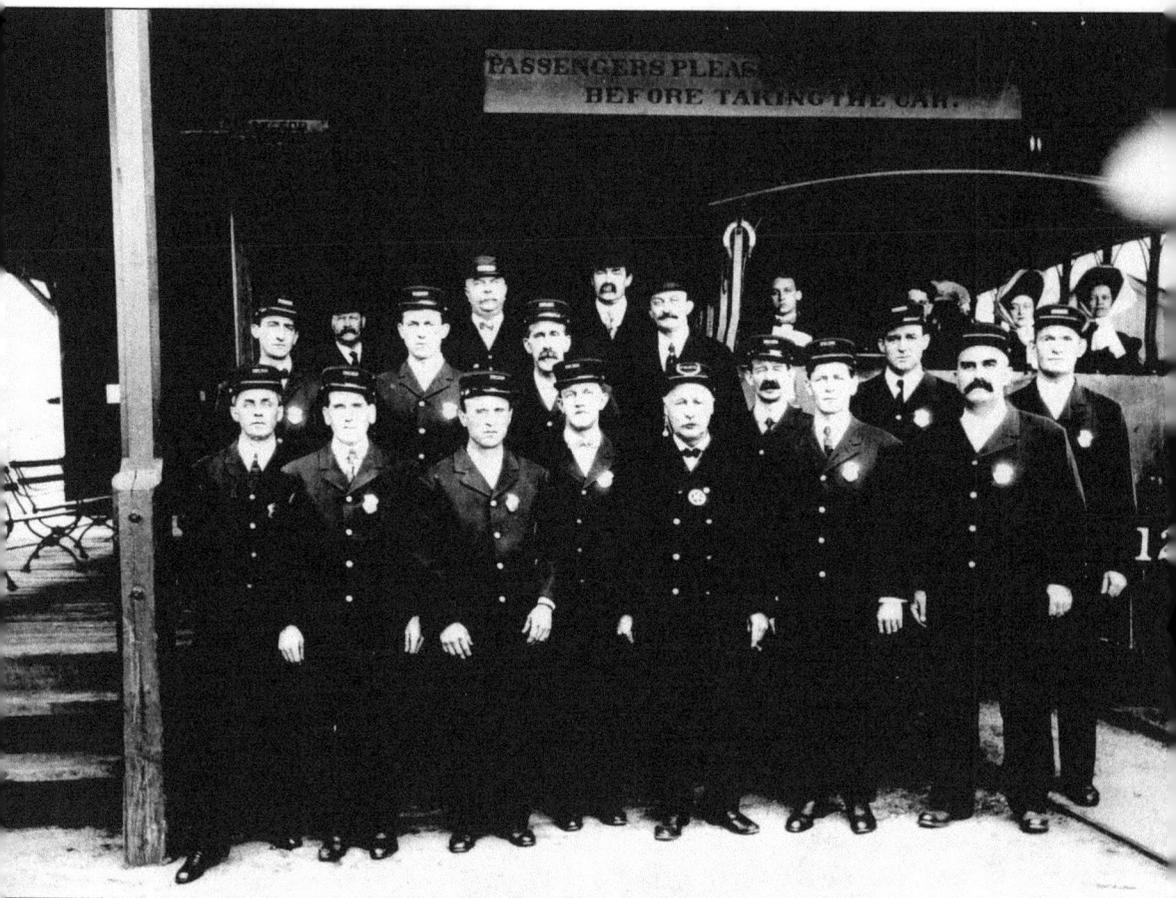

With passengers already seated in the car, Switchback Gravity Railroad workers pose for a group photograph. As the economic decline was becoming apparent to the Lehigh Coal and Navigation Company, Thomas Edison was consulted in 1904 about electrifying the Switchback. After experiencing the exhilarating ride to and from Summit Hill, Edison was adamant: "No changes should be made." Ever intrigued, the Wizard of Menlo Park made another trip to Mauch Chunk with his wife and guests in July 1929, four years before the gravity railroad closed. Arriving in style at the American Hotel in an open Lincoln automobile, the party came to ride on Mauch Chunk's famous Switchback. By then 83 years old, Edison stayed grounded while his wife and guests, escorted by Switchback manager S. K. Evans, boarded a VIP car controlled by the railroad's best "runner," Charles Sibbach. When the party reached the tops of the Pisgah and Jefferson Planes, they were awe-struck by the majestic vistas on every side. And as they speeded back to Mauch Chunk, Mrs. Edison exclaimed, "Here we enter the way to paradise!"

While tourism declined in the 20th century as the automobile came into its own, visitors were still lured to Mauch Chunk to ride on the famous Switchback "roller coaster." But by 1933, the thrill ride was over. The main drive shaft bearing in the Mount Pisgah engine house broke. Without spare parts or money to do repairs, the Switchback was forced to close. Shown here is the derelict engine house before it was torn down.

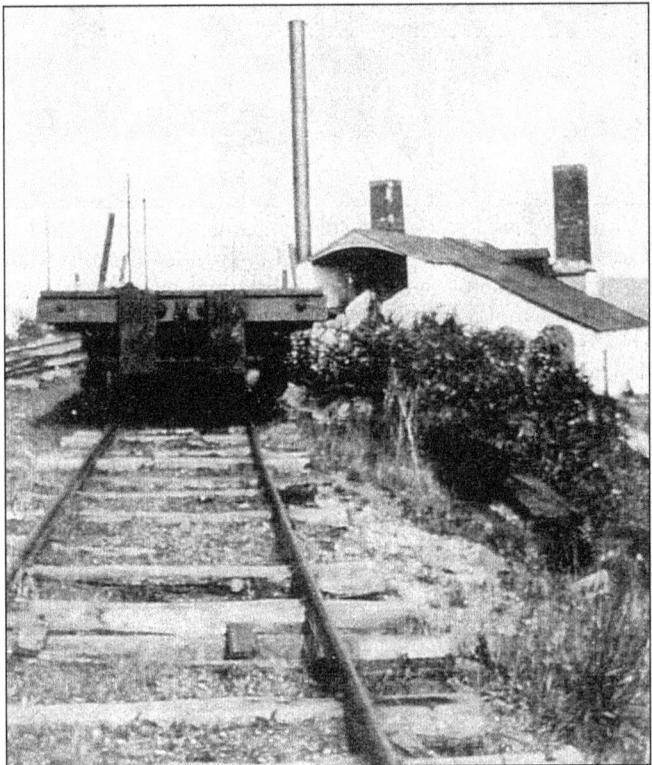

A flatcar is abandoned on a siding beyond the Mount Pisgah engine house.

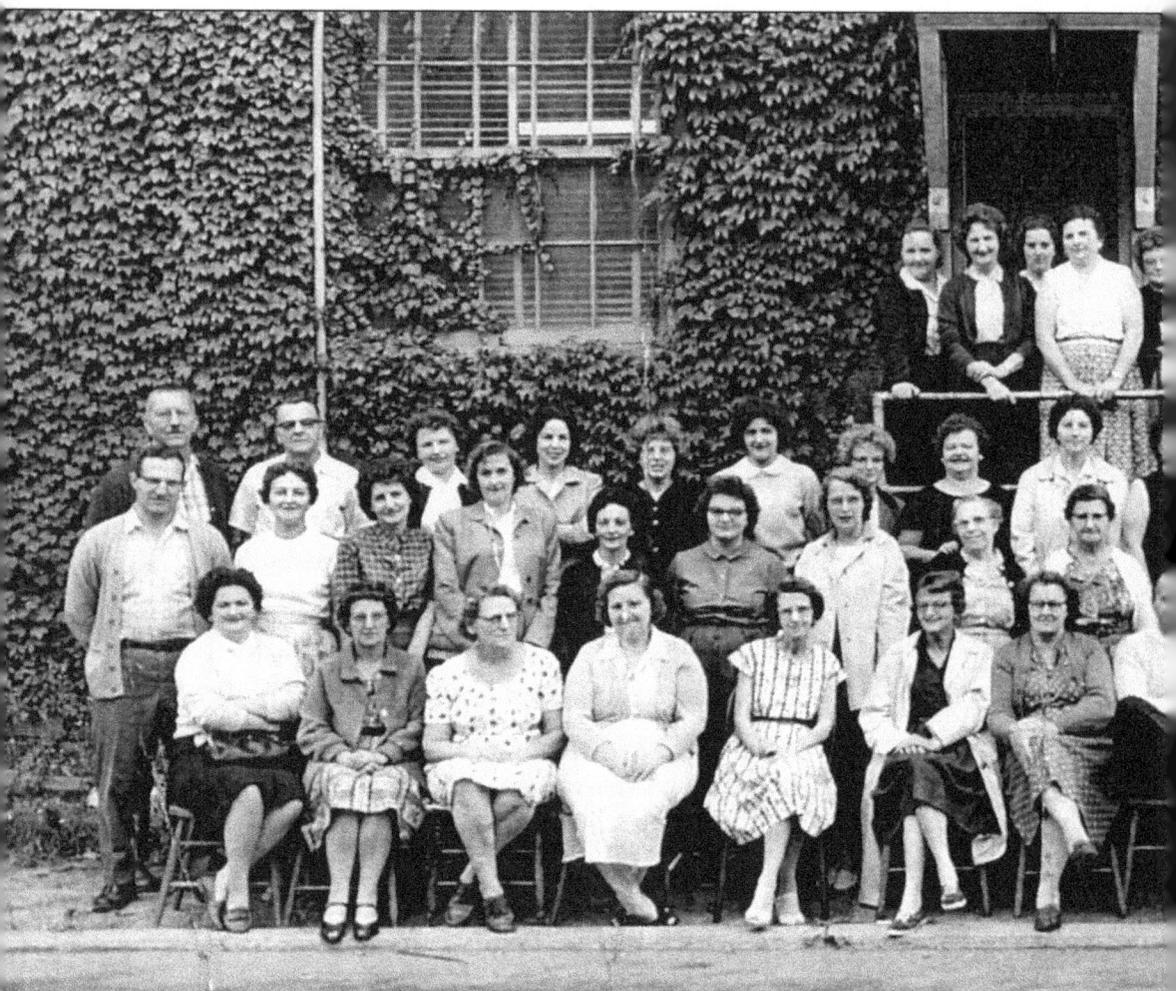

With the Switchback sold for scrap metal, mining and railroading on the decline, and the Great Depression lingering over the nation, things in Mauch Chunk went from bad to worse. Many people left town to seek better lives elsewhere. As the remaining male population was mostly unemployed, women supported their families by toiling in the small garment factories that sprang up to take advantage of cheap labor. Although World War II saw a rise in coal production and railroading, when the war ended unemployment was as high as ever. With male

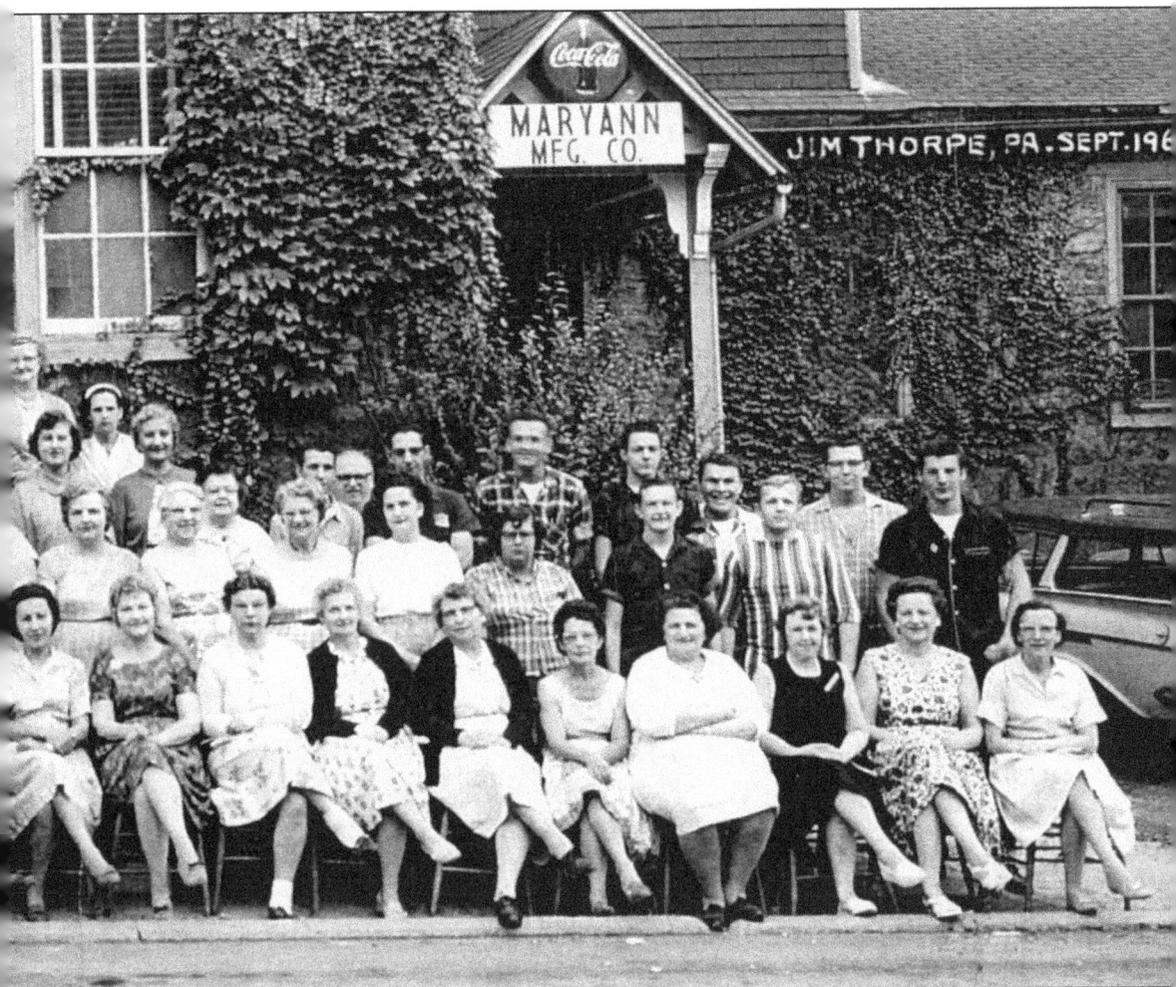

supervisors in charge, women were still the means of production. This 1962 photograph, taken outside the Maryann Manufacturing Company, typifies what had been happening for the past three or four decades. In an area with a tourist economy, small garment factories continued as a source of female employment until the 1990s when free trade sent local jobs to such places as China, Mexico, and India.

On September 27, 1937, the track, 11 passenger coaches, 3 flatcars, 1 tank car, power houses, car barns, and repair shops were all sold at auction. Bought by Isaac Weiner of Pottsville for $18,100, the scrap metal was soon on its way to Japan—as old-time Mauch Chunkers like to say, "Returning as bombs and bullets when the Japanese bombed Pearl Harbor."

The weed-grown Switchback tracks, seen here at landmark Five Mile Tree, were torn up for scrap metal.

Six

MAUCH CHUNK BECOMES JIM THORPE

With Mauch Chunk's economy in the doldrums in the 1950s, Joe Boyle, publisher and editor of the *Mauch Chunk Daily Times* (later known as the *Times-News*), decided to do something about it. He asked his readers to pledge a nickel a week for five years to establish an industrial development fund to attract businesses to the area. To add to the fund, he strung tapes from the courthouse up the hill and through town, asking visitors and motorists to "stick a nickel on the tape for Mauch Chunk." A September 12, 1983, account in *Forbes* magazine put the fund's 1953 figure at $35,000.

Viewing a television program about Boyle's efforts while visiting Philadelphia, Patricia Thorpe, widow of the legendary 1912 Native American Olympian Jim Thorpe, had a plan. To perpetuate her late husband's athletic legacy, she proposed to Boyle that she bring his body to Mauch Chunk for burial if residents agreed to rename their town Jim Thorpe and finance a mausoleum for his enshrinement out of the nickel-a-week fund. As an inducement to accept her proposal, Mrs. Thorpe promised to persuade the Football Hall of Fame to locate in the community, build a sports complex, establish the Jim Thorpe Museum, and help finance a 500-bed hospital. None of her promises materialized.

Seeing Patricia Thorpe's proposal as "divine intervention" for the economy of his struggling town, Boyle approached local officials and added a proposal of his own. If residents accepted the name change, the rival towns of Mauch Chunk and East Mauch Chunk should unite under the name Jim Thorpe. On May 18, 1954, a referendum was put before the voters. It passed by a margin of 10 to 1. By bringing the rival towns together, Joe Boyle had realized not only his own dream, but that of his publisher father, the late James Boyle.

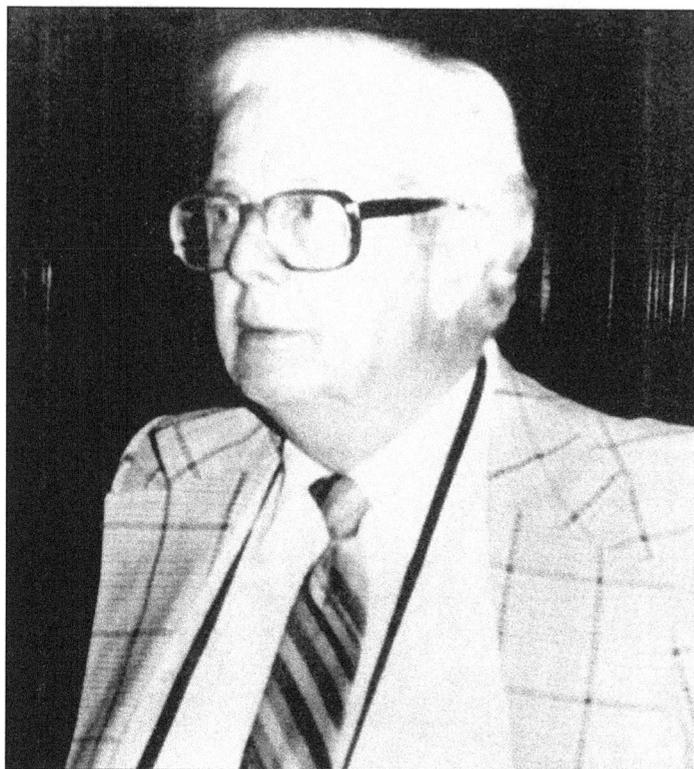

Joseph Lawrence Boyle (1915–1992), journalist, publisher of the *Mauch Chunk Daily Times* and civic leader, played a major role in changing the name of Mauch Chunk, Pennsylvania, to Jim Thorpe. (Courtesy of Rita Boyle.)

Joe Boyle's efforts to jumpstart Mauch Chunk's economy through the nickel-a-week fund (emblem shown here) precipitated a stranger-than-fiction sequence of events. Patricia Thorpe, widow of Olympic athlete Jim Thorpe, disinterred her husband's body and brought it to Mauch Chunk for burial in exchange for the town assuming his name.

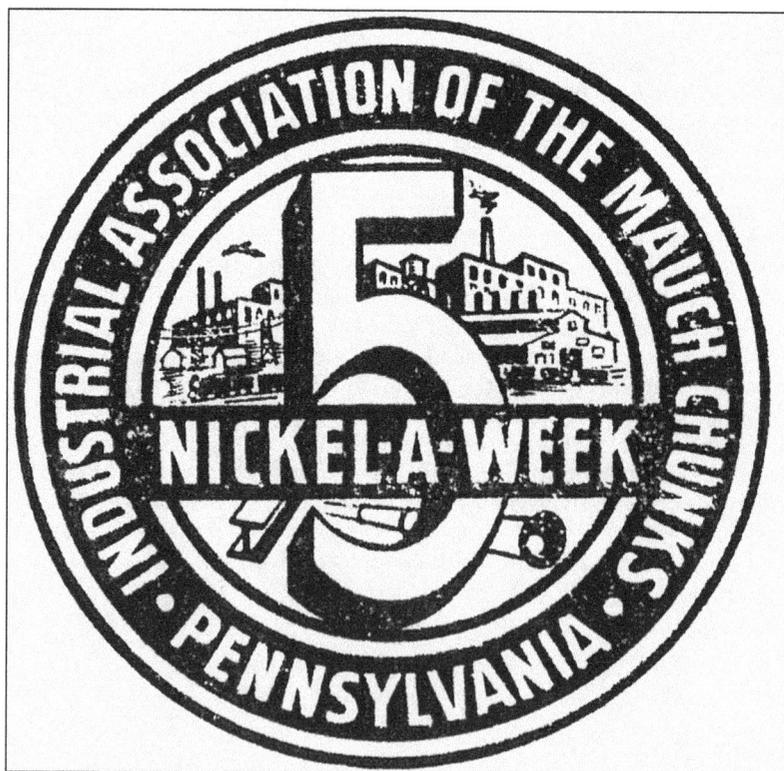

INDUSTRIAL ASSOCIATION OF THE MAUCH CHUNKS

5

NICKEL·A·WEEK

· PENNSYLVANIA ·

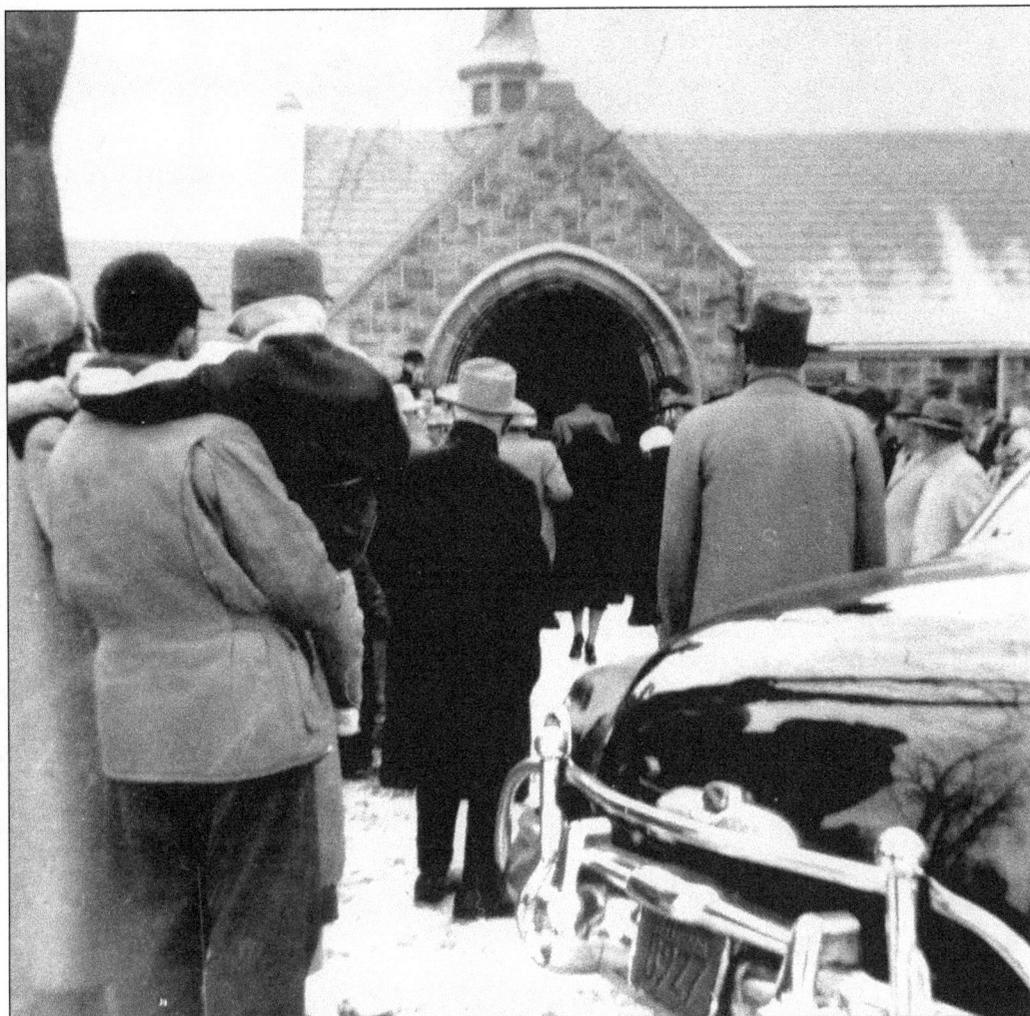

On February 8, 1954, three months before Mauch Chunkers would vote on Patricia Thorpe's proposal, Jim Thorpe's body arrived. Schools closed for the day as the hearse and a cortege of 30 cars and veterans' groups made their way to the chapel in Evergreen Cemetery. Townspeople, many uncertain about which way they would vote, watched respectfully as the coffin was placed in a temporary crypt. As pallbearers staggered under the weight of the casket, one remarked that it must be filled with rocks, whereupon rumor spread that the town had been duped. To squelch the rumor, Joe Boyle and two morticians opened the lid. After removing a plastic bag from the corpse's head, Joe declared, "There's no doubt it is Jim!" (Courtesy of Thomas Potter.)

Signs appeared through the town encouraging citizens to vote. On May 15, 1954, 2,203 people voted in favor of the name change, while 199 voted against it. (Courtesy of the *Mauch Chunk Times-News*.)

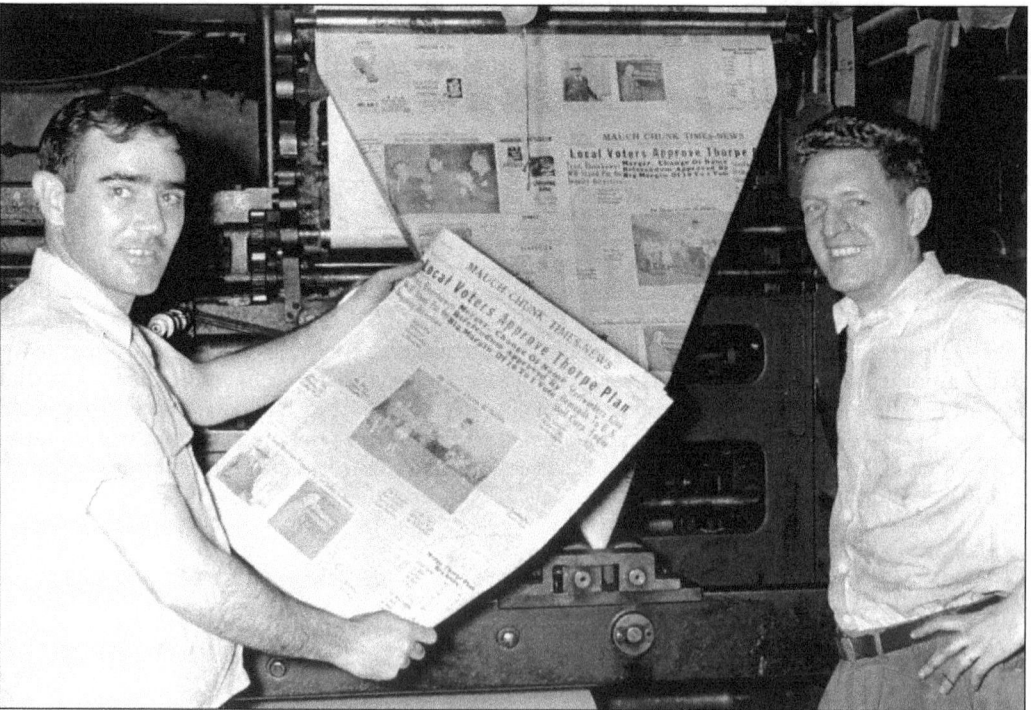

Banner headlines in the *Times-News* state, "Local Voters Approve Thorpe Plan." (Courtesy of the *Mauch Chunk Times-News*.)

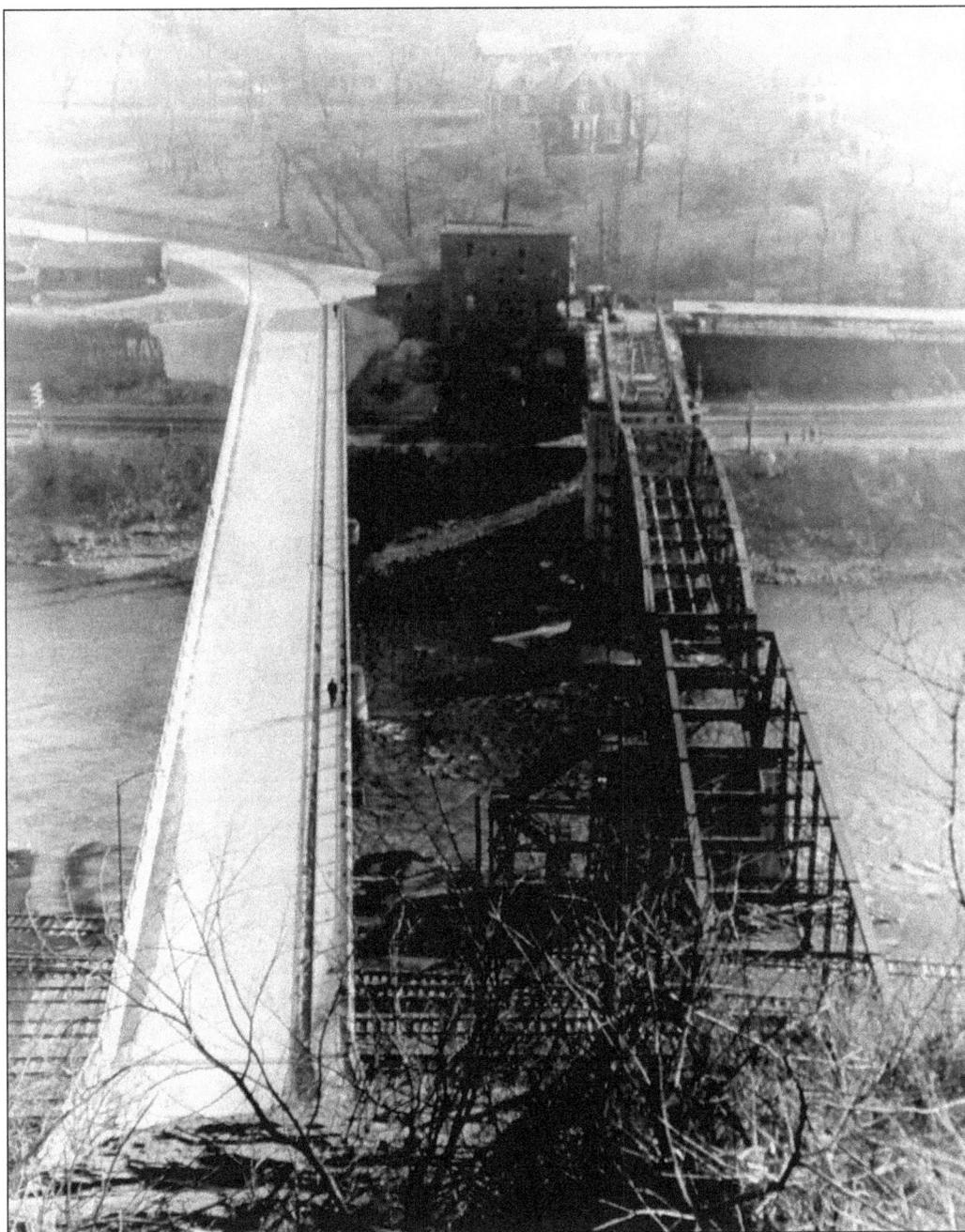

In this unique and symbolic photograph, old and new bridges link the rival towns on both sides of the Lehigh River. The new bridge, erected by Pine Brook Iron Works of Scranton at a cost of $528,000, opened on November 10, 1951, three years before Mauch Chunk would become Jim Thorpe. The tape was cut by chief burgesses Sam Miller and John Mason. The first motorists across the bridge were Mauch Chunk Council president G. Cleve Beers and East Mauch Chunk attorney Frank X. York. The old bridge, a narrow iron span surfaced with wood planking, was torn down shortly after the new bridge opened. (Courtesy of Ray Mulligan.)

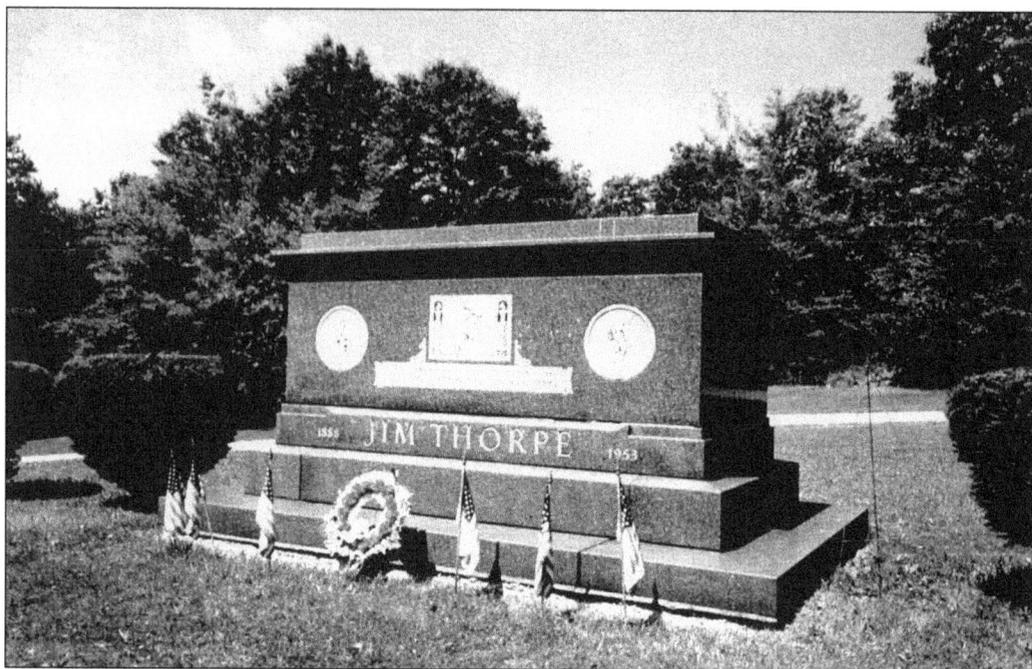

After the name change vote, it would be three more years before Jim Thorpe was finally laid to rest in the red granite mausoleum, paid for by Mauch Chunk nickels, on Route 903 in East Jim Thorpe.

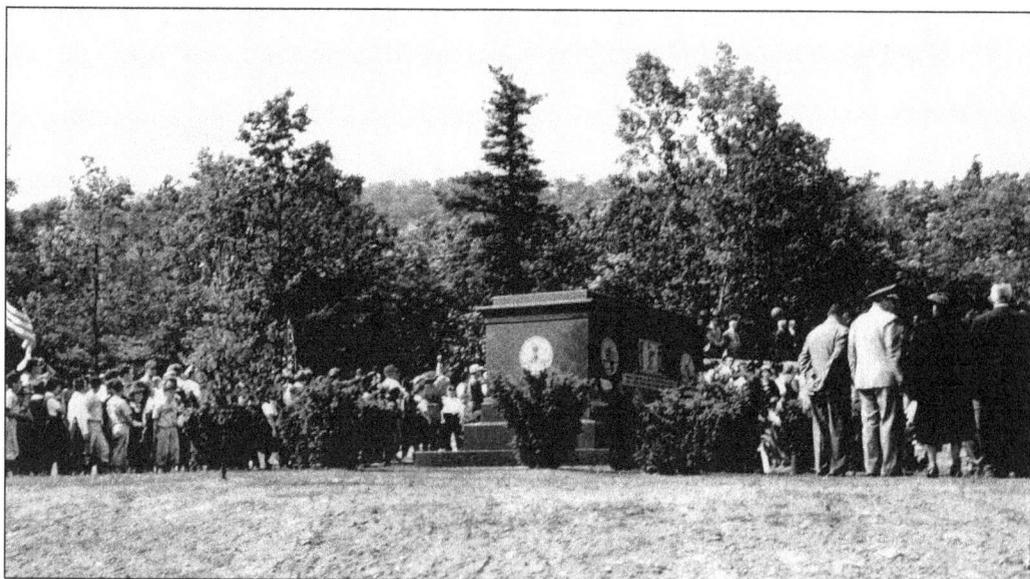

On May 28, 1957, over 2,000 people paraded to the monument to celebrate its dedication. There were schoolchildren dressed as Native Americans, decorated floats, marching bands, and convertibles carrying officials. Mindful of his football days playing for West Point against Jim Thorpe and the Carlisle Indians, Pres. Dwight D. Eisenhower sent a color guard. (Courtesy of Laura Thomas.)

Patricia Thorpe (center) attends the ceremony with Joe Boyle (right) as Jim Thorpe is laid to rest for the third time. The woman on the left is thought to be Grace Thorpe. Not in attendance are Jim Thorpe's sons, who believed their stepmother had sold their father's body as a tourist attraction.

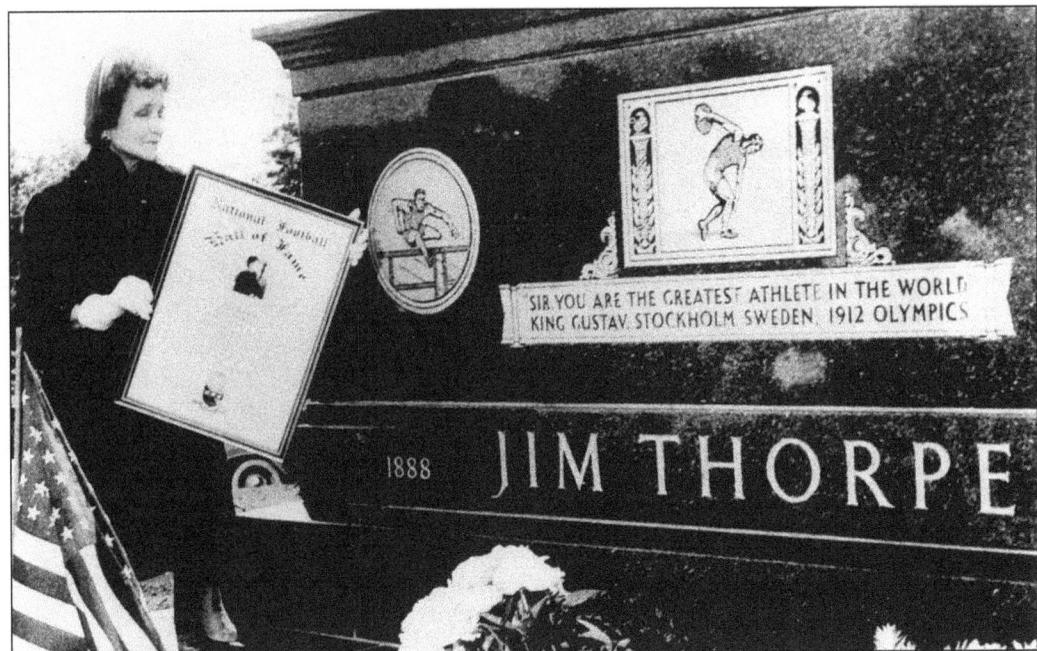

Patricia Thorpe receives a plaque at the monument. Expressing her gratitude to the citizens of Jim Thorpe, she was optimistic. "Great things will come to pass in the aftermath of this magnificent tribute to my husband." But only time would reveal that.

71

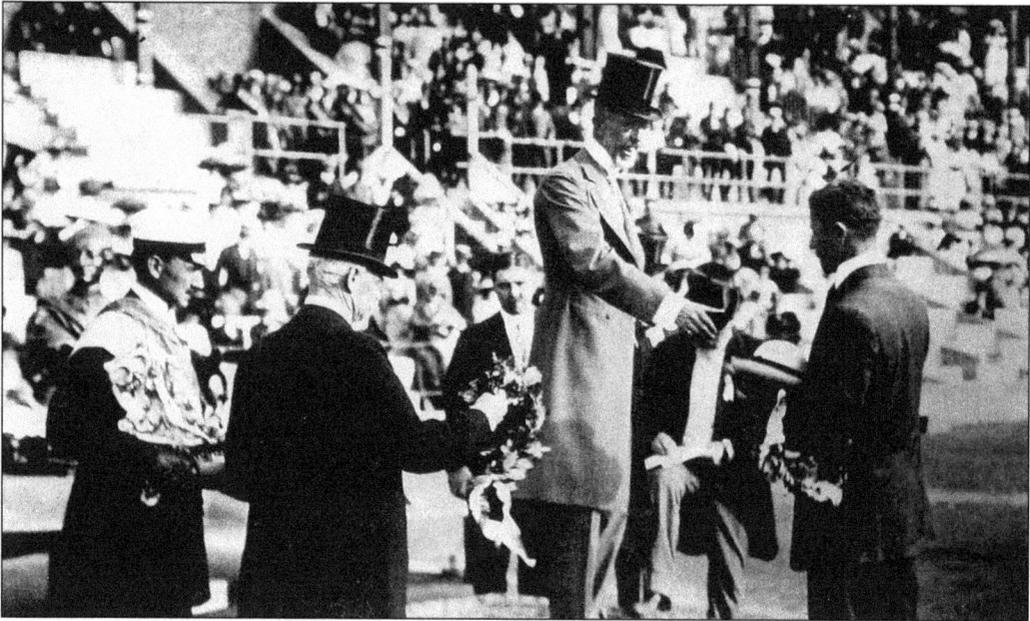

Who is Jim Thorpe? Though Mauch Chunkers may have asked themselves that question before the name change vote, afterward they knew the answer. Winner of the pentathlon and decathlon—a feat that has never been duplicated—Jim Thorpe was proclaimed "the greatest athlete in the world" by King Gustav of Sweden as he accepted his gold medals at the 1912 Stockholm Olympics.

This Swedish cartoon presents a complimentary view of the athlete but a skewed view of his life on the Sac and Fox Reservation in Keokuk Falls, Oklahoma. (Courtesy of Lars Wass, the Swedish Association for Promotion of Sports.)

As the sun blazed a golden path to her door while she was giving birth on May 22, 1887, Charlotte Thorpe named one of her twin sons Wathohuck (Bright Path). Traumatized by the early deaths of his twin brother and mother, Wathohuck, better known as Jim Thorpe, had an unsettled childhood. After running away from home, he was sent to the Carlisle Indian School in Pennsylvania to learn a trade. Under "Pop" Warner's coaching, he became the school's star football player and an Olympic hero of such proportions that the 1912 Fifth Olympiad in Stockholm became known as "the Olympics of Jim Thorpe." But his heroic status was not to last. On January 28, 1913, a *New York Times* headline screamed, "Olympic Prize Lost: Thorpe No Amateur." Jim Thorpe had broken Olympic rules by playing minor-league baseball while at Carlisle. With his records stricken, his gold medals were awarded to Ferdinand Bie of Norway, pentathlon runner-up, and Hugo Weislander of Sweden, decathlon runner-up. Though drinking heavily, Jim Thorpe continued his athletic career until 1929, playing for eight professional football teams and the New York Giants baseball team.

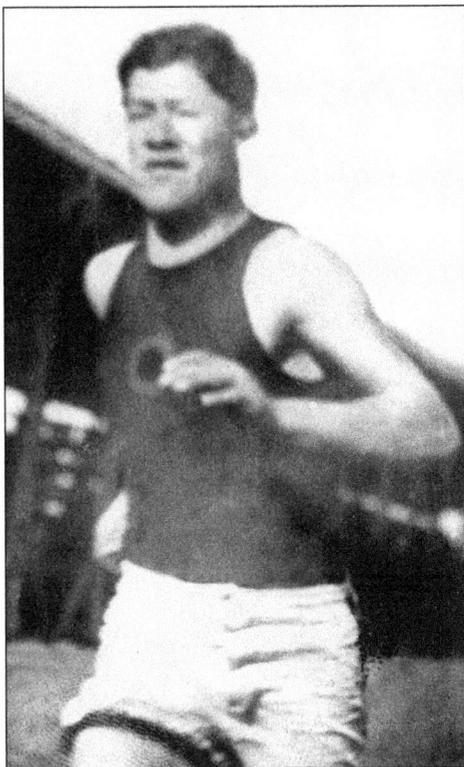

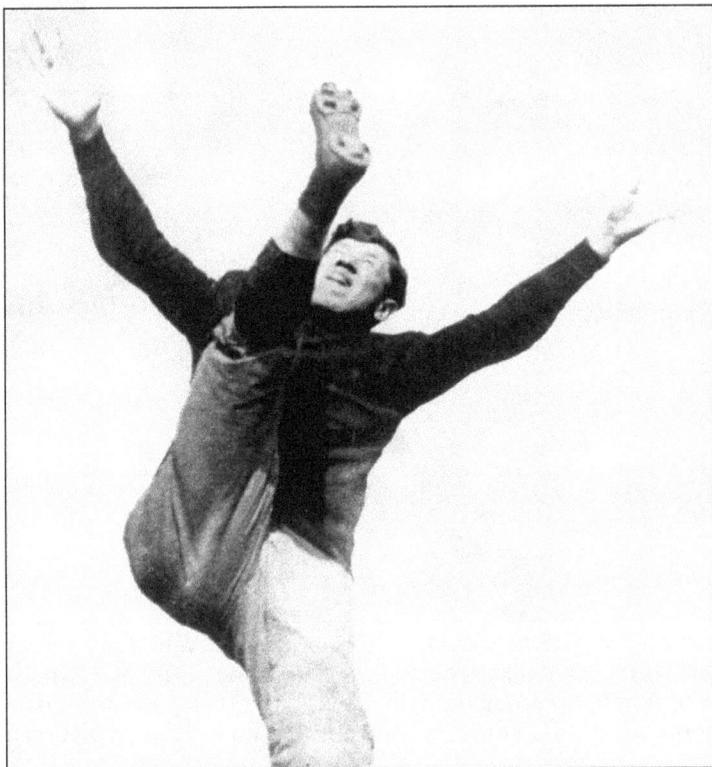

Dwight D. Eisenhower was quoted as saying, "On the football field, there was no one like him."

73

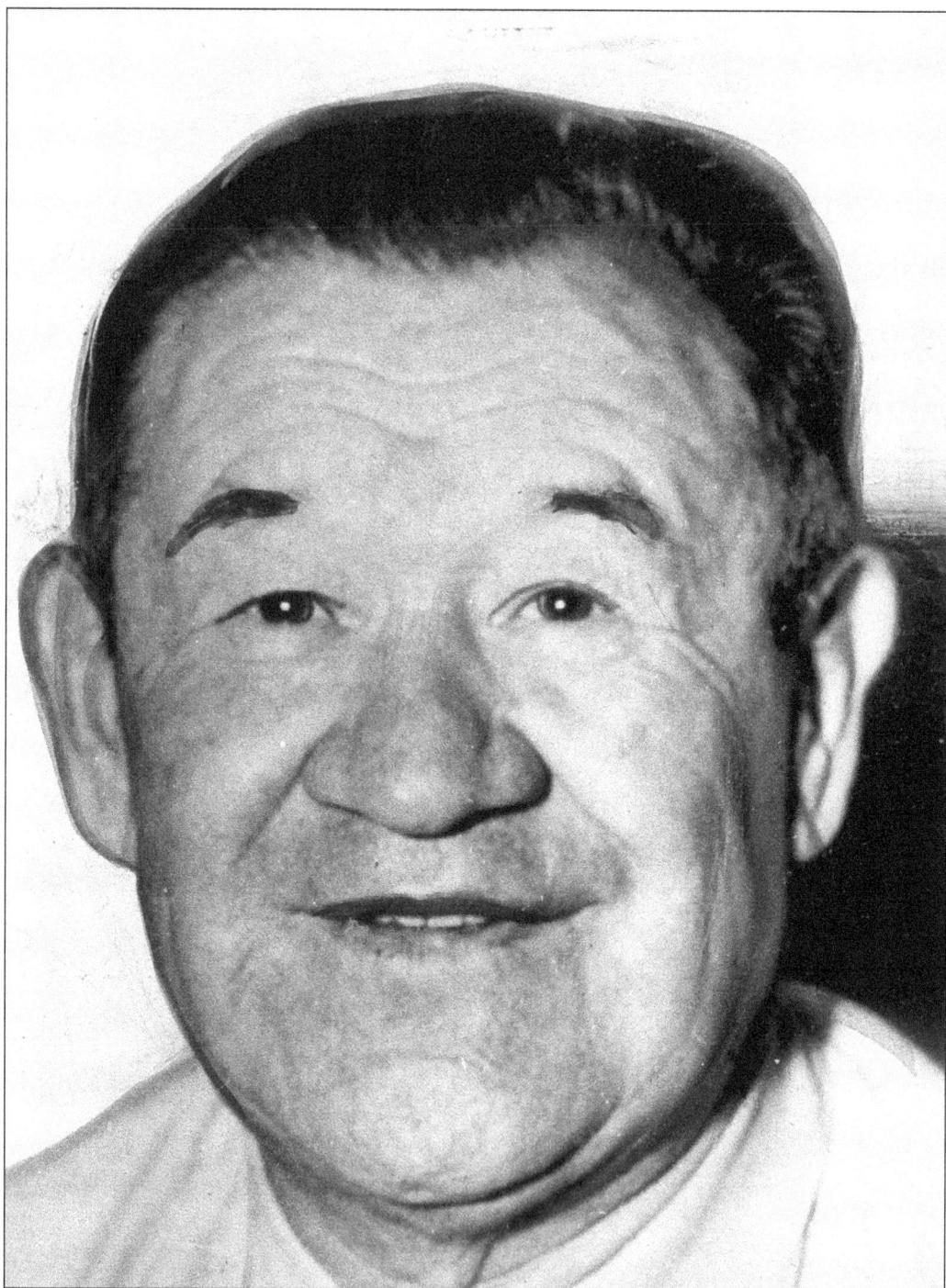

After his retirement from athletics, Jim Thorpe went from job to job. When he passed away on March 28, 1953, in California, he was broke. After years of battling with the Olympic authorities, his gold medals were restored posthumously in 1982. This photograph was taken in 1950, three years before Thorpe's death. (Courtesy of the Smithsonian Institution National Anthropological Archives.)

Seven

THE TOWN OF
JIM THORPE

With the enshrinement of Jim Thorpe and the town's change of name, hopes were high for a new beginning. But when the ceremony was over and the excitement died down, the economic situation only worsened. The Lehigh Coal and Navigation Company, the town's economic mainstay since 1818, suspended its mining operations in May 1954. This produced a domino effect on local railroads. Without coal to transport, engineers, train conductors, and operations and maintenance personnel were thrown out of work. From a high of 2,200 workers in the Lehigh Valley Railroad's Packerton Yards in the 19th century, only 17 employees remained when the yards closed for good on March 16, 1973. Passenger service did not fare any better. The Central Railroad of New Jersey ended its local passenger runs in September 1952, followed by the Lehigh Valley Railroad on February 4, 1961. By March 31, 1978—more than 125 years after it had begun operations—the Lehigh Valley Railroad was broke. The Route of the Black Diamond was history.

In 1979, a study was commissioned by the Carbon County Planning Commission to enable Jim Thorpe to serve more than one function, give the town a sense of purpose, and renew its vitality and self-sufficiency. Planning consultants Venturi, Rauch, and Scott Brown determined that the town's economic future lay in three areas: historic preservation, outdoor recreation and tourism, and commercial revitalization. The overview of what they observed in their study was bittersweet: "The coal mines, canal and even the railroad, now in decay, seem to form part of the Romantic landscape, even part of the very American wilderness they once stood against. Symbols of human battle against an overwhelming nature now seem to return themselves to nature as Romantic ruins."

It would be these "Romantic ruins" and the "Romantic landscape," not the enshrined body of Jim Thorpe, that would emerge as the key to the town's economic future.

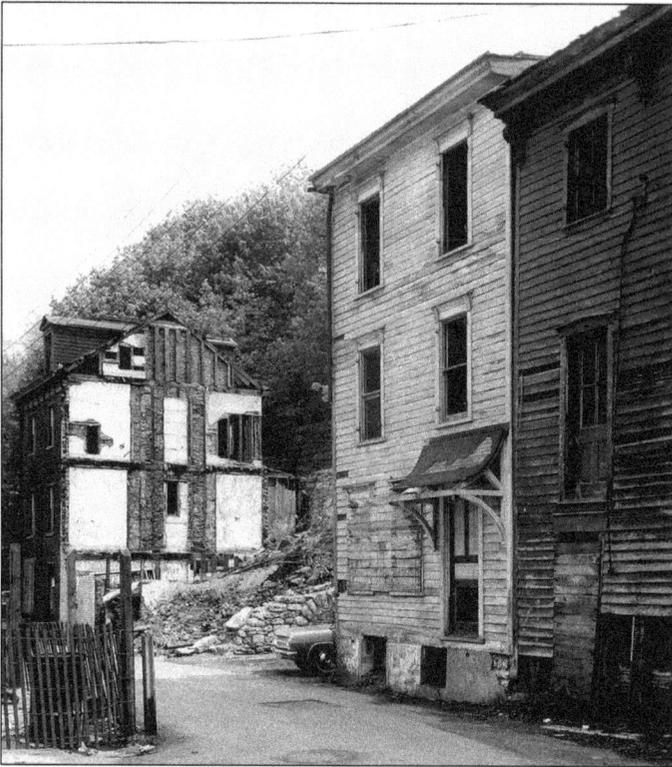

These images of desolation give an idea of the depth to which the town's once-prosperous economy fell. Above, decaying and collapsed houses line a back alley in Jim Thorpe. Below, the former bustling Central Railroad Station is a ghost of its former self. Its platform is deserted and its passenger cars, once packed with excited tourists, stand vacant on weed-grown tracks. It appears ready for the wrecking ball. The 1888 station, however, the pride of the New Jersey Central Railroad, was about to become the center of Jim Thorpe's revived tourist industry.

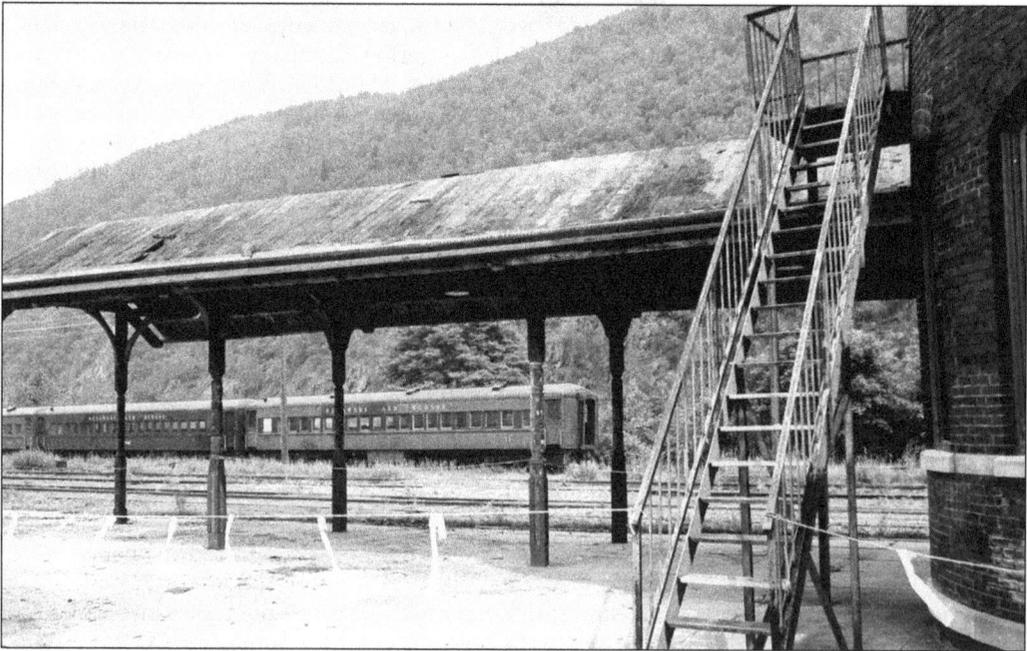

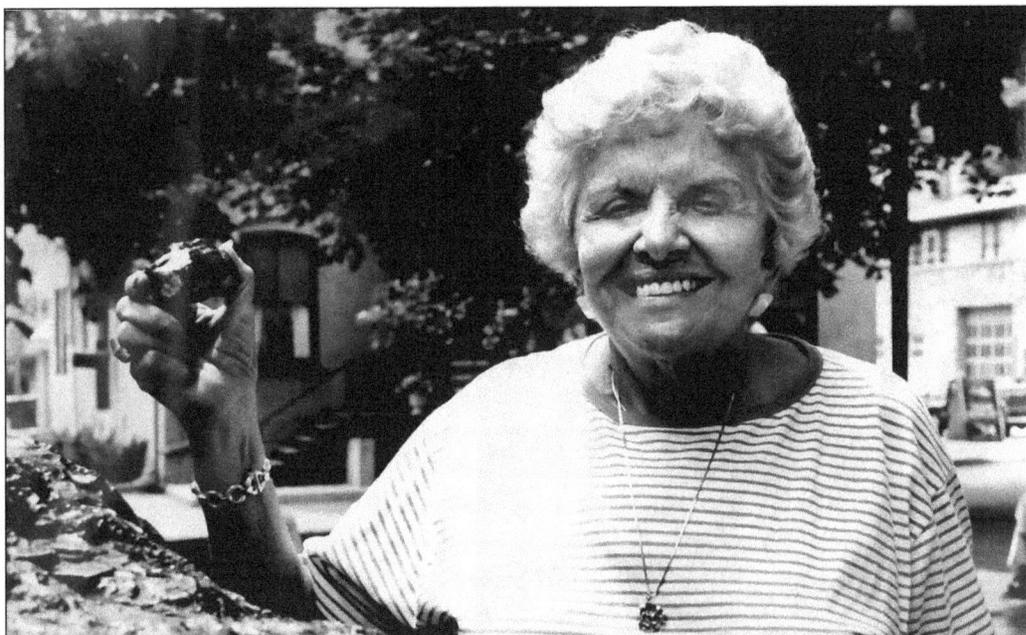

As head of the Carbon Tourist Promotion Agency, Agnes McCartney had the important job of turning Jim Thorpe's economy around. Here she is seen holding a piece of coal symbolizing Carbon County and representing the large block of anthracite in Packer Park, which pays tribute to the enterprise and ingenuity of those who turned a wilderness into a flourishing town.

The Central Railroad of New Jersey station in the heart of Jim Thorpe was renovated and used as Carbon Tourist Promotion headquarters. (Courtesy of Agnes McCartney.)

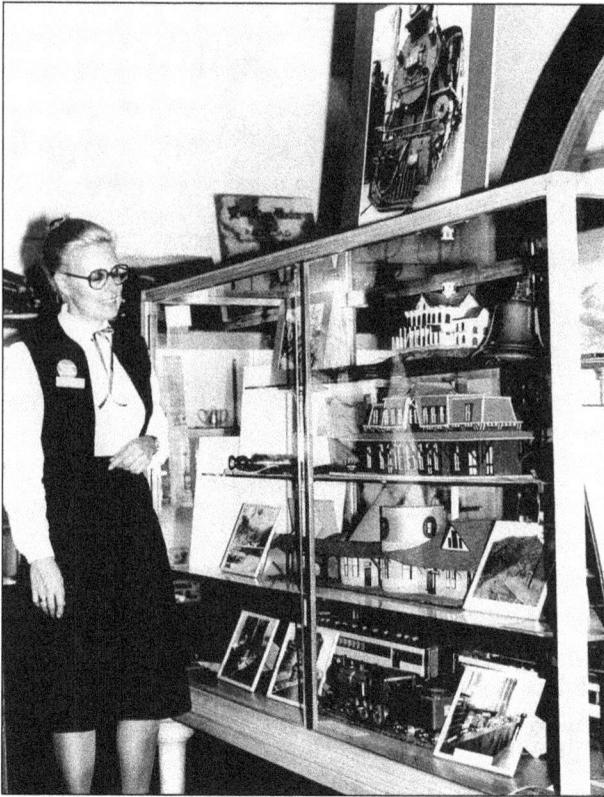

The railroad station was the center of activities. While a museum was set up on the inside, outside, on weekends, anything and everything was going on that would bring tourists back to the impoverished town. (Courtesy of Agnes McCartney.)

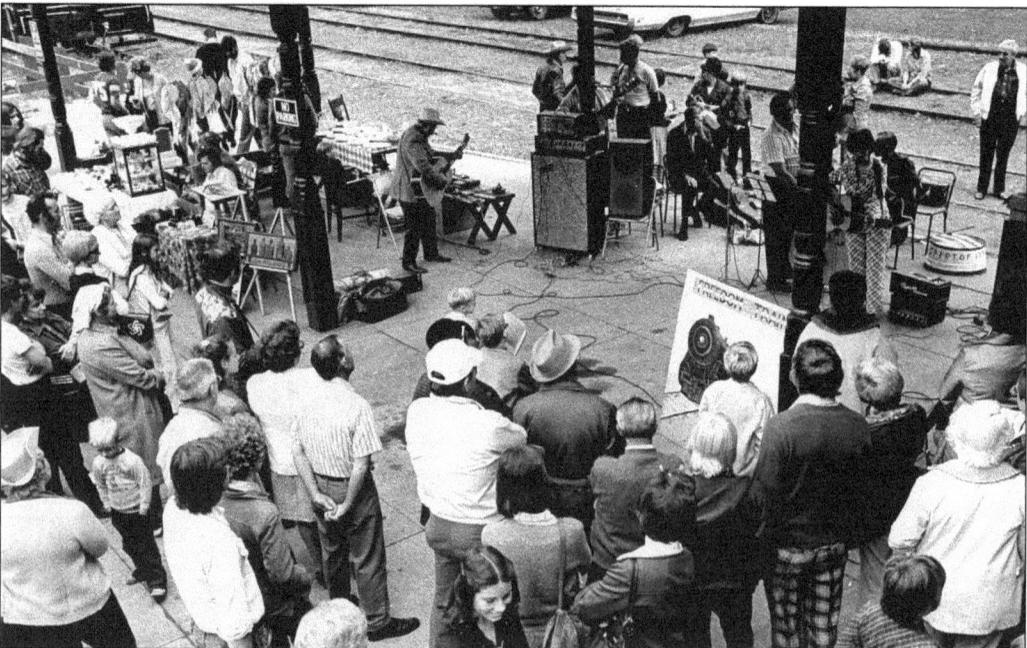

These promotions included food vendors and flea market specials—even a strolling musician playing a guitar. (Courtesy of Agnes McCartney.)

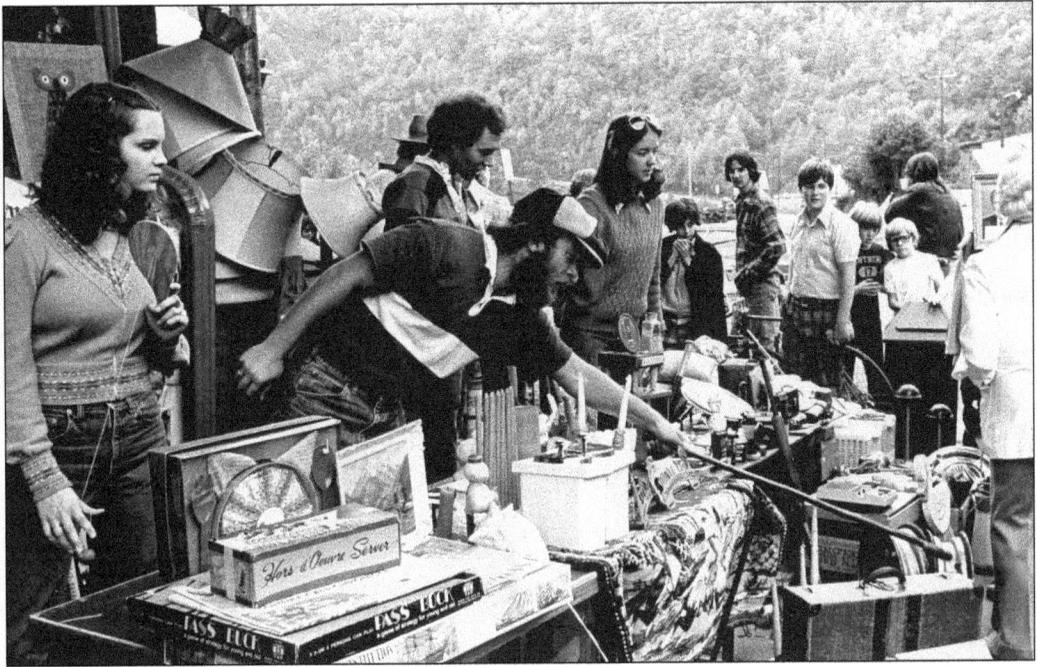

Residents of the hard-up town were eager to sell whatever they could manage to do without. (Courtesy of Agnes McCartney.)

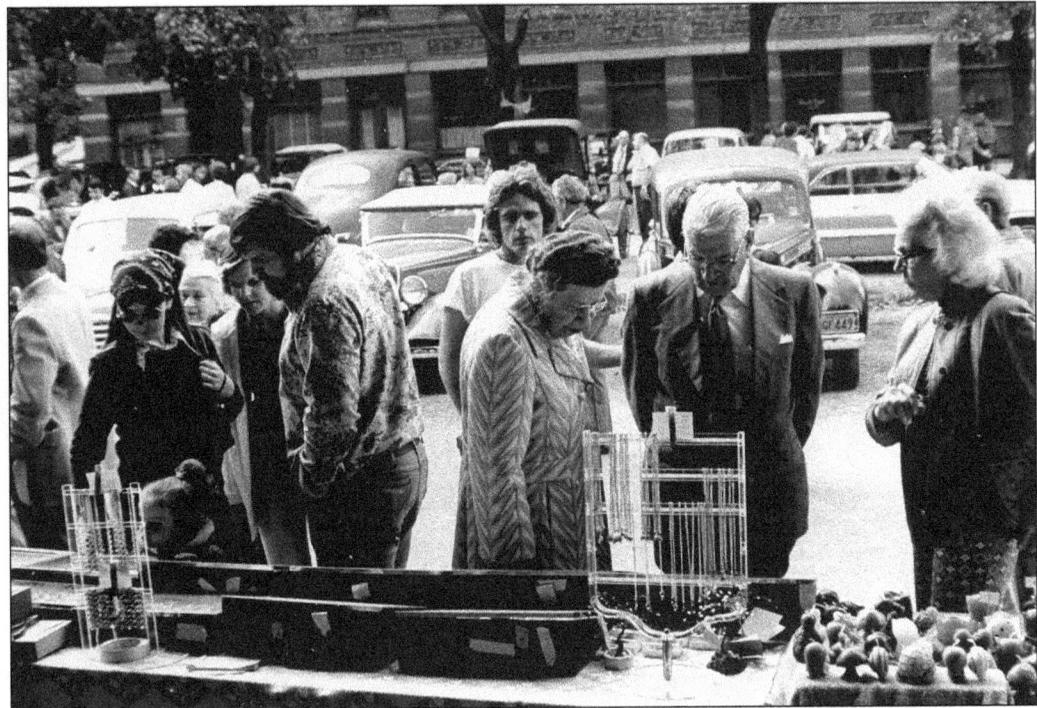

With one man's trash being another man's treasure, buyers were out looking for a bargain. (Courtesy of Agnes McCartney.)

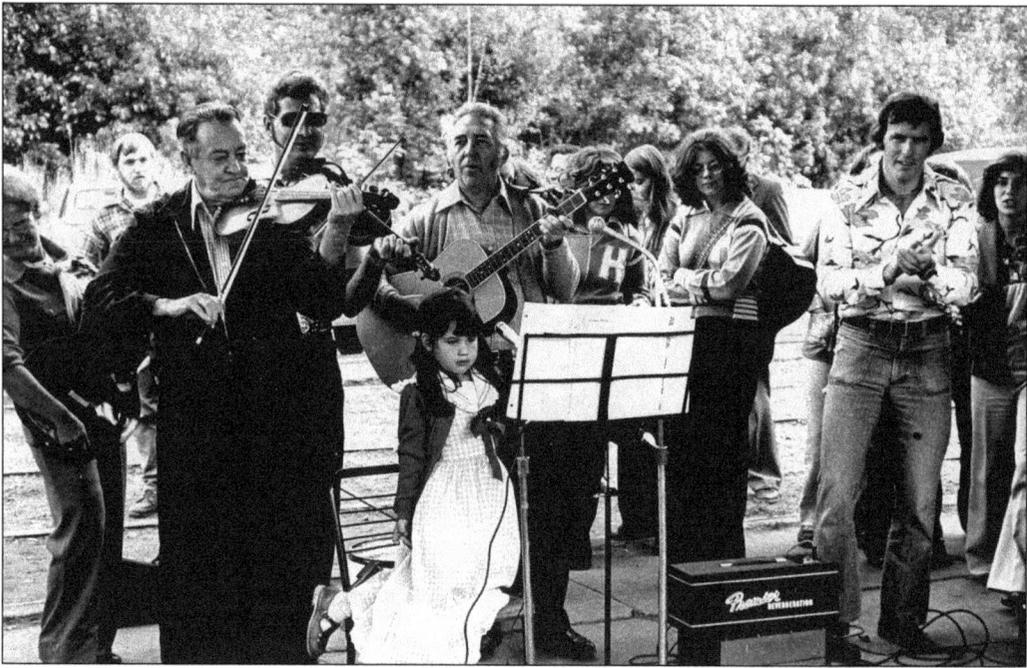

Country music groups performed on the long station platform. (Courtesy of Agnes McCartney.)

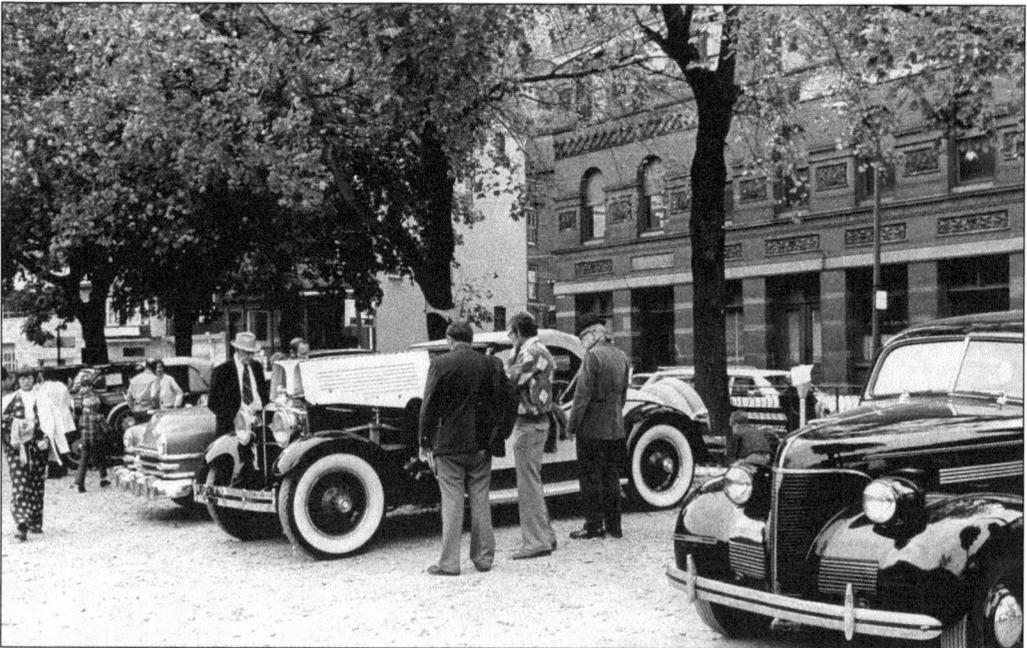

Antique car shows lured tourists to Packer Park in front of the station. The Lehigh Coal and Navigation building on Susquehanna Street appears in the background. (Courtesy of Agnes McCartney.)

While some people drooled over antique cars, others preferred a horse-and-carriage ride through town. In this photograph, the railroad station is behind the times. Its sign has not yet been changed to reflect the town's new name. (Courtesy of Agnes McCartney.)

Parallel to Broadway, Race Street, a terrace of homes built by Asa Packer for his workers, was enjoying a revival of its own. Newcomers were starting to buy the old stone houses and turn them into gift, art, and antique shops. (Courtesy of Agnes McCartney.)

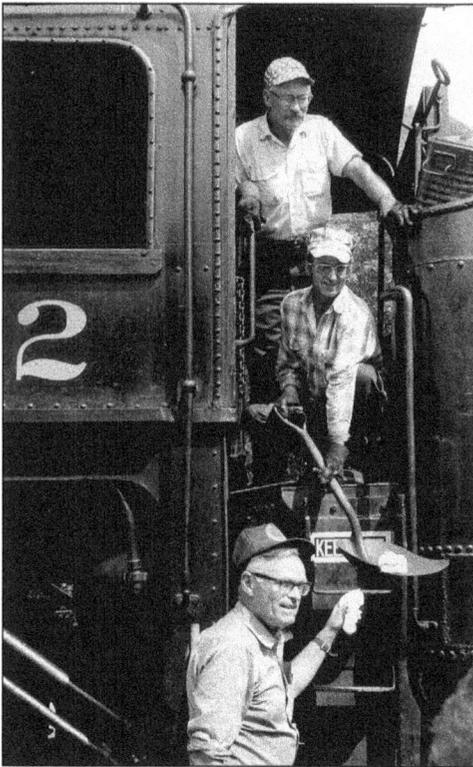

The Jersey Central station was the hub of tourist promotion activities—but what is a restored railroad station without a train? On Labor Day, 1971, George "Mr. Railroad" Hart, president of the Railroad Museum of Pennsylvania in Strasburg, arrived in Jim Thorpe ready to begin Rail Tours Incorporated. Although it was already fall, he ran three standing-room-only excursions that year. Hart operated Rail Tours until the end of 2004. In 2005, the Reading Blue Mountain and Northern Railroad assumed control. From top to bottom in the above early photograph are the engineer, the fireman, and George Hart. Below, passengers pile into the coaches. (Both courtesy of Agnes McCartney.)

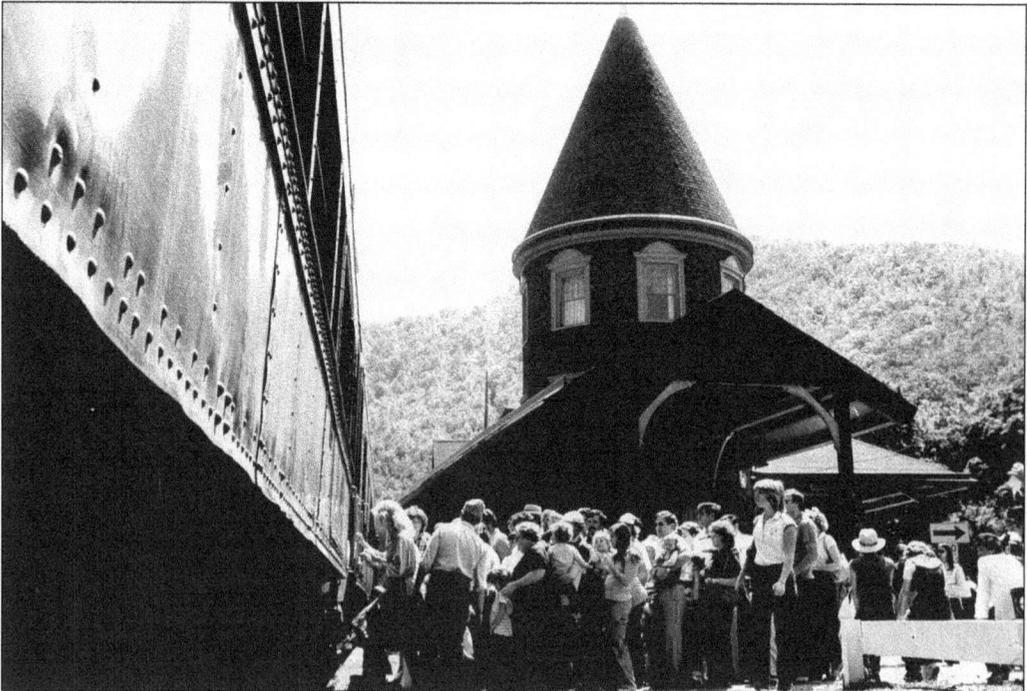

Rail Tours ran special trains to celebrate
Christmas and Easter. Santa rode aboard
the train at Christmas and the Easter
Bunny did the same at Easter. This
youngster searches for colored eggs during
a hunt midway through the train's run.
(Courtesy of Agnes McCartney.)

Beauty pageants brought visitors to town.
Here, the young winners show off their lovely
dresses on the steps of one of George Hart's
railroad cars. (Courtesy of Agnes McCartney.)

While the area's natural beauty remained its greatest asset, easy access to places like Glen Onoko Falls and Flagstaff Mountain was compromised. In 1911, after fire destroyed the Wahnetah Hotel, the wooden bridges and stairways to Glen Onoko's three waterfalls and the summit of Broad Mountain fell into ruin. In the 1970s, the only bridge across the stream was a fallen tree trunk. (Courtesy of Agnes McCartney.)

By the time this photograph was taken, the trolley cars and amusements on Flagstaff were long gone. All that remains here is the dance pavilion known as the Ballroom in the Clouds (background), where Landsford's Dorsey brothers played. Attending the Pocono Mountain Laurel Blossom Festival are, from left to right, Albert Koch, county commissioner; Mrs. Flood, wife of Rep. Daniel Flood; A. Franklin Wehr, the owner of Flagstaff Park; Dr. Karl Gruber, the Austrian ambassador to the United States; Agnes McCartney, the executive director of the Carbon County Tourist Promotion Agency; James Walker, the commissioner of Carbon County; and two unidentified men.

The Bear Mountain Lions (now Jim Thorpe Lions) began sponsoring the Community Nurse Program in 1949. The first community nurse was Marie Ferry (right). Dubbed "an angel of mercy" by grateful Mauch Chunkers, her 22-year tenure took place at a time of great economic need. In 1971, Nurse Ferry's much-appreciated successor was Charlotte S. Kemmerle, RN. (Courtesy of the Jim Thorpe Lions Club.)

Although some doctors left for greener pastures elsewhere, Dr. George Thomas and his wife and office nurse, Laura, remained in town during its time of hardship. In gratitude for their lengthy public service, the townspeople erected a plaque outside their residence on Millionaires' Row. Alluding to the Robert Frost poem, it reads, "They took the road less traveled and it has made all the difference." Laura Thomas was a founding member of the Mauch Chunk Museum.

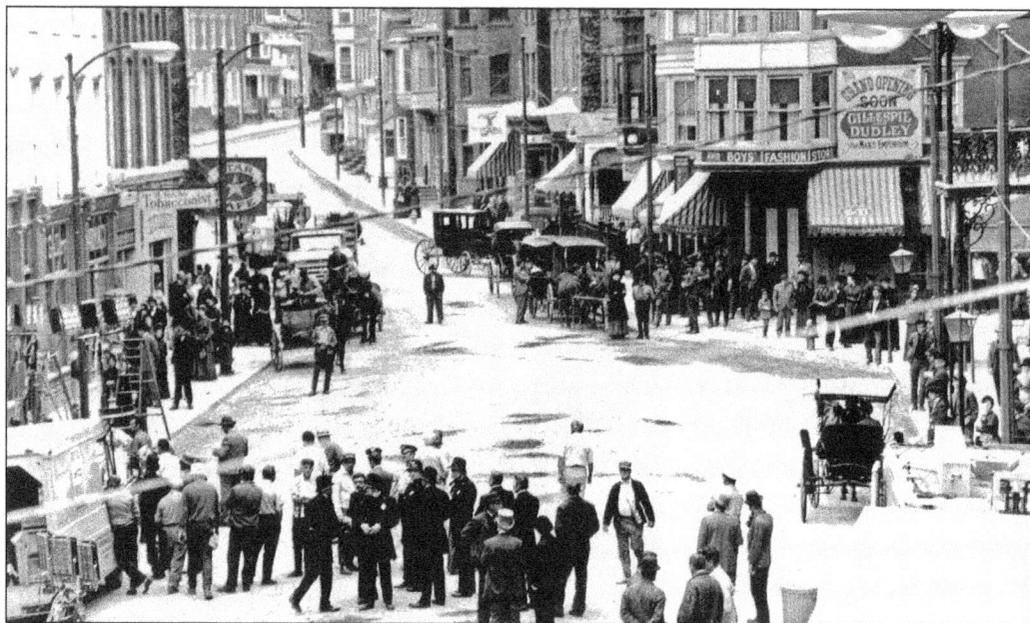

Lights, camera, action! In 1968, a bright spot in the economic gloom occurred when Paramount shot *The Molly Maguires*, starring Sean Connery, Samantha Eggar, and Richard Harris. About 300 townspeople were hired to serve as extras through the Pennsylvania State Employment Service. Carbon County commissioners received $5,000 and the Jim Thorpe Borough Council was given $15,000 for the use of the town as a movie set.

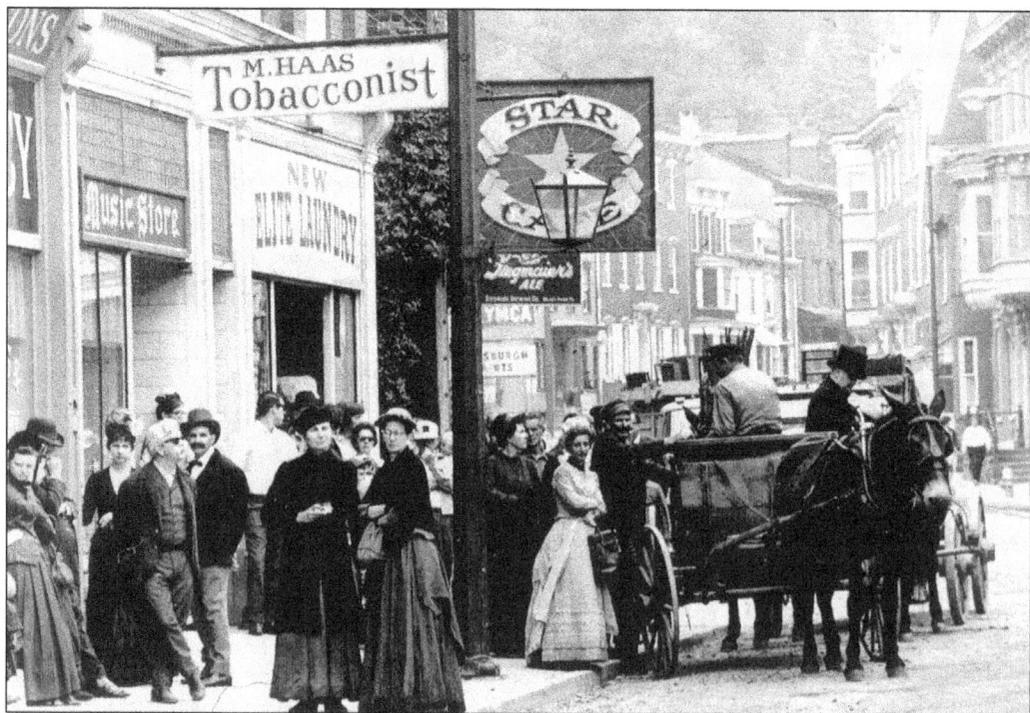

Bygone days return to Jim Thorpe as dirt covers Market Square. Storefronts assume their 1877 appearance, gaslights replace streetlights, and parking meters disappear.

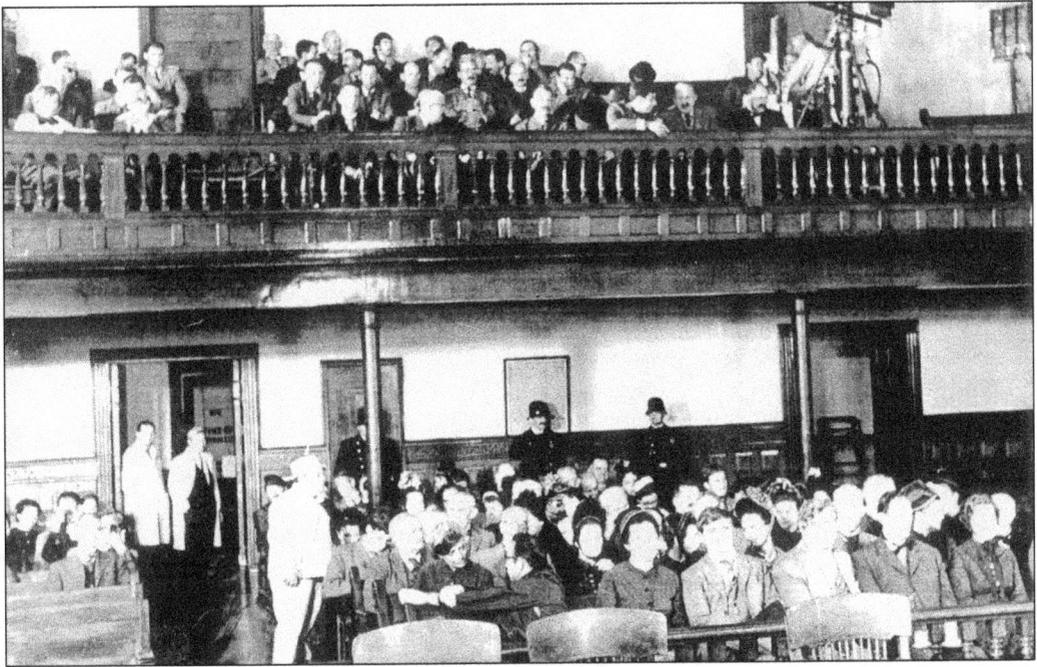

Although the Mollies were tried in an earlier courthouse constructed in 1843, the movie's trial was reenacted in the present courthouse. Here, relatives and townspeople anxiously await the verdict.

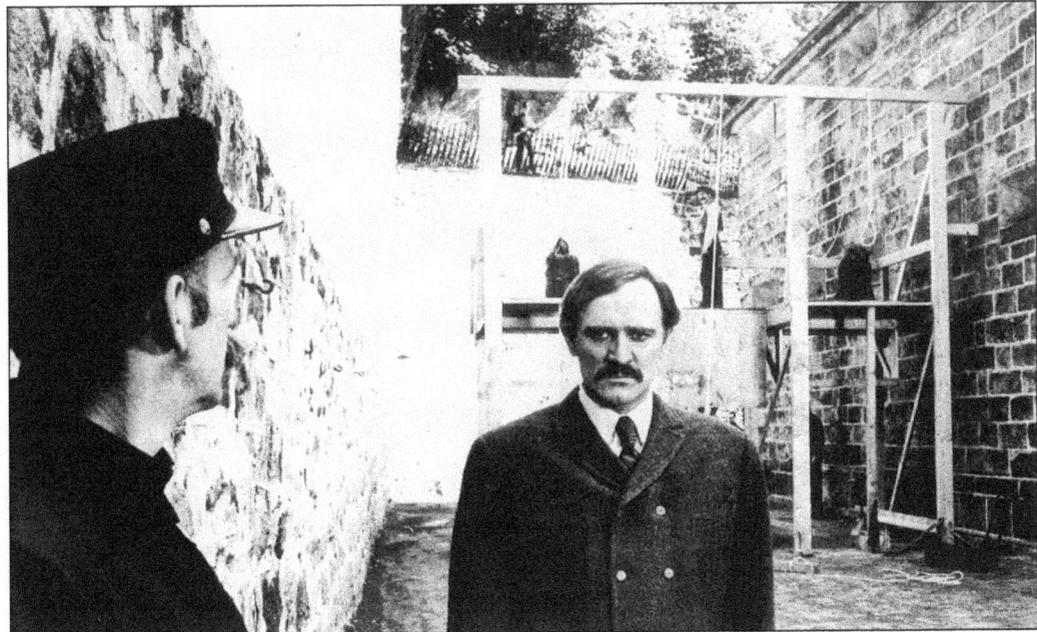

With prisoners still confined inside Carbon County Prison in 1968, the gallows were constructed in the courtyard.

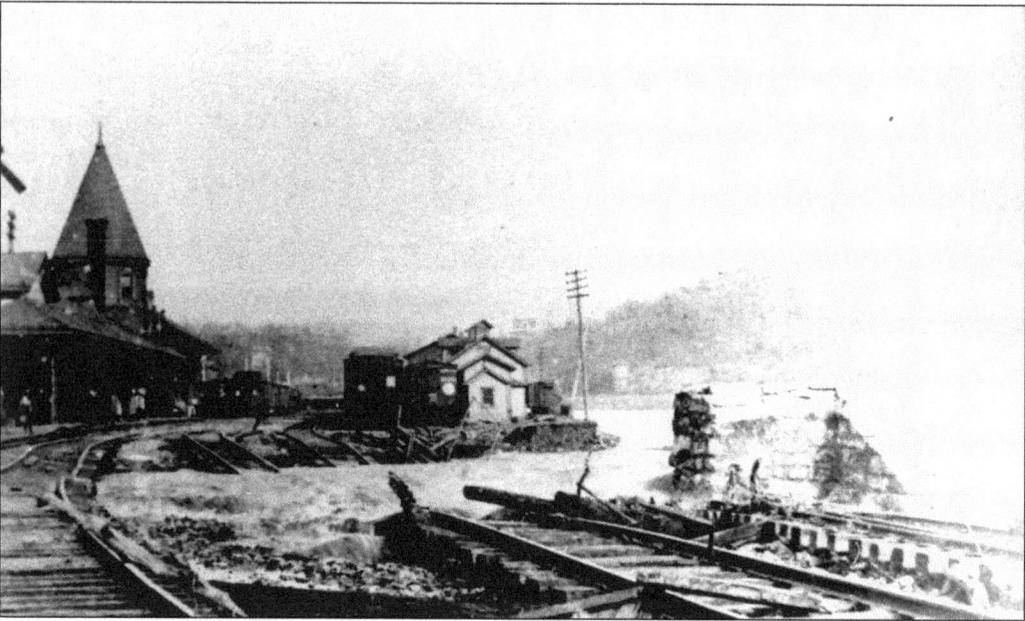

As the newly named town of Jim Thorpe worked hard to resuscitate itself, it was no match for Mother Nature. In 1968, the Mauch Chunk Creek overflowed its culvert and flooded the downtown. Although this flood did not compare to the disastrous flood of 1902 (shown here), when the pedestrian bridge across the Lehigh was swept away, it was indeed time for the state of Pennsylvania and the town to institute new measures of flood control.

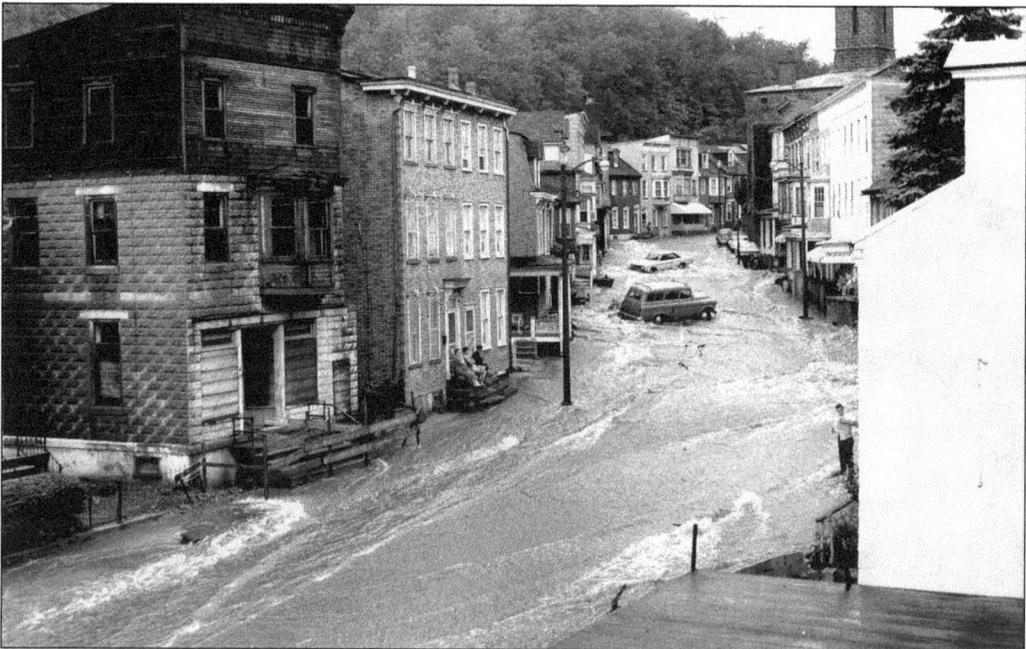

As the volume of water in the Mauch Chunk Creek exceeded the capacity of its underground culvert, water poured down West Broadway, swamping basements and parked cars during the flood of 1968. (Courtesy of Evelyn Norwood.)

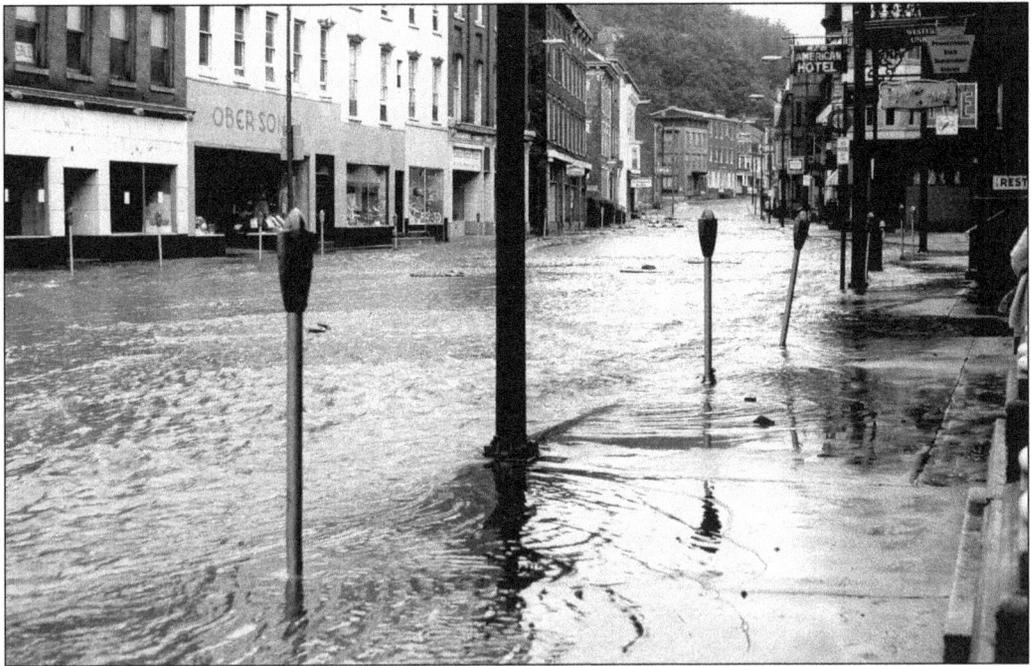

As the overflow raced down Broadway, Market Square became a river. (Courtesy of Evelyn Norwood.)

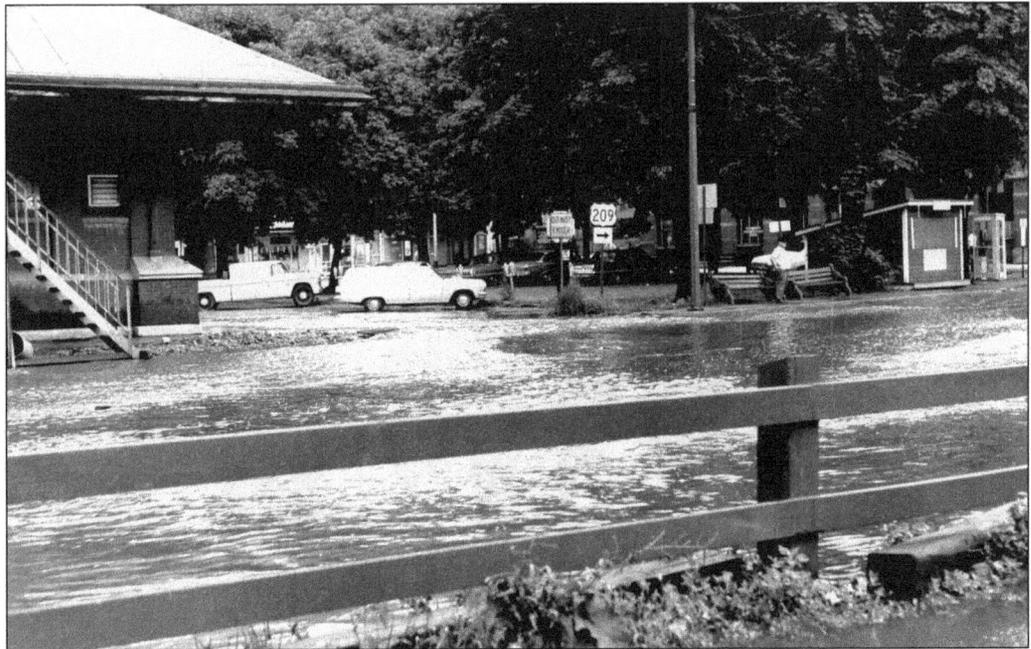

The streets around the Jersey Central station were a lake. (Courtesy of Evelyn Norwood.)

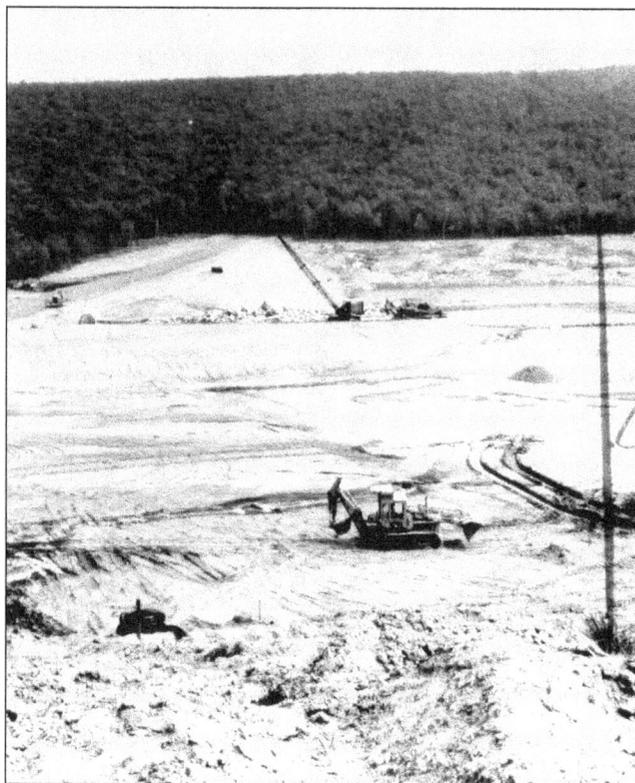

Flood control in Jim Thorpe soon took two forms: the construction of the Francis Walter Dam on the Lehigh River above White Haven and, at the suggestion of local engineer John McGinley, the damming of Mauch Chunk Creek above Jim Thorpe. The Mauch Chunk Creek dam served two purposes. It controlled flooding in Jim Thorpe and resulted in the formation of one of Carbon County's greatest assets, beautiful Mauch Chunk Lake Park.

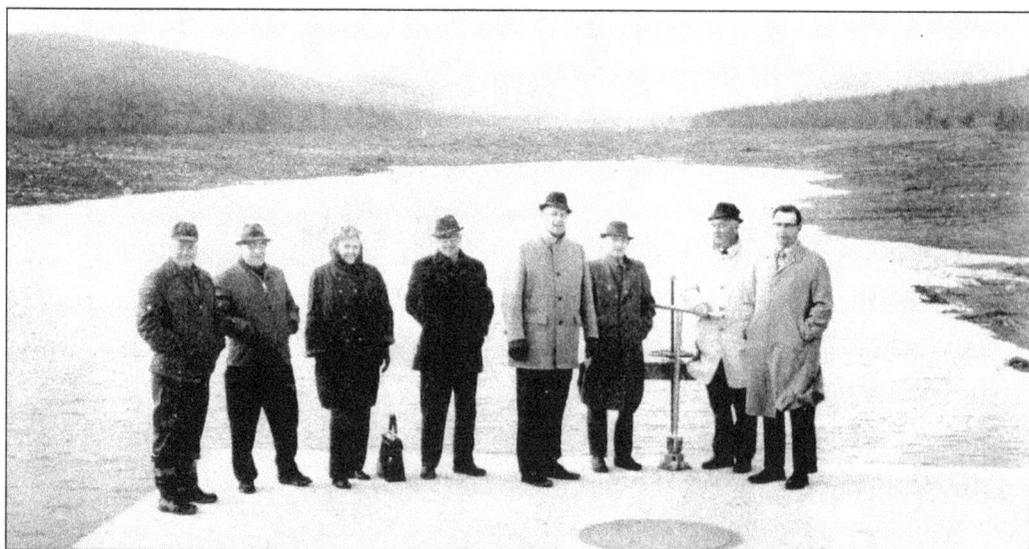

Officials stand atop the completed dam as the Bloomingdale Valley between Jim Thorpe and Summit Hill floods to form the two-and-one-half-mile-long Mauch Chunk Lake.

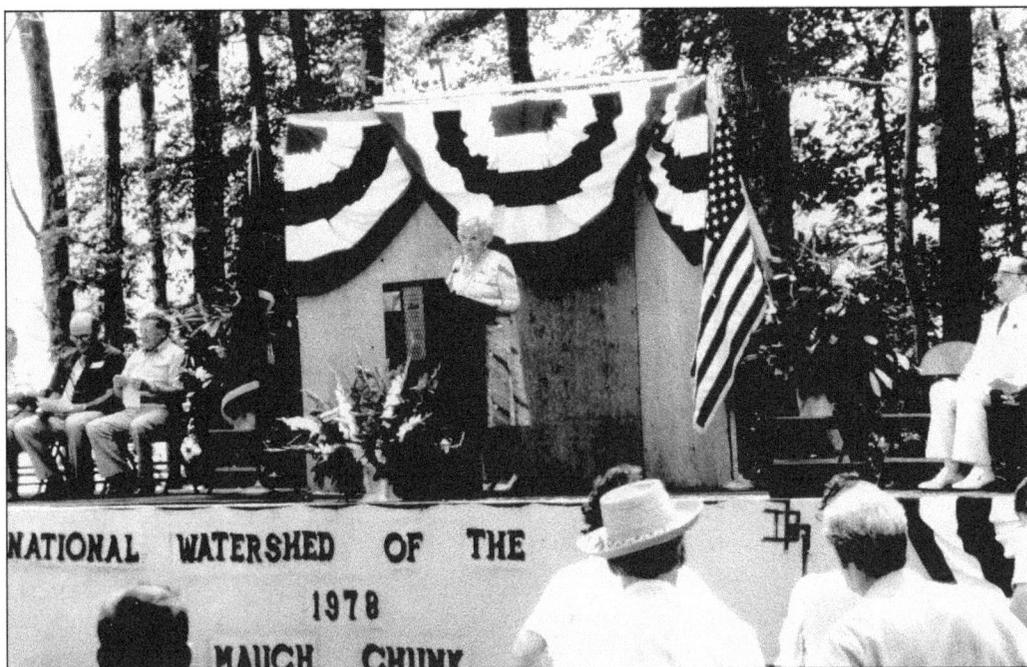
On August 27, 1974, Agnes McCartney, who obtained funding for the project, addressed the crowd at the dedication of Mauch Chunk Lake and Park.

The park's first director, Dennis De Mara, created a recreation area enjoyed by locals and visitors alike. Intersected by the downhill trail of the Switchback Gravity Railroad, the park includes facilities for swimming, boating, and camping.

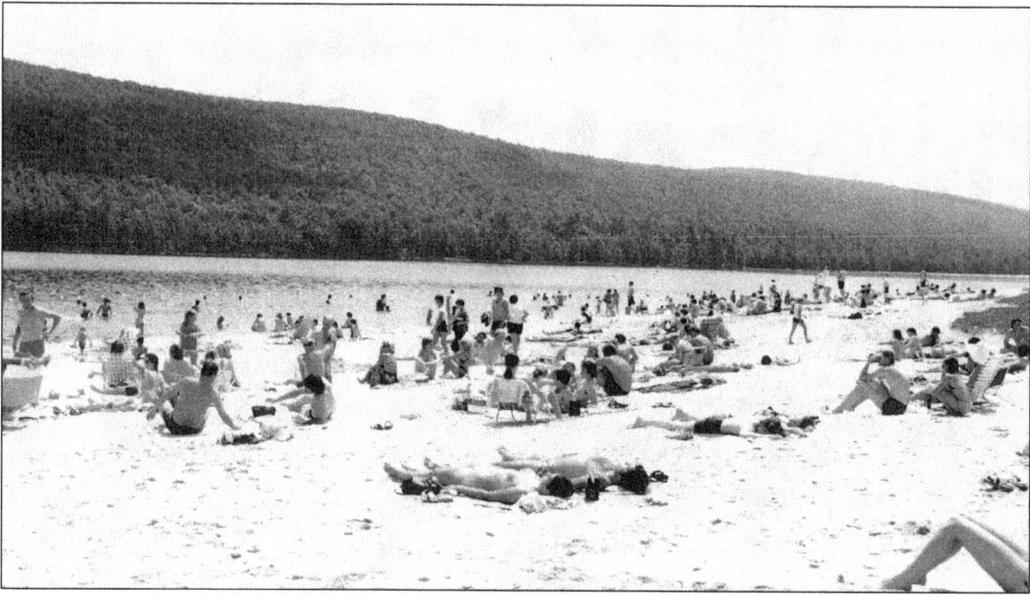

The swimming beach, located between the campgrounds and boat launch, is a popular spot to cool off for local residents and visitors to Mauch Chunk Lake Park. (Courtesy of Dennis De Mara.)

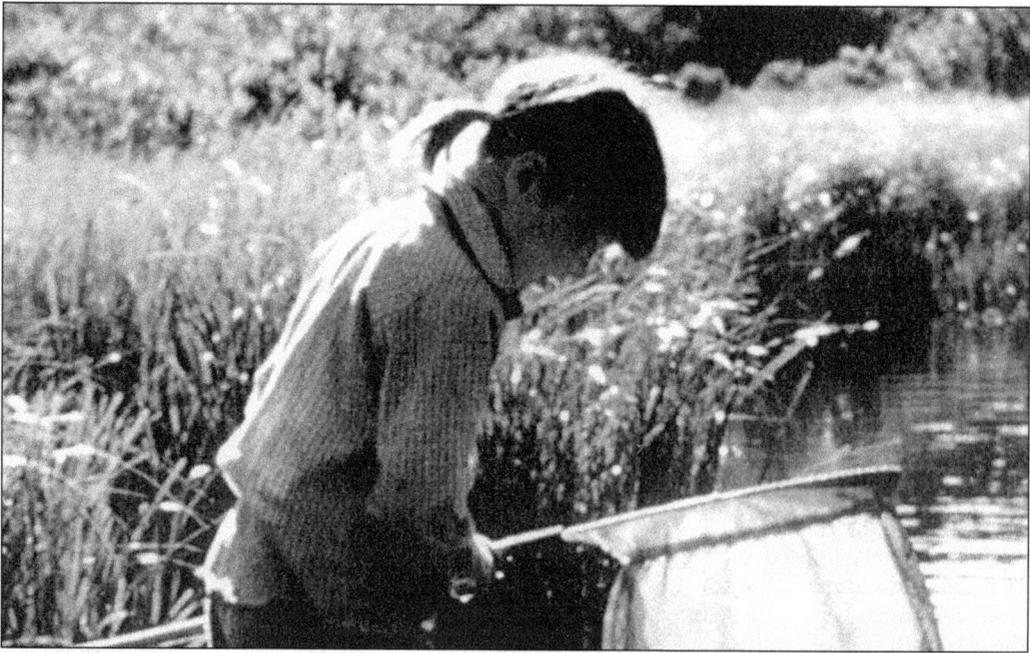

The Carbon County Environmental Center stands at the west end of Mauch Chunk Lake. With its visitors' center, raptor care center, woodland, meadow, and wetland trails, it provides an exciting educational experience for people of all ages. Here, a child examines the contents of her net as she seines in the wetlands. (Courtesy of Dennis De Mara.)

Through the grant-funded Main Street Project, Jim Thorpe's Victorian buildings were given a face lift. In this photograph, Main Street manager Elissa Marsden cuts the ribbon after renovations are completed on the downtown Vathis building. (Courtesy of Agnes McCartney.)

By the time the project ended, Elissa Marsden had taken slides of every building, doorway, window, cornice, balcony, and overhang in Jim Thorpe. Shown here is the doorway of a home on Millionaires' Row, now Victorian Ann's Bed and Breakfast. (Courtesy of Louise Ogilve.)

Restoration progresses at the large brick triple-bay-windowed building at the head of Market Square. Purchased by Tom and Betty Lou McBride, the first-floor store became the site of Jim Thorpe's first new business, the Treasure Shop. (Courtesy of Elissa Marsden.)

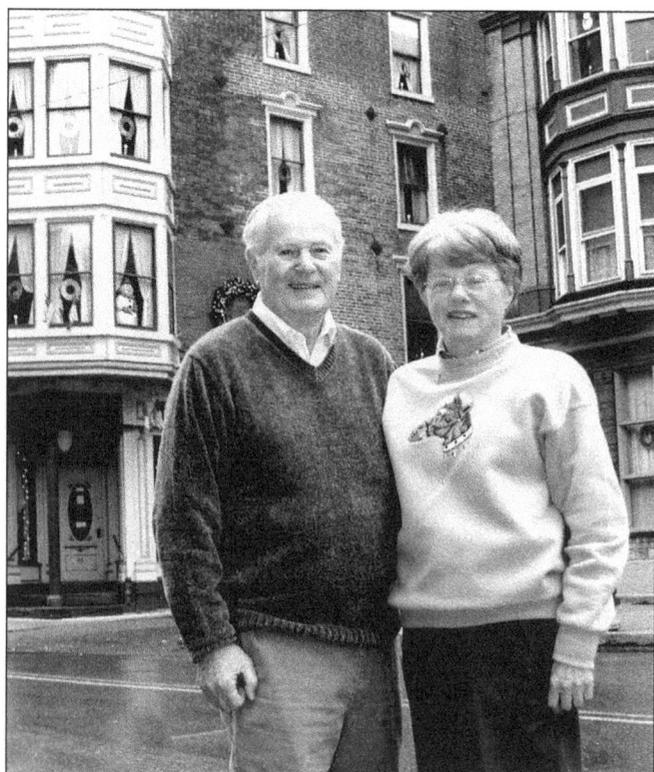

In this recent photograph of the McBrides, they stand in front of the Treasure Shop, its windows decorated for Christmas. (Courtesy of Al Zagofsky.)

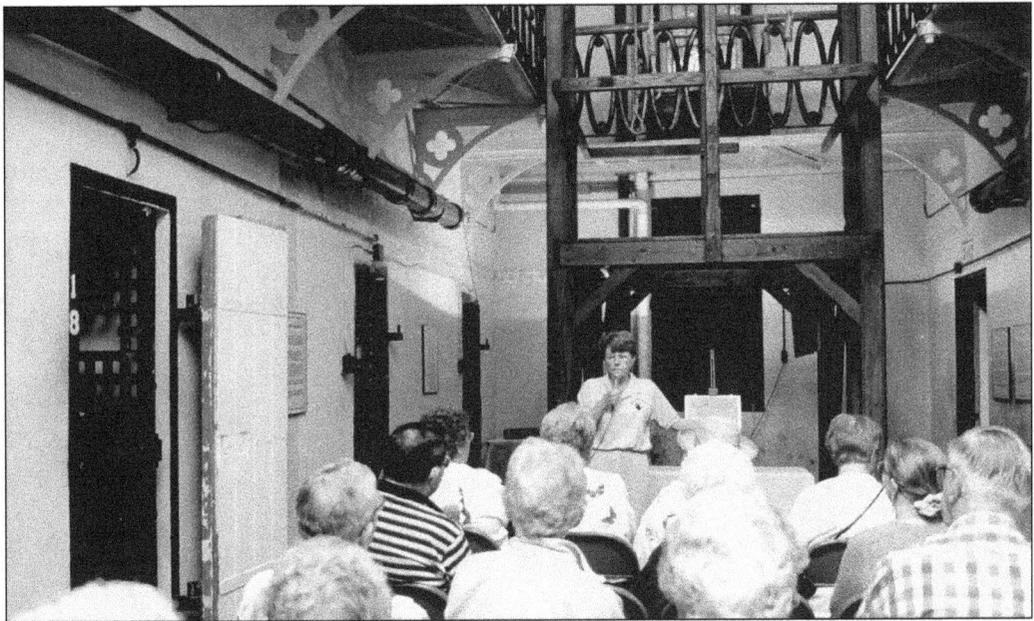

The Treasure Shop, which sells Irish imports, is a success story. When prisoners moved to a new jail, the McBrides bought the old fortress and turned it into a museum. With its two-tier balconied interior looking the same as the day the Molly Maguires were hanged, Betty Lou McBride leads visitors on a voyage of discovery through the cell block, dungeons, and courtyard. (Courtesy of Mary Wohlhaas.)

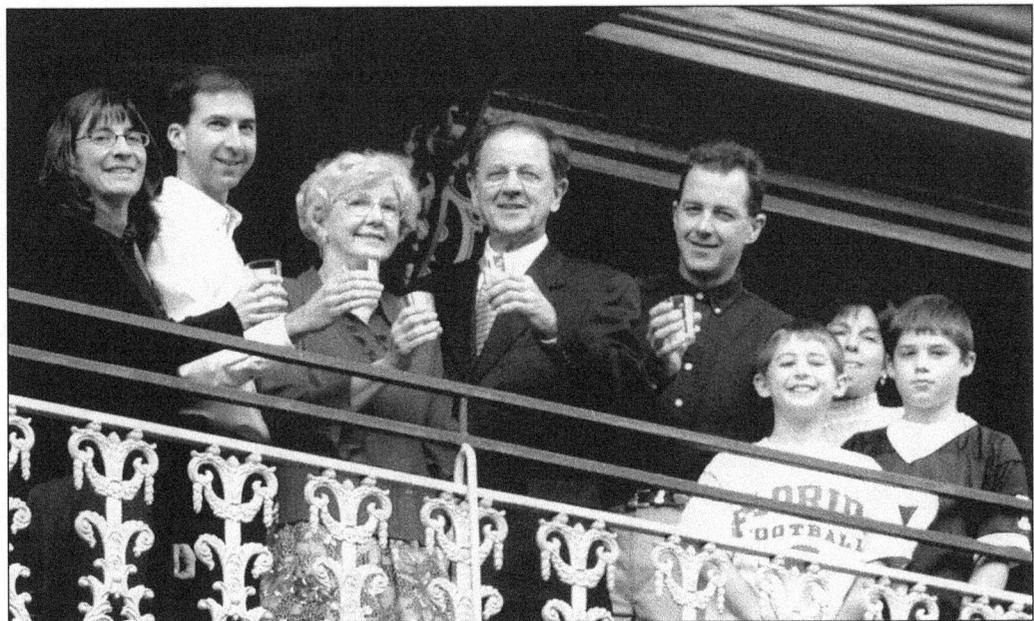

The American Hotel on Market Square, boasting a guest list of past celebrities, had seen better days by the 1980s. Purchased by the Drury family and renamed the Inn at Jim Thorpe, today it retains its 19th-century elegance while offering state-of-the-art facilities. Celebrating the hotel's completion on the balcony are, from left to right, Lisa, Mark, Janet, John, David, Evan, Maryann, and Matthew Drury. (Courtesy of Al Zagofsky.)

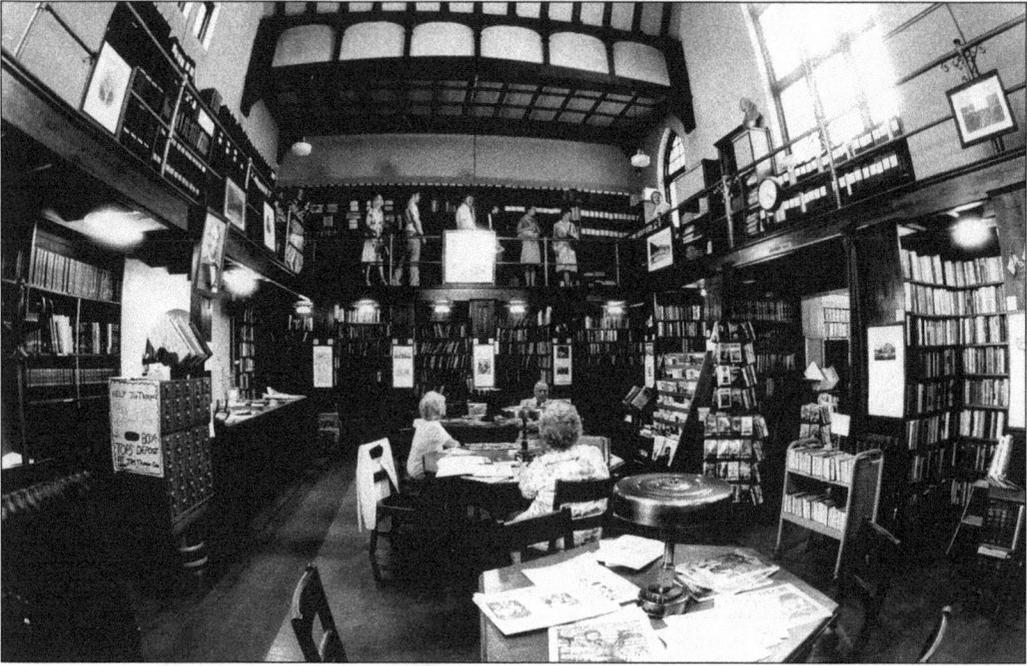

Just as the town was improving its appearance, a fire gutted the interior of the Dimmick Memorial Library on December 13, 1979. The main room of the library is pictured here before the blaze began. (Courtesy of Agnes McCartney.)

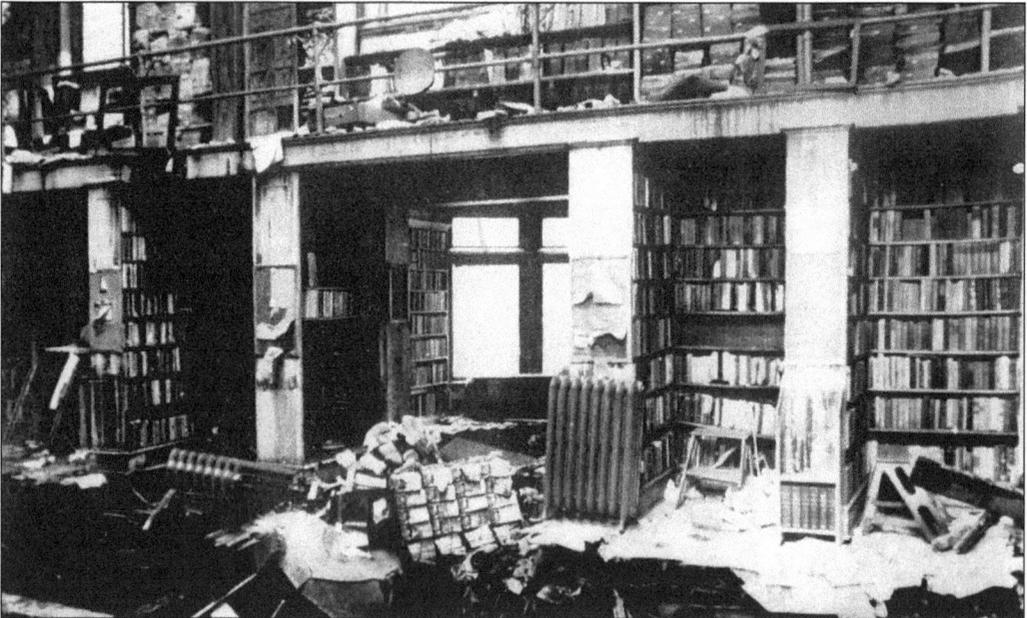

By the time the fire was extinguished, the floors of the main room, children's reading room, and part of the office had collapsed into the basement. Although many valuable books and papers were lost, much of the archival material was dried out and saved. The interior of the library was rebuilt and, with skillful restoration, it retains its Victorian ambiance today. The exterior remained virtually untouched. (Courtesy of the Dimmick Memorial Library.)

An abandoned church and Philadelphian John Drury came together in 1988. The former St. Paul's Methodist Church, descendant of Mauch Chunk's first church, became the Mauch Chunk Museum and Cultural Center.

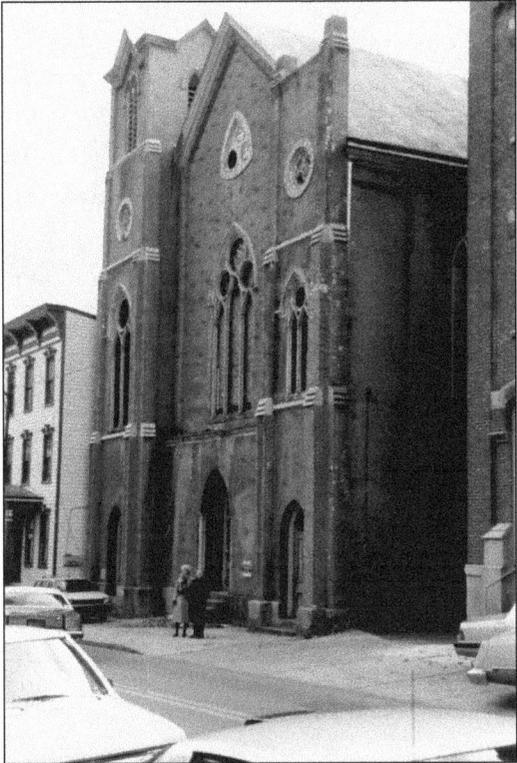

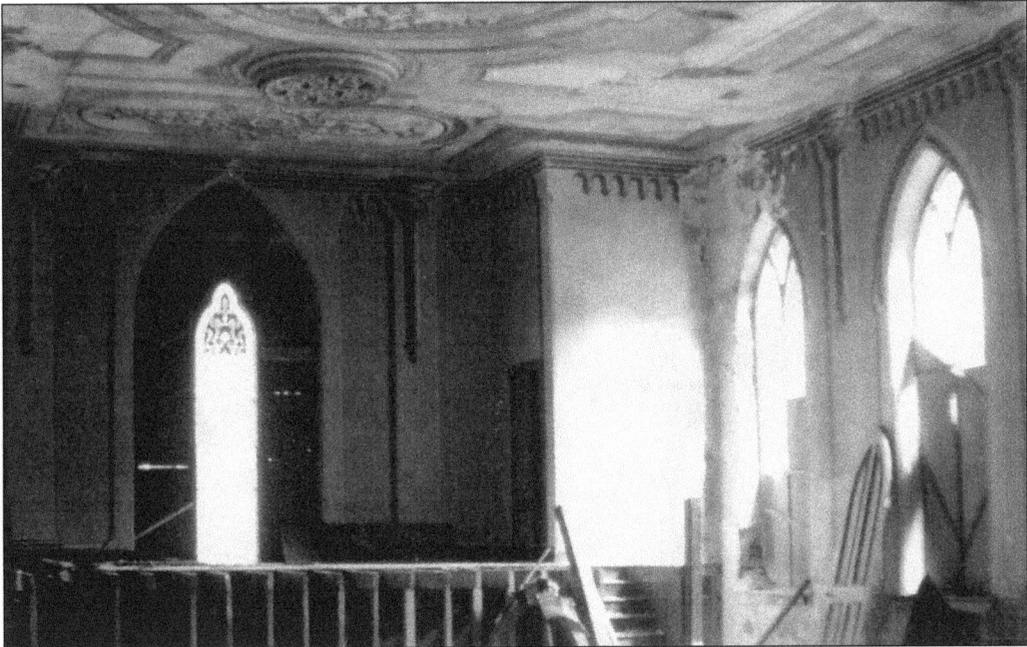

Gutted, waiting for the wrecking ball, the abandoned church took 10 years to restore. Today, with a museum telling the story of Mauch Chunk on the ground floor and a hall with two stages, klieg lights, and sound equipment on the second, the Mauch Chunk Museum and Cultural Center is both a place to discover local history and a gathering place for the community.

This glimpse inside a typical Victorian parlor is provided by the Mauch Chunk Museum. (Courtesy of Al Zagofsky.)

As Norman Ellis operates the working model of the Switchback Gravity Railroad, museum visitors listen to his commentary and observe the car ascending Jefferson Plane. (Courtesy of Mary Wohlhaas.)

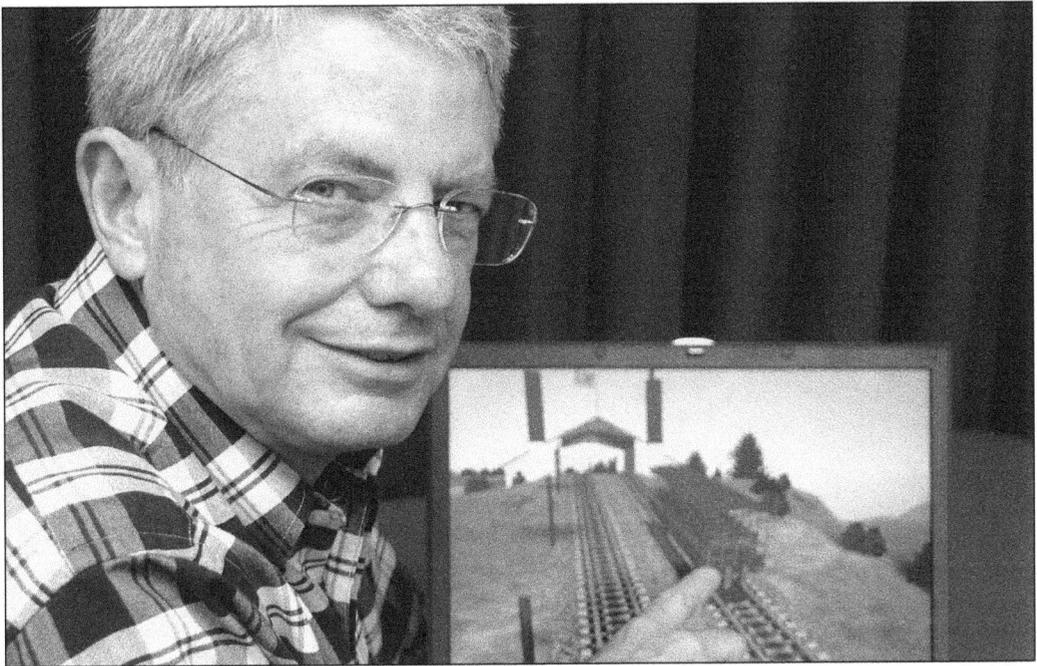

Walter H. Niehoff, a member of the Switchback Gravity Railroad Foundation and a retired engineer, built the 30-foot working model of the Switchback Gravity Railroad, now housed in the Mauch Chunk Museum. Niehoff's latest project is a virtual 18-mile round-trip ride on the Switchback Gravity Railroad, modeled with the help of Microsoft Train Simulator. He presents his latest creation to Switchback Foundation members using a laptop computer. (Courtesy of Al Zagofsky.)

The Mauch Chunk Museum provides programs for all ages. Two elderhostelers, attending one of the museum's programs, are seen role playing Asa and Sarah Packer on the ground-floor porch of the Asa Packer Mansion.

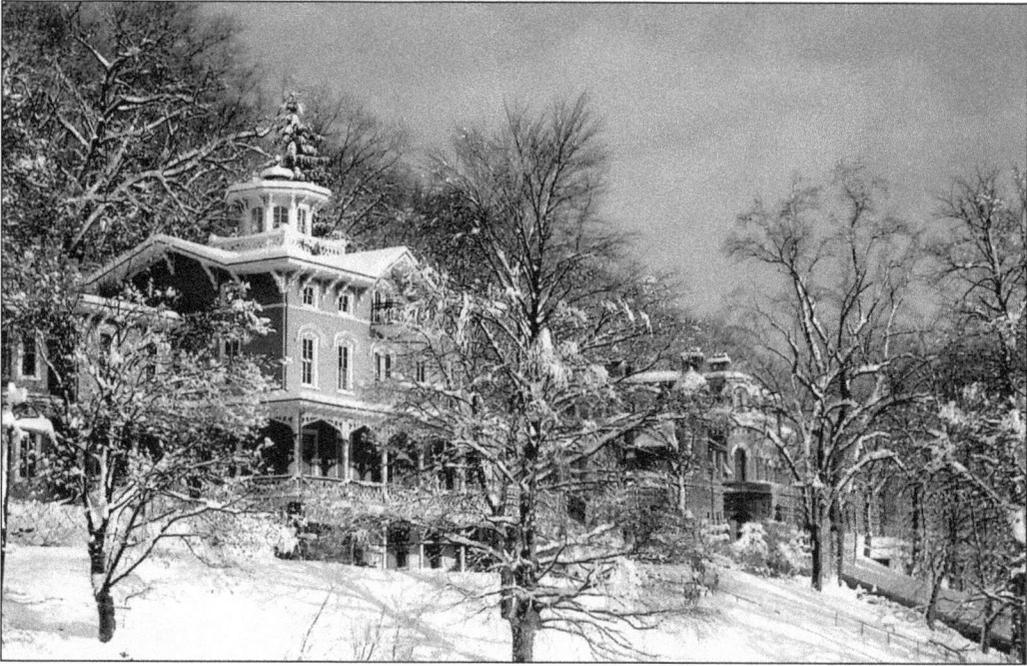

One of Jim Thorpe's greatest treasures is the Asa Packer Mansion, a National Historic Landmark pictured in this contemporary photograph. Willed to the borough of Mauch Chunk by Packer's daughter Mary in 1912, complete with its contents, the mansion now operates under the trusteeship of the Jim Thorpe Lions Club. (Courtesy of David Drury.)

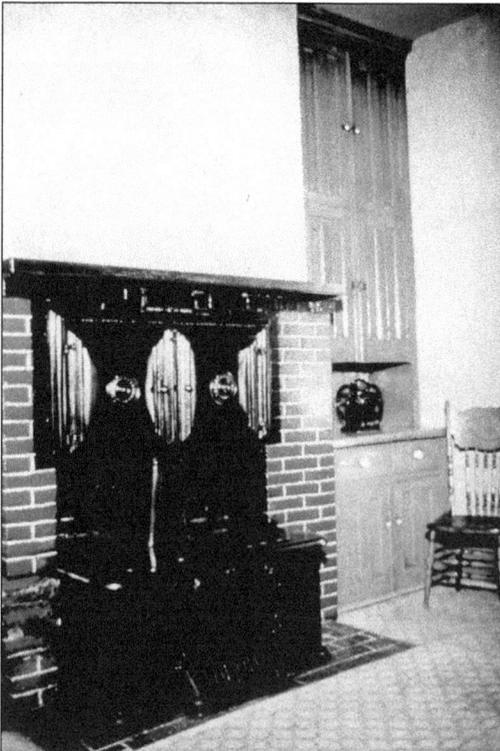

Everything—from this state-of-the-art 19th-century kitchen stove with its various gizmos and gadgets, to the finest china, custom-made furniture, European porcelains, and art—is in the same position it was when Mary Packer last stepped out for a walk. Visitors are treated to a recital on Mary Packer's Welty Cottage orchestrion. The orchestration and 100 music rolls were purchased in Switzerland for $500. (Courtesy of the Jim Thorpe Lions Club.)

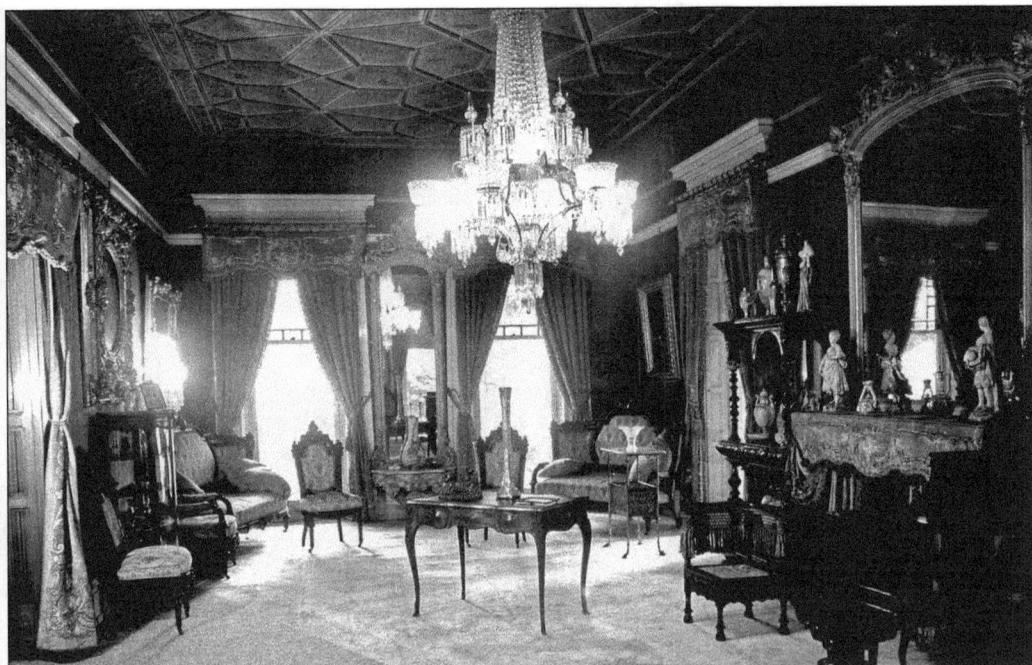

The large west parlor was refurbished in 1878 for Asa and Sarah Packer's 50th wedding anniversary. It features pink upholstered rosewood furniture, an icicle chandelier, gold-threaded pink velvet curtains, porcelain, and art. (Courtesy of the Jim Thorpe Lions Club.)

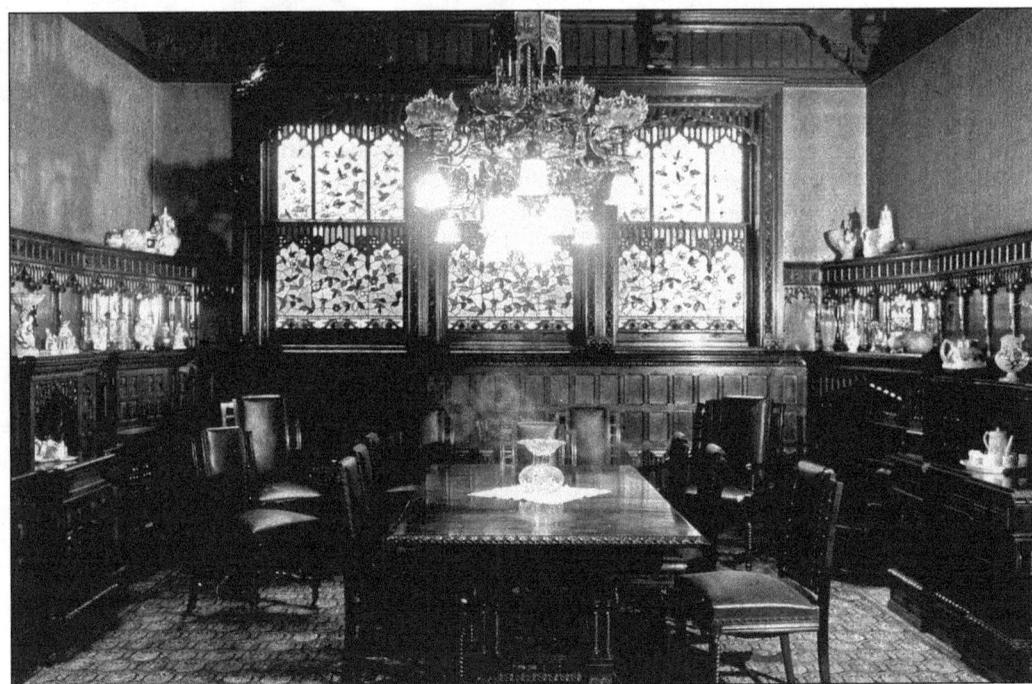

The dining room was sometimes used as a boardroom. Paneled in Honduras mahogany, it has a vaulted ceiling, pocket doors, and a large jeweled stained-glass window. (Courtesy of the Jim Thorpe Lions Club.)

As well as trusteeship of the Asa Packer Mansion and sponsorship of the Community Nurse Program, the Jim Thorpe Lions have established a unique connection with the legacy of Josiah White, founder of the Lehigh Coal and Navigation Company. A Quaker who prospered in Mauch Chunk and wished to give something back to society, Josiah White bequeathed $40,000 to open a home for poor Quaker children outside Wabash, Indiana, when he died on November 15, 1850. Named Josiah White's Institute, the home initially fulfilled its purpose, then became a federally supported home for Native Americans. Today it is a modern facility for the care and treatment of troubled youth. Completing this philanthropic circle, the Lions Club sell souvenir bags of black diamonds (anthracite) to tourists, with proceeds benefitting Josiah White's Institute. Shown here, from left to right, are the following: (first row) Craig Zurn, Jim Trainer, and Jim Zurn; (second row) Wilfred Gardiner, Bob Marzen, Bill Reabold, Ron Sheehan, Frank Rossino, Bill Ocker, Harold Queen, George Hiller, nurse Debbie Fikentscher, John Drury, Frank Rubenetti, and Jim Gallagher. (Courtesy of Al Zagofsky.)

Another jewel in Jim Thorpe's architectural firmament is St. Mark's Church on Race Street. Endowed by Asa Packer, the stone church has an asymmetrical tower and a roof garden. Its arched Gothic interior features a high altar with marble reredos and magnificent stained-glass windows. Guided tours of the church complex are conducted during the tourist season.

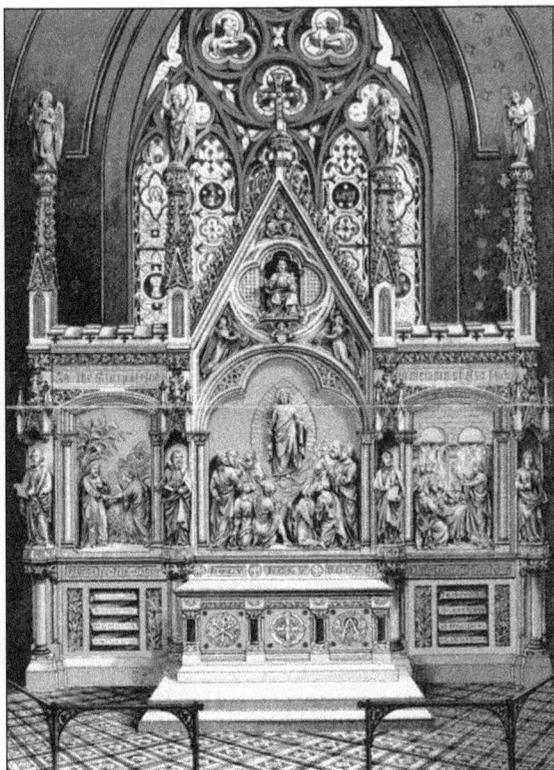

Erected in memory of Asa Packer by his family, the marble altar and reredos rise 23 feet and extend across the width of the chancel. The altar is inlaid with Maltese crosses and surrounded by molding. Four Sienna marble columns containing circular motifs form three panels across the front of the altar. The reredos consists of three elaborately carved bays, each depicting an aspect of the Ascension. Above the central Ascension scene is a seated figure of the Lord.

103

The Opera House has had three incarnations since it was built about 1881. At the time of this 19th-century photograph, it was a vaudeville house and a covered market. To the left of the Opera House is the Presbyterian church, now an art gallery.

Without money to fix the Opera House's deteriorating tower, it was torn down during the town's darkest days, and the building became a movie house. Today, refurbished through the fundraising efforts of the Mauch Chunk Historical Society, it is once again a theater. (Courtesy of Joe Boyle.)

Eight

SALVAGING THE PAST

As Jim Thorpe's buildings are restored and their original uses changed, as longtime residents and entranced newcomers open shops along Market Square and Broadway, and galleries along Race Street, there is new pride in the town's heritage. Whether it be restoration, preservation, or the discovery of long-lost industrial artifacts, Jim Thorpers are on a mission. The theme is retro. Anything and everything that brings Mauch Chunk's illustrious past to life is treasured. In a sense, the poverty years did the town a service. Without money to modernize or tear down the fine heritage buildings that form its nucleus, Jim Thorpe remains a town out of time, a Victorian jewel in the 21st century.

Parkhurst, once the home of Lehigh Coal and Navigation managers, is still standing on Center Street in East Jim Thorpe. It is pictured in 2003, when the deteriorating end unit was sold at a sheriff's sale and then resold to an interested party. The mystery buyer was the Mauch Chunk Museum. On the steps talking to contractors is the museum's president, John Drury. (Courtesy of Al Zagofsky.)

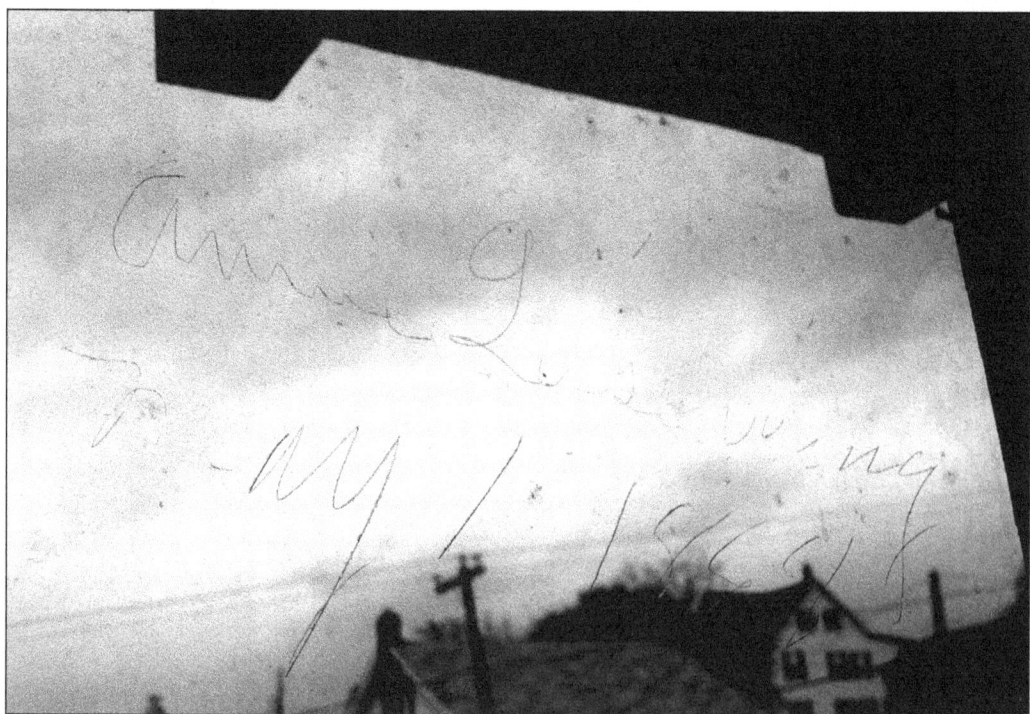

Proclaiming the authenticity of the museum's purchase, the signature of Leisenring's daughter Annie and the year 1860 are etched on a windowpane. (Courtesy of Al Zagofsky.)

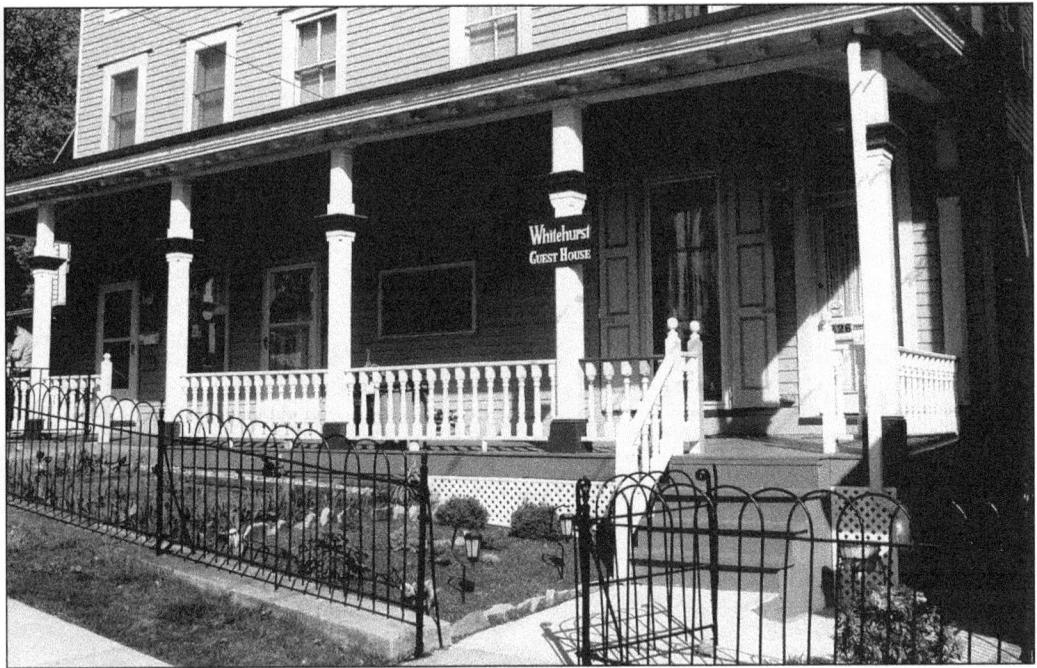

The right end unit has been renovated, converted into a guest house, and renamed Whitehurst in honor of the home's two previous names. Income from the guest house supports the maintenance of the Mauch Chunk Museum. (Courtesy of Al Zagofsky.)

Although over the years the exterior has suffered, the interior has maintained its Victorian ambiance. The front parlor is decorated with period furnishings and images and artifacts relating to its first occupants, the three Lehigh Coal and Navigation Company managers Josiah White, Edwin Douglas, and John Leisenring. (Courtesy of Al Zagofsky.)

In 1986, the Switchback Gravity Railroad Foundation was established to restore the Switchback Railroad. Since then, plans had to be curtailed. Today the organization's aim is to install a cable-pulled rail system on the Mount Pisgah Plane so that riders can enjoy the same scenic panorama that others did a century ago, and view the remains of the engine house, two reservoirs, and the trestle foundation. Opposite is the prototype cable car. (Courtesy of Al Zagofsky.)

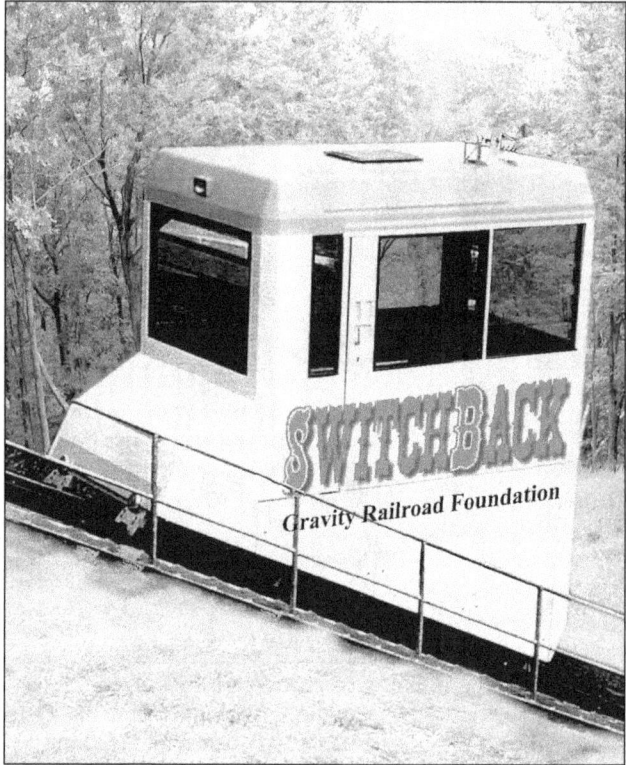

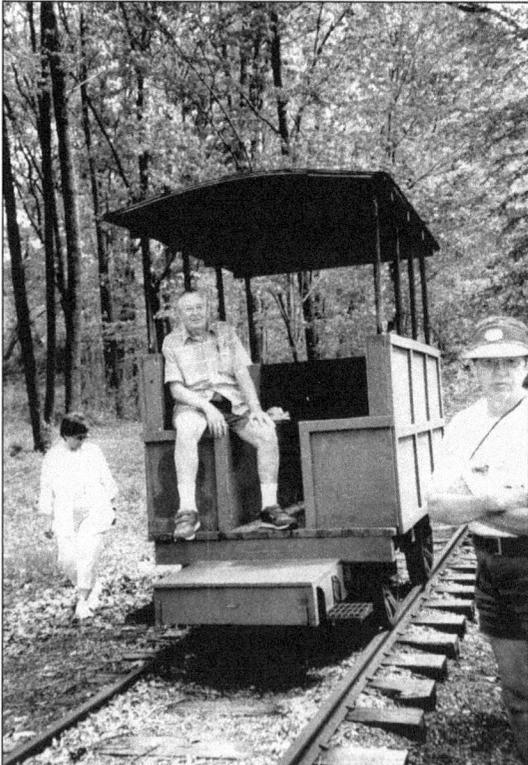

Levio Grosso, president of the Switchback Gravity Railroad Foundation, is seated in this early model Switchback car, located on a 40-foot demonstration track at the entrance to Mauch Chunk Lake Park. (Courtesy of Al Zagofsky.)

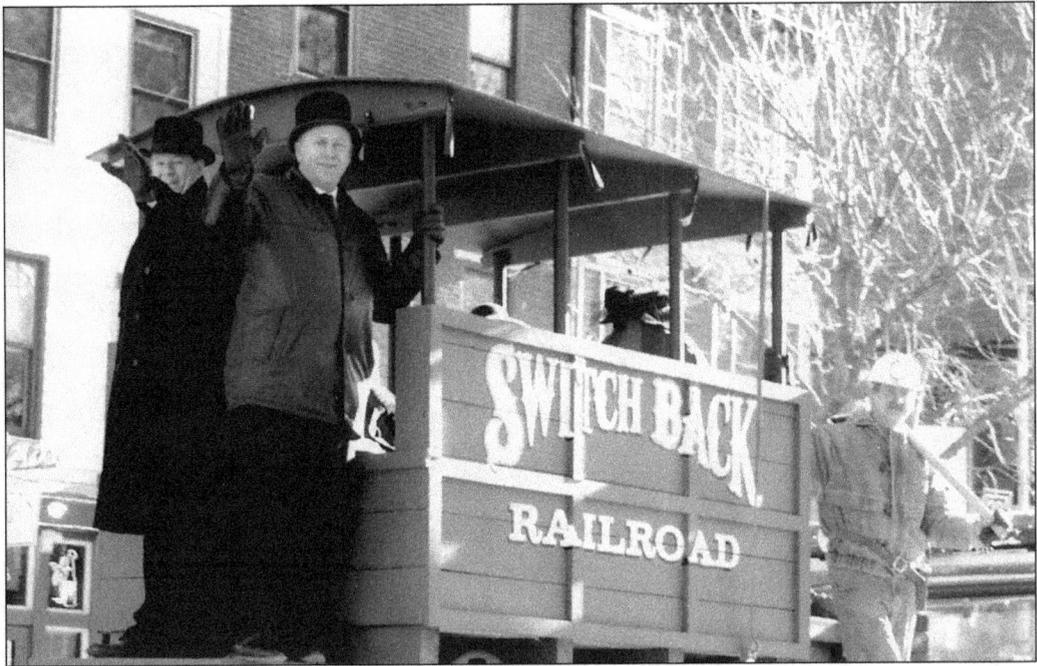

Levio Grosso's model Switchback car is used to promote the Switchback Gravity Railroad Foundation's cause. Here it is paraded through the streets of Harrisburg at Governor Rendel's 2002 inauguration. Two Carbon County Commissioners, Charles Getz and William O'Gurek, wave as Steve Perdie poses as a coal miner. (Courtesy of Al Zagofsky.)

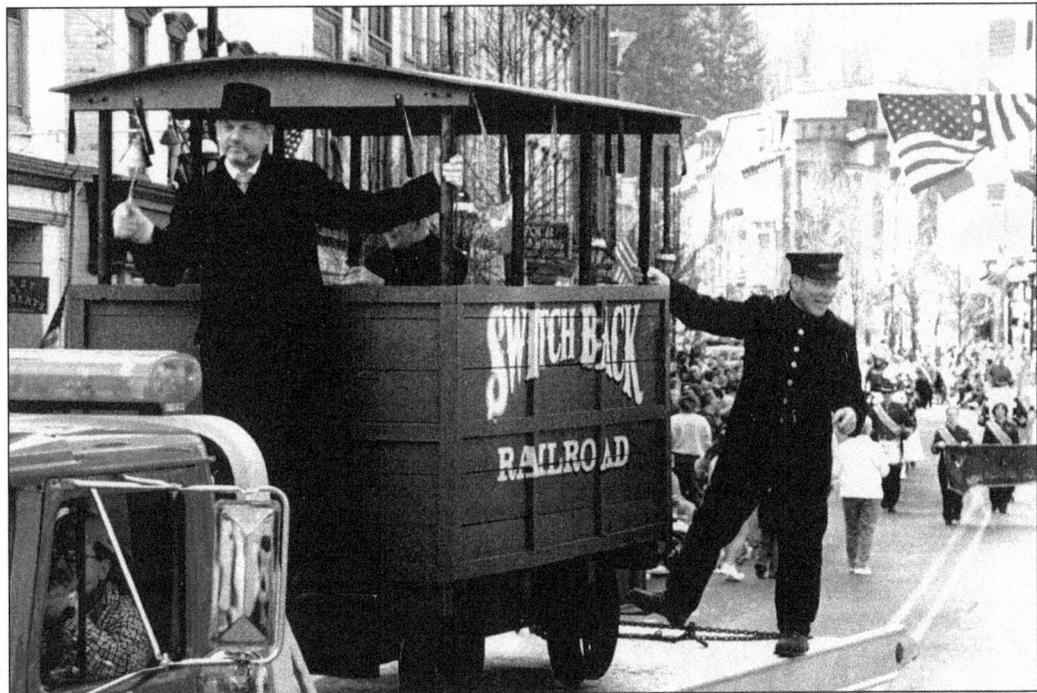

The Switchback car again travels through the streets, this time in Jim Thorpe, the town where it all began. Al Zagofski rings the bell as Jeff Wartluff works the crowd.

Switchback Gravity Railroad Foundation members, accompanied by Carbon County commissioners and Elissa Marsden (foreground, with her back to the camera), the former Main Street manager and the current heritage development manager with the Delaware and Lehigh National Heritage Corridor, take in the panoramic vista atop Mount Pisgah Plane as they study the feasibility of the cable car project.

Elissa Marsden leads the way down Mount Pisgah Plane, now a hiking and mountain biking trail.

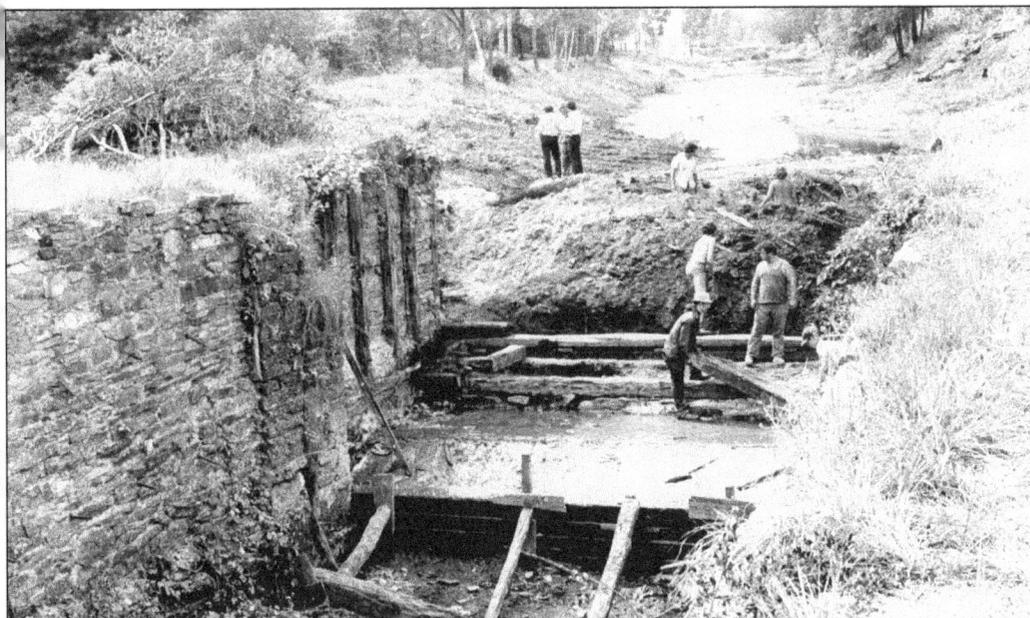

On August 17, 1965, canal lands from Palmerton to Jim Thorpe were sold at auction and purchased for $16,000 through a grant obtained by the Carbon Tourist Promotion Agency. Silted up after half a century, the canal from Lock 6, south of Jim Thorpe, to the Lehigh River outlet lock at Parryville (Lock 13) was bulldozed and water was reintroduced. Here Lehigh Canal Commission volunteers are hard at work on the project. (Courtesy of Joe Boyle.)

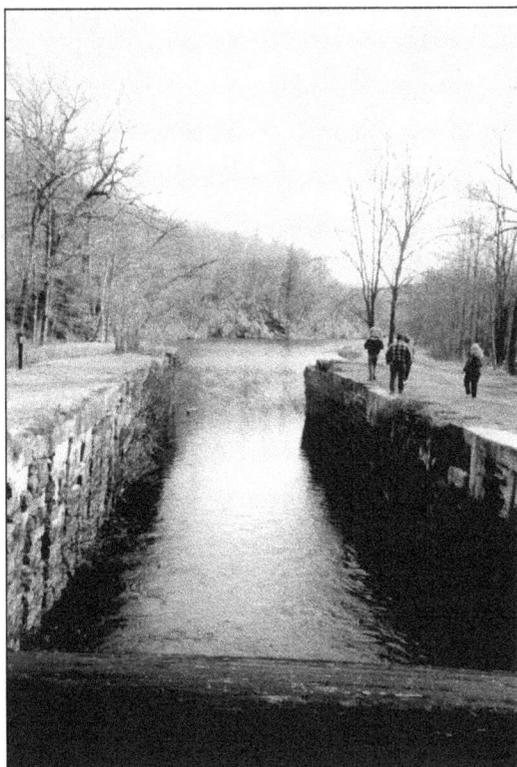

As the towpath winds its way north, the turbulent Lehigh is on one side, the tranquil Lehigh Canal on the other. Although the walls of Lock 7 are intact, the gates are long gone. Josiah White's unique drop gate would have held back the water at the top end of the lock; a pair of sturdy miter gates would have stood at the bottom end.

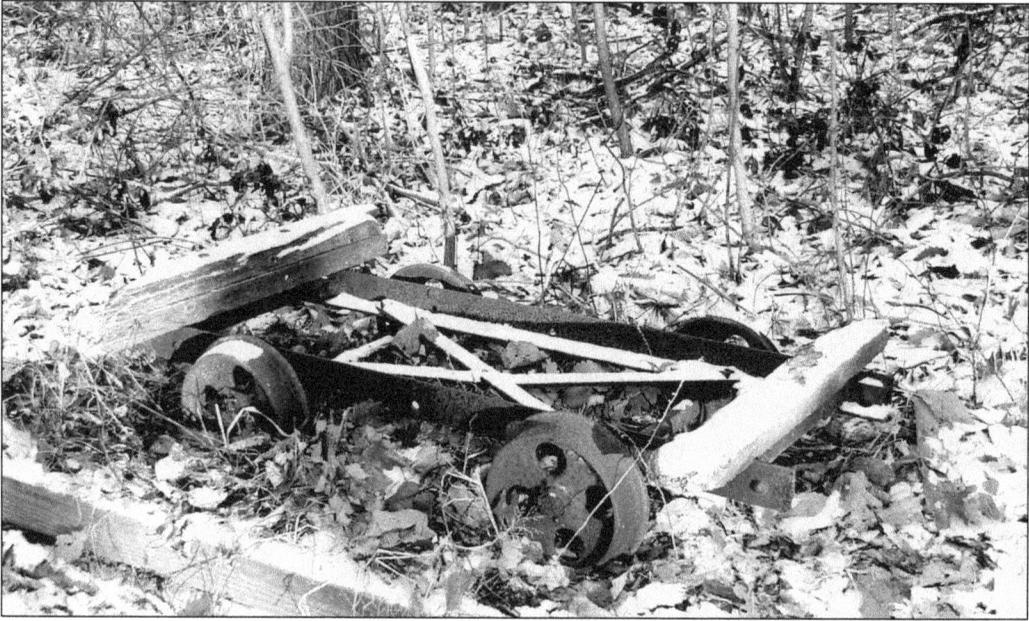

Hunting for artifacts along the Lehigh Canal and Switchback rail bed has become a pastime for local historians and Jim Thorpers of all ages. Like those of other small towns that thrived during America's industrial revolution, the proud citizens of Jim Thorpe wish to validate their history and put it on display. A treasured link to Mauch Chunk's past is this rusting chassis of a coal wagon. (Courtesy of Al Zagofsky.)

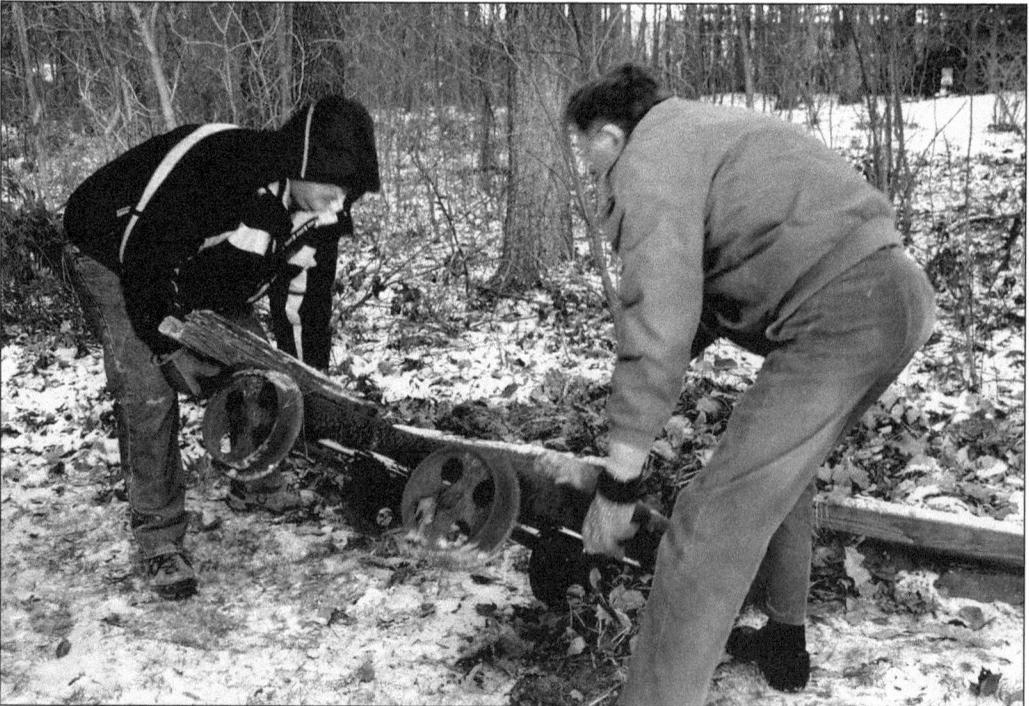

Embedded in the ground for more than a century, the chassis requires two "weight lifters" to free it from the mud and load it onto a truck. (Courtesy of Al Zagofsky.)

Low water in the Lehigh is a great time to treasure hunt. A turbine, used to generate electricity for Mauch Chunk's trolley cars, lies above water near the remains of the Packer Dam. The Carbon County Electric Railway Company began trolley service in Mauch Chunk in 1893, and the line was extended to East Mauch Chunk in 1898. By 1903, trolley lines connected Lansford, Tamaqua, and Lehighton to Mauch Chunk.

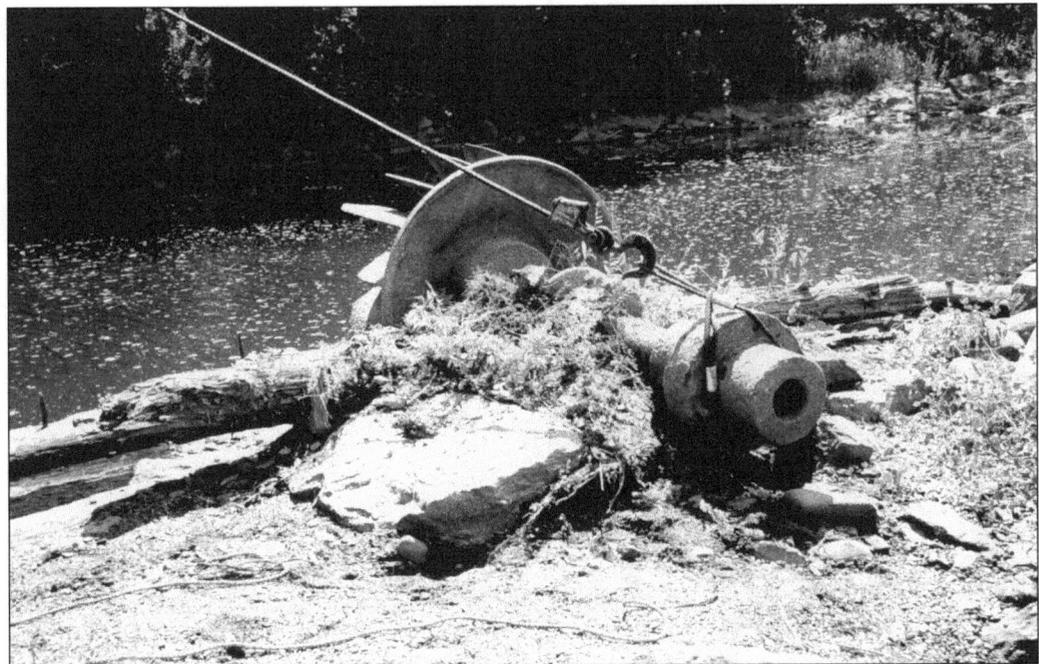

A work crew and a wrecker retrieve the turbine.

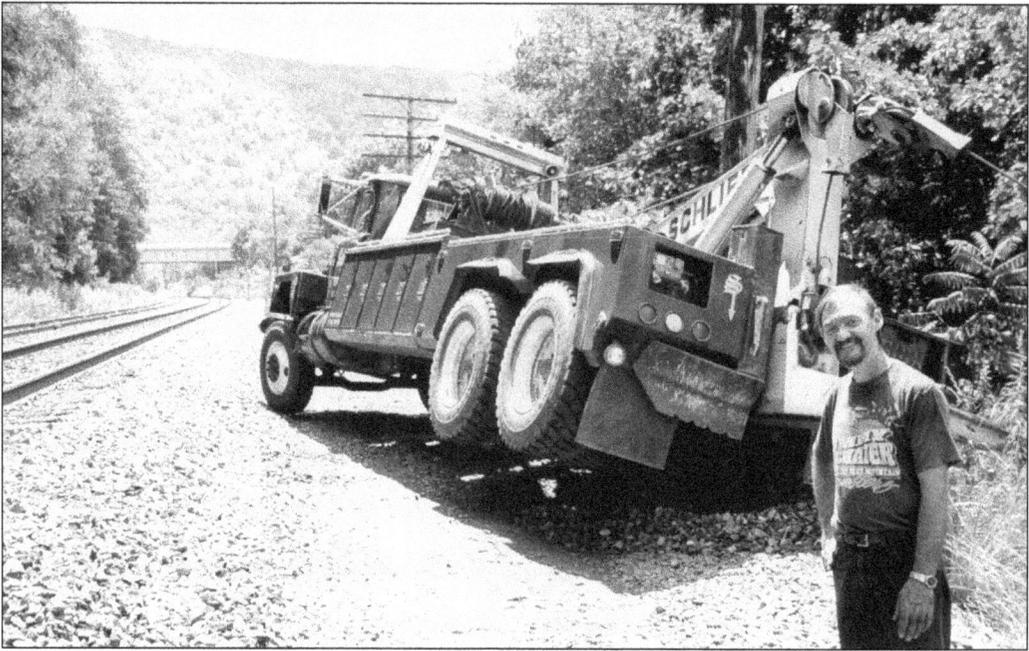

Even the wrecker has keeled over under the weight of the load. "Hard to believe," says Mike Heatter, local contractor.

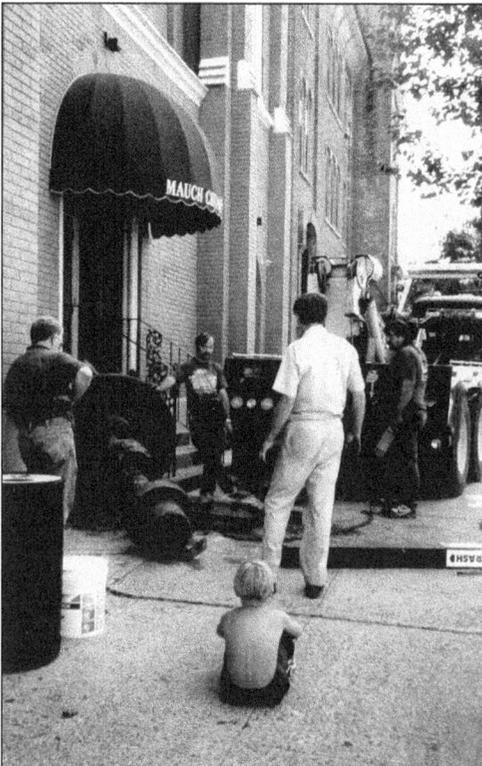

The work crew, with a small boy looking on, moves the turbine to its final resting place in front of the Mauch Chunk Museum on West Broadway.

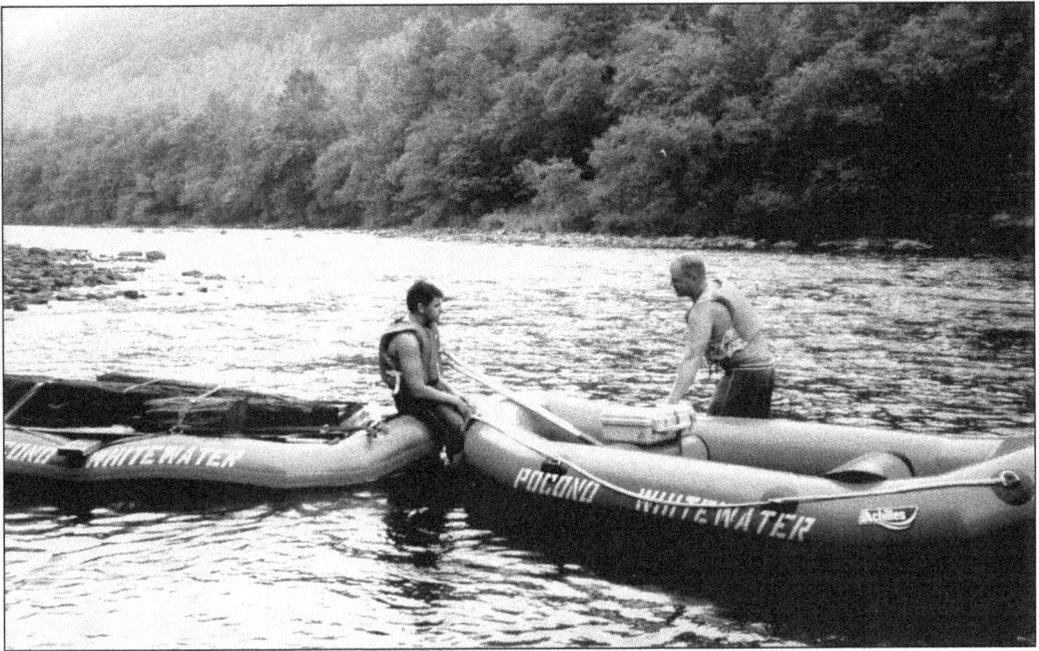

An expedition from Whitewater Rafting retrieved a partially submerged piece of wood from the Lehigh River below Jim Thorpe. Here the crew loads it onto one of the rafts.

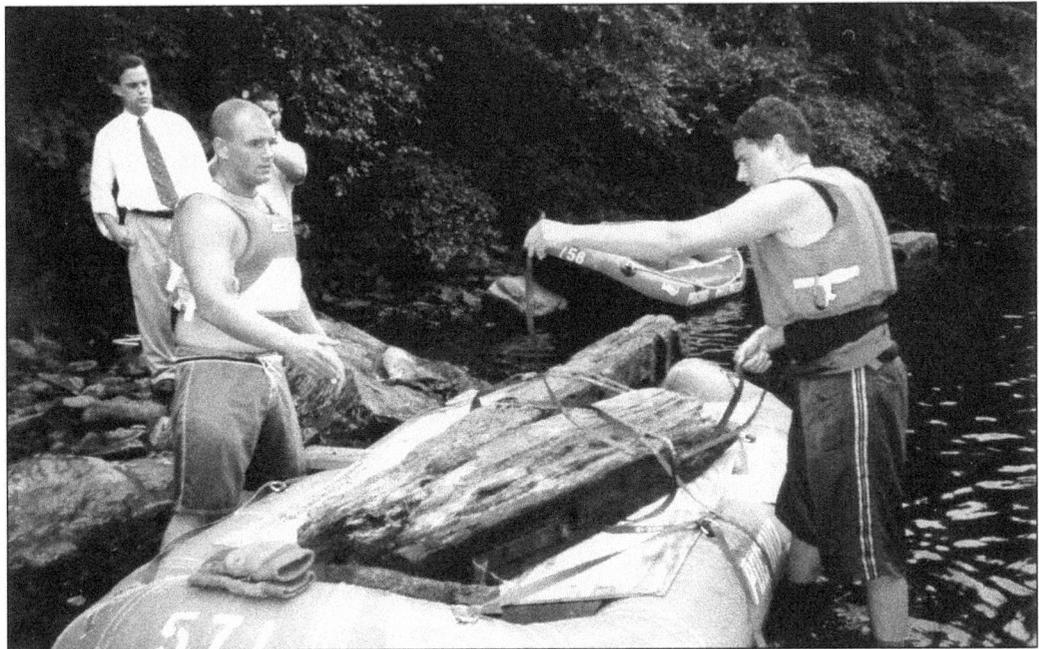

The find was taken by truck to the Mauch Chunk Museum for identification.

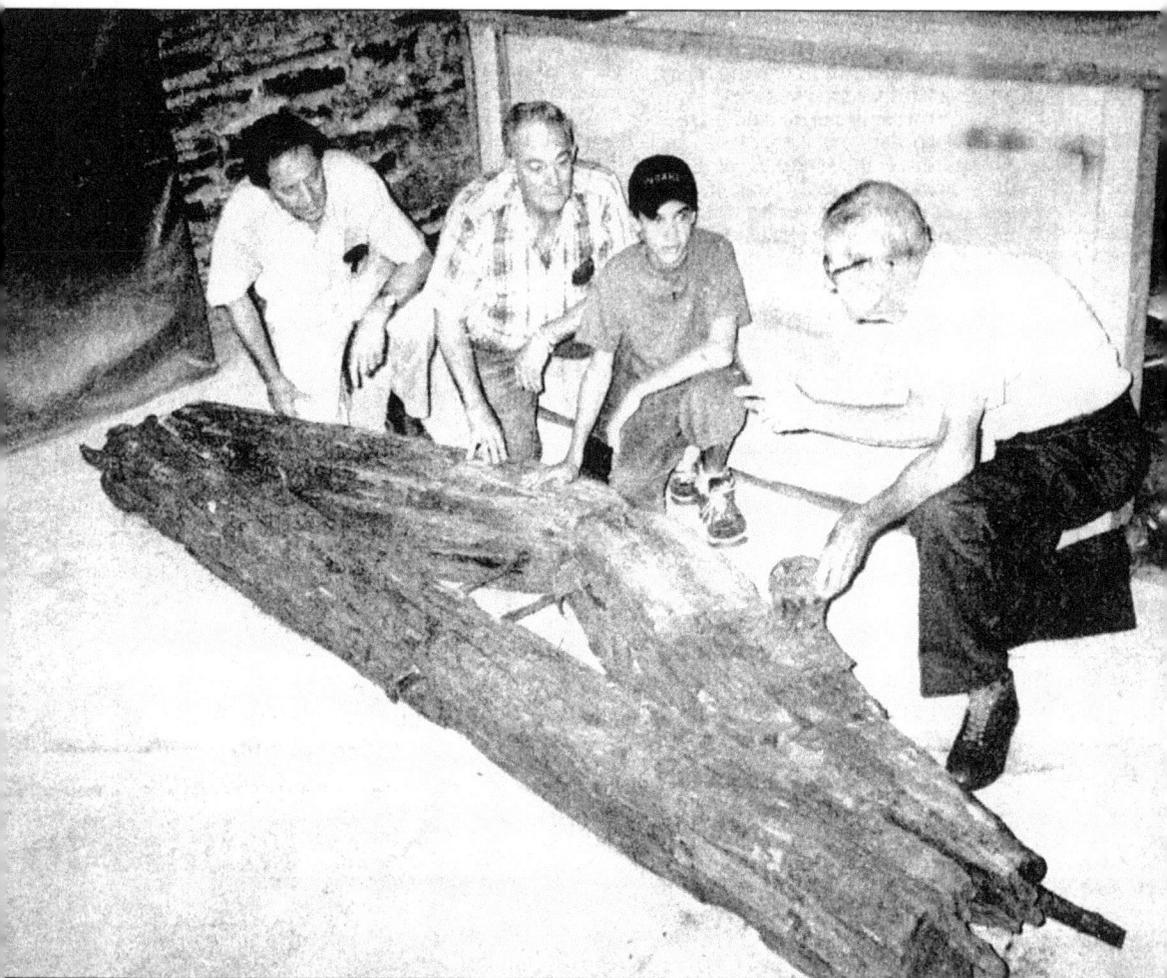

Lehigh Canal expert and former canal worker Richard Arner identified the object as part of the canal boat docking system in Mauch Chunk. The bollard, for securing the rope when a boat tied up, was intact in the structure. Seen here, from left to right, are John Drury, president of the Mauch Chunk Museum, where the artifact will go on display; John Parry, who found the object; his grandson Timothy; and the late Richard Arner. (Courtesy of *Times-News*.)

As pieces of Mauch Chunk's industrial past are retrieved and identified, they will become part of an industrial garden in front of Broadway House, a guest house on West Broadway opposite the Mauch Chunk Museum.

Here a crowd of interested onlookers watches as Switchback Gravity Railroad Foundation members excavate the pit housing the barney that pushed coal or passenger cars up Mount Jefferson Plane.

With this 160-foot-high trestle across the Lehigh River recently inspected and repaired, rail excursionists will soon be able to get a bird's-eye view of the vast sweep of mountain and river as the turbulent Lehigh curves through its rocky gorge.

A trail from Jim Thorpe now provides access across this old Jersey Central Railroad bridge to the waterfalls of Glen Onoko and the Delaware and Lehigh National Heritage Corridor through the Lehigh Gorge.

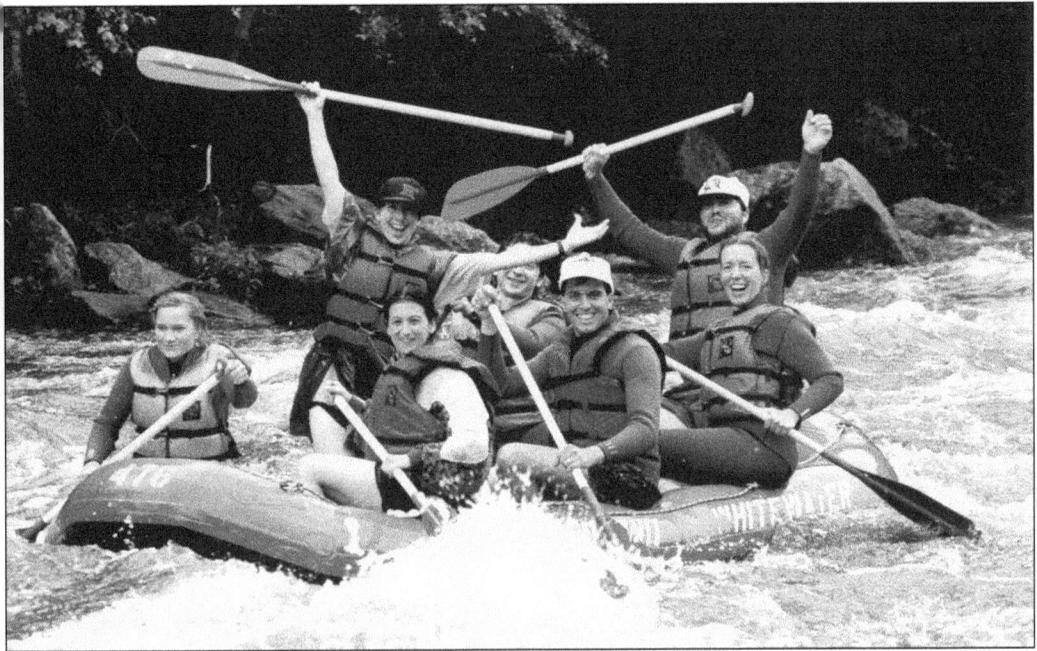

Spirits are high as rafters ride the Lehigh's white water through its magnificent gorge. Those who prefer a lazy float can embark at Jim Thorpe and float downstream to Bowmanstown along more tranquil water. (Courtesy of Whitewater Rafting.)

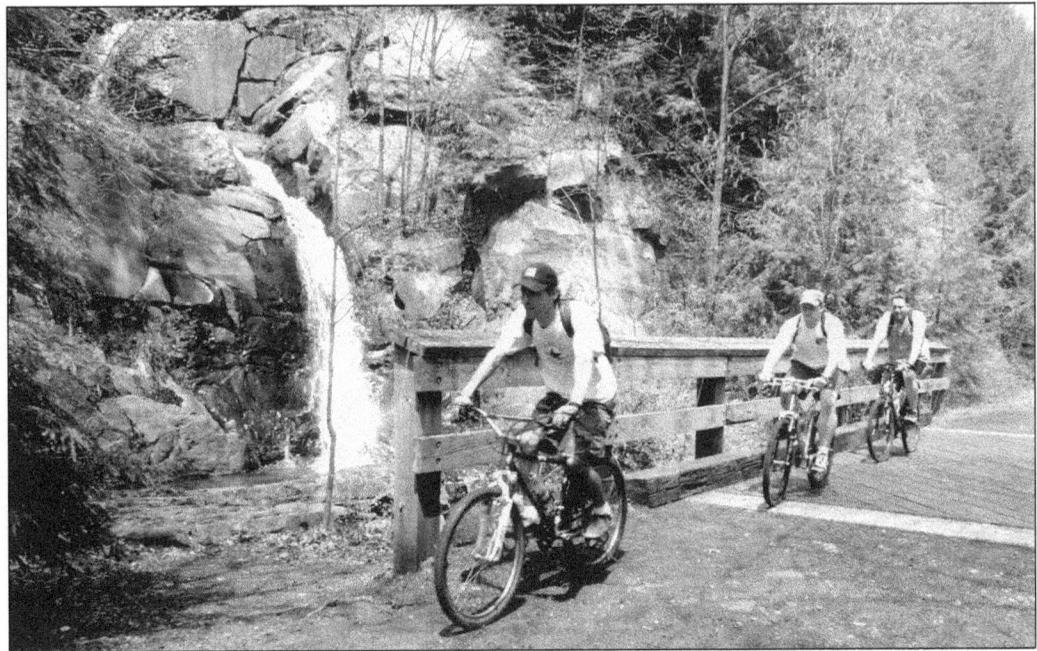

Another popular sport is mountain biking along the uphill and downhill routes of the former Switchback Gravity Railroad and along the scenic Lehigh Gorge trail, part of the 150-mile Delaware and Lehigh National Heritage Corridor. Here bikers are midway through the gorge, heading back to Jim Thorpe from White Haven. (Courtesy of Al Zagofsky.)

From this photograph, it is hard to believe that boats plied the Lehigh River through its gorge along the Upper Grand section of the Lehigh Navigation from 1838 until 1862. Passage was made possible by 20 dams, ranging from 16 to 58 feet in height, and 29 locks, with lifts from 10 to 30 feet. With a 600-foot drop in elevation between White Haven and Mauch Chunk, 20.5 miles of the navigation were in the river and only 5.5 miles in a canal.

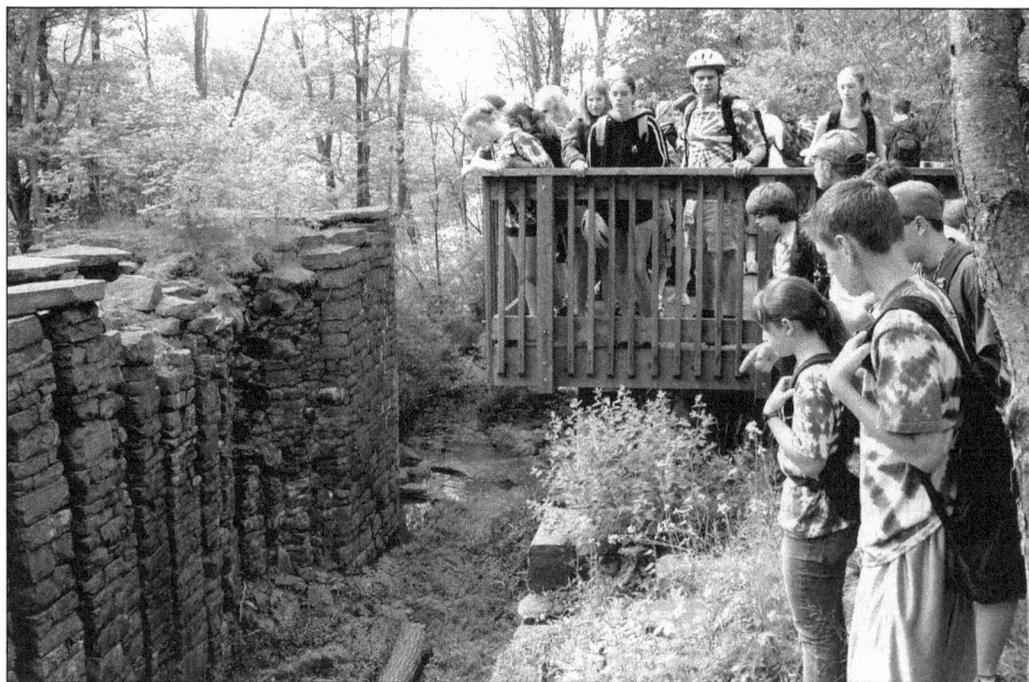

Schoolchildren stand on the overlook above the remains of Lock 28, the best-preserved lock on the former Upper Grand section. This lock, situated a mile below the White Haven terminus, had a 22-foot lift. (Courtesy of Al Zagofsky.)

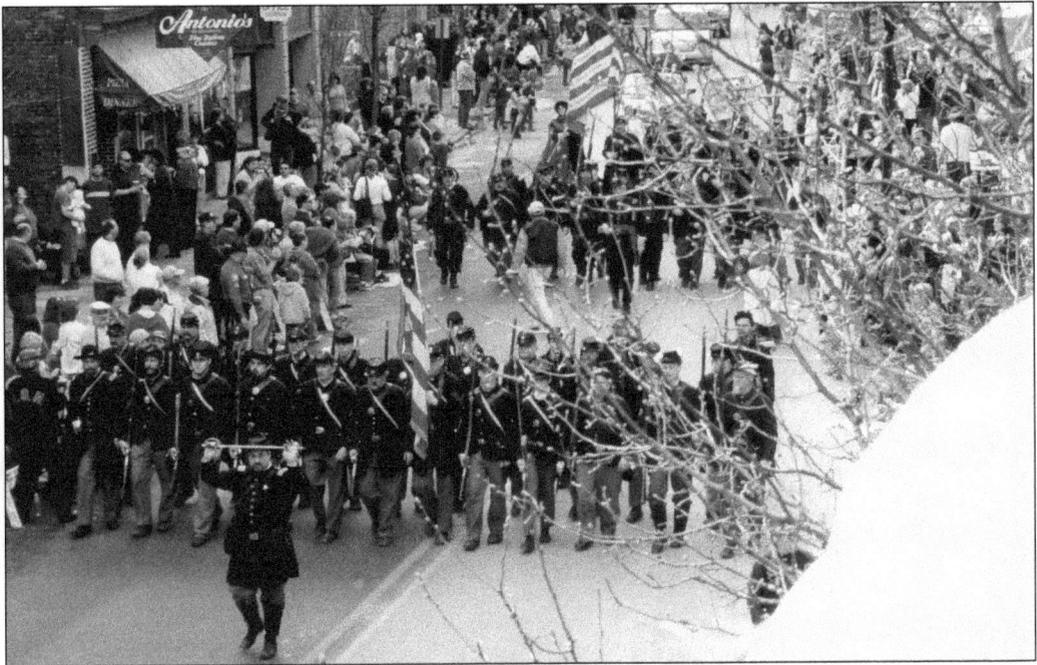

The town has always been known for its parades. Here in a retro moment, Bucktails re-enactors parade through Jim Thorpe. The Bucktails are the same Civil War regiment that marched down Broadway in 1891 in honor of veterans (see page 52).

Crowds throng the sidewalks as they wait for the St. Patrick's Day parade to make its way down Broadway to the reviewing stand on the balcony of the Inn at Jim Thorpe. (Courtesy of Anne Baddick.)

In a moment significant to Jim Thorpe's Irish, St. Patrick's Day marchers, including Ancient Orders of Hibernians from all over the area, stop for a blessing at the Immaculate Conception Church. (Courtesy of Anne Baddick.)

As bagpipes wail, the marchers pay their respects to the seven Mollies who were hanged in Carbon County Jail while fighting for the rights of coal miners. (Courtesy of Anne Baddick.)

122

Nine

THE SAGA OF THE OLYMPIAN CONTINUES

As Jim Thorpers honor the athlete by tending to his memorial and enhancing the grounds with a sunken sculpture garden, commemorate his birthday with festivities and a staged Olympic run, name the high school football team the Olympians and, in 1998, campaign for their hero to be named Athlete of the Century, the tug-of-war to return Jim Thorpe's body to Oklahoma continues. While Thorpe's daughter Grace is satisfied with what the town has done for her father, the rest of the family believes that his body was auctioned off by his third wife, Patricia, as a tourist attraction. According to an article appearing in the *Times-News* in February 2001, Bill Thorpe put it this way: "She took his body around, farmed him out to bidders. Patsy put a lot of focus on Pennsylvania because Dad had played football there. So she went into Pittsburgh and Philadelphia and Carlisle and Harrisburg. What she was looking for was money."

Refusing to visit the mausoleum, Jim Thorpe's sons demand that their father receive a Native American burial on the soil of his birth. Although they enlisted the help of Oklahoma lawmakers in October 2001, Gov. Frank Keating refused to intervene, stating in the *Times-News*, "I learned that the town of Jim Thorpe has honored his memory well. They have lived up to their part of the bargain." Possibly there was more to Keating's refusal than just the legendary athlete's memory—the 1954 agreement between Patricia Thorpe and local officials appears to be airtight:

> The first party [Patricia Thorpe] agrees for herself, her heirs, administrators and executors, that neither she nor any of them will remove or cause to be removed the body of her said husband, Jim Thorpe, from the confines of the boroughs of East Mauch Chunk and Mauch Chunk, the electorates which have, on May 18, 1954, committed themselves to consolidate under the name of Jim Thorpe under and subject, however, to the following proviso:
>
> That said obligation shall be binding upon the first party and upon her heirs, administrators and executors only for so long as the boroughs of East Mauch Chunk and Mauch Chunk, parties hereto, are officially known and designated as Jim Thorpe.

Jim Thorpe's family are, from left to right, Jack, Grace, William, Gail, Carl, Charlotte, and Richard.

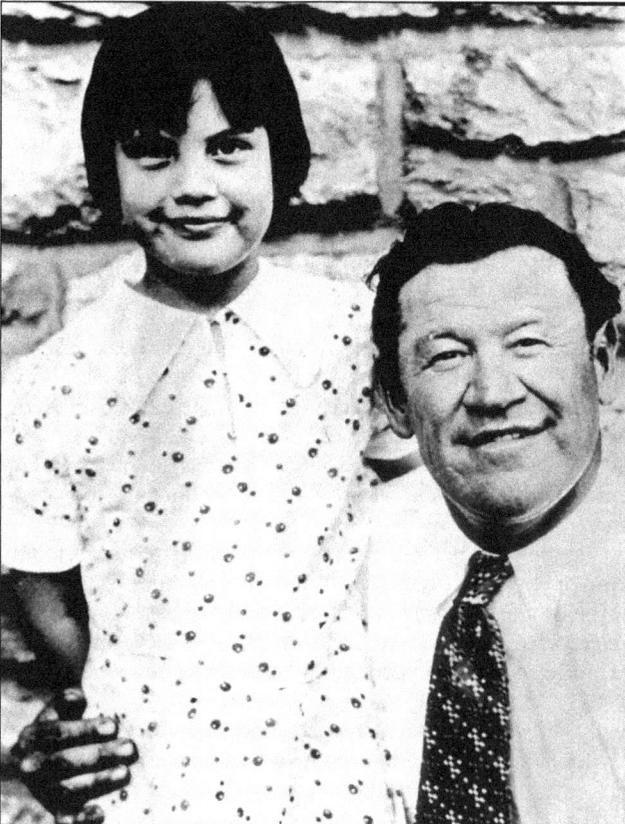
Grace Thorpe, who appreciates what the town has done in his memory, is pictured here with her father.

Jim Thorpe and Joe Boyle meet in spirit at the monument as Joe Boyle Circle surrounds Jim Thorpe's granite mausoleum. (Courtesy of Mike Urban, *Times-News*.)

Jim Thorpe's gold medals were returned to his family posthumously in 1982 after years of letter-writing by Jim, his family, and individuals and organizations who believed he had been wronged by the Olympic Committee.

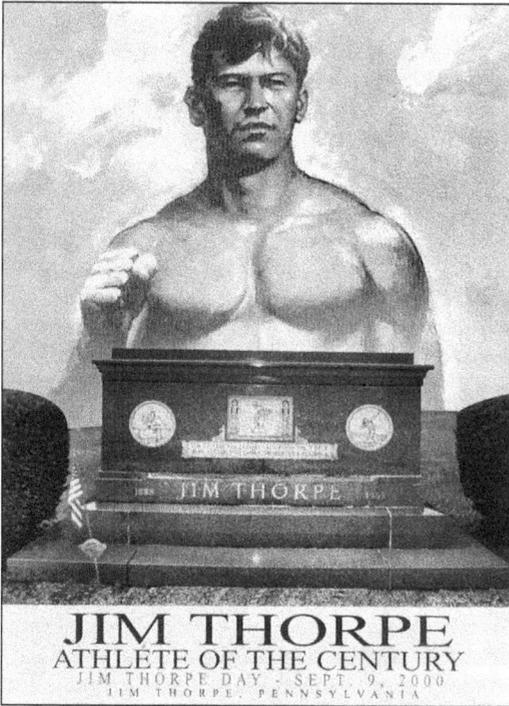

This composite image was used by Jim Thorpers to support Grace Thorpe's campaign to name her father Athlete of the Century in 2000. Although Jim Thorpe was named *Sports Illustrated*'s Athlete of the Century and his image appeared on a Wheaties box, he did not receive the coveted top award.

JIM THORPE
ATHLETE OF THE CENTURY
JIM THORPE DAY · SEPT. 9, 2000
JIM THORPE, PENNSYLVANIA

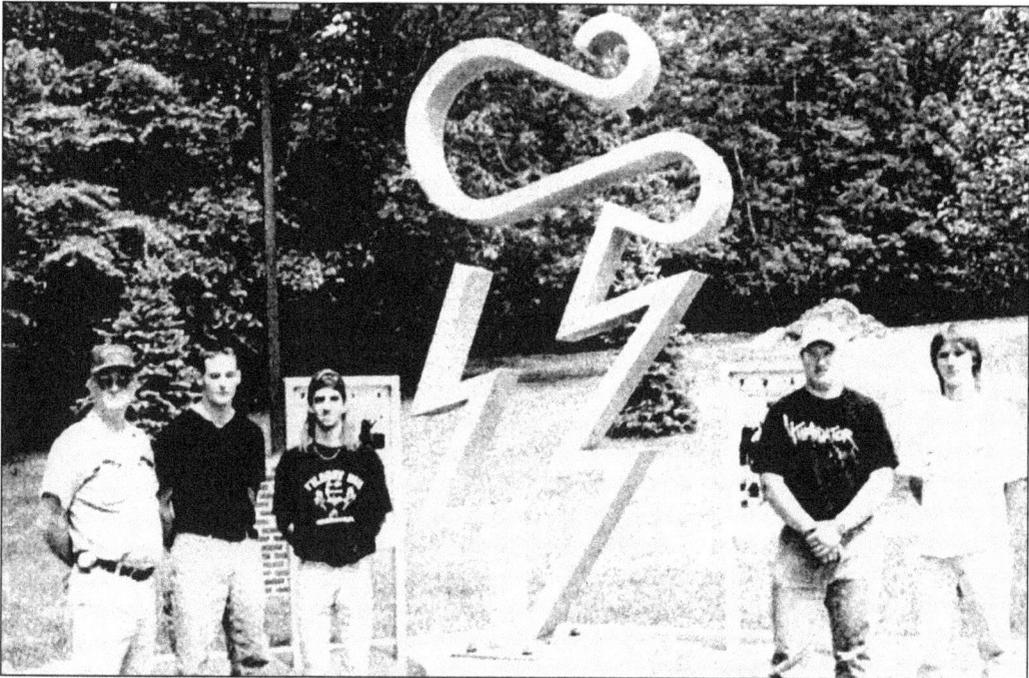

Coinciding with Grace Thorpe's campaign to have her father declared Athlete of the Century, the Jim Thorpe monument was re-dedicated in May 1998. Students from Carbon Area County Vocational Technical School installed walkways, lights, signage, and a sculpture to honor the Olympian. Teacher Wayne Hittinger (left) and Vo-Tech seniors, from left to right, Pete Malaska, Ben Weaver, Charles Christman, and Matt Bryfogle put finishing touches on the memorial garden.

126

On hand to re-dedicate the monument were, from left to right, Rita Boyle, widow of newsman Joe Boyle; Danny McGinley, president of the Carbon County Sports Hall of Fame; Grace Thorpe; Lyle Augustine Jr., director of the Carbon County Area Vocational Technical School; Dennis Gallager, mayor of Jim Thorpe; and George Bibighaus, Carbon Hall of Famer. (Courtesy *Times-News.*)

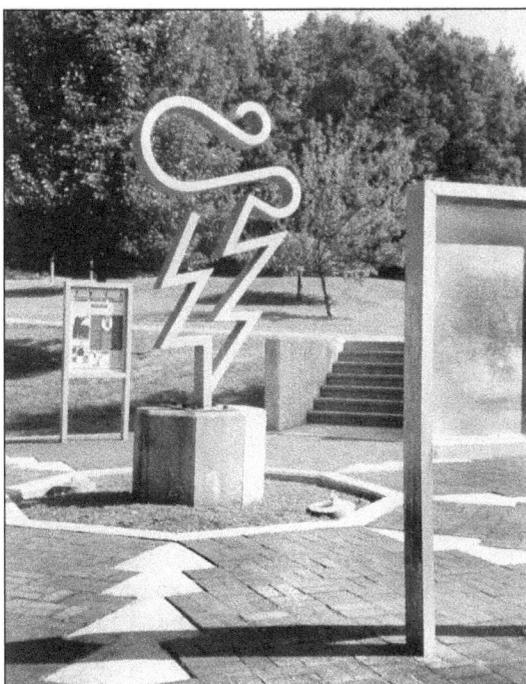

Surrounded by displays of Jim Thorpe's athletic feats, the sunken garden's paving and linear structure compliment the sharp outline of the lightning sculpture.

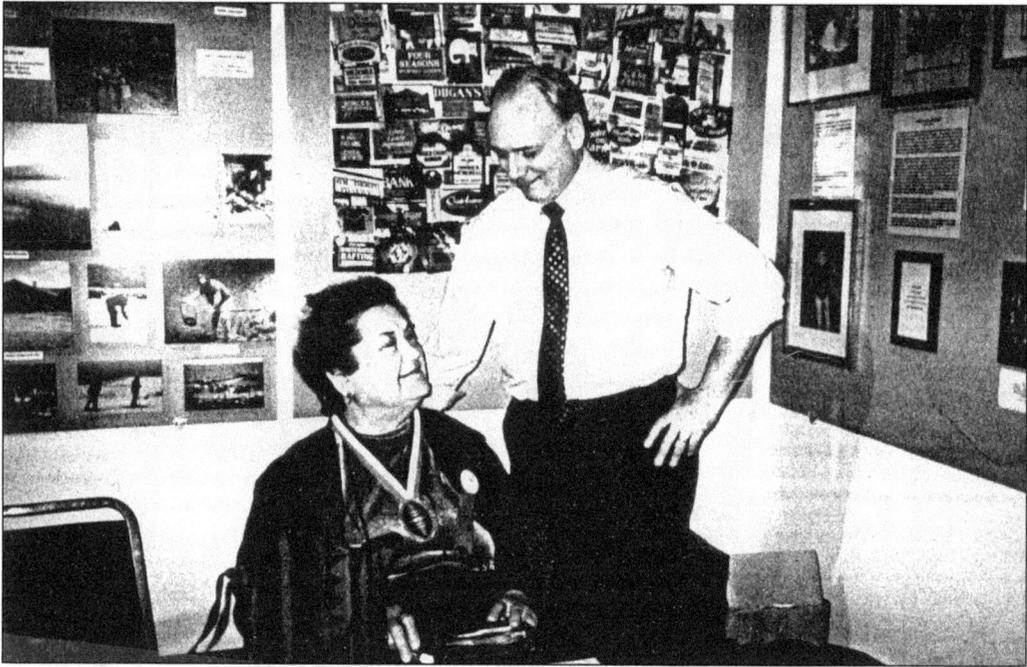

After laying cedar branches at the base of her father's tomb on a visit to town, Grace Thorpe signs a book about the legendary athlete in the Mauch Chunk Museum and Cultural Center. Pastor Jim Rosselli looks on.

These days, Grace Thorpe's granddaughters Teresa Thorpe Gwen and Carla Thorpe take her place at ceremonies honoring the Olympian. Here they are seen with state representative Keith McCall as he reads a proclamation from the Pennsylvania House of Representatives declaring May 19, 2001, James Francis Thorpe Day in Pennsylvania. (Courtesy of the *Times-News*.)

www.ingramcontent.com/pod-product-compliance
Lightning Source LLC
Chambersburg PA
CBHW050641110426
42813CB00007B/1874